WHAT'S SO FUNNY?

What's So Funny?

A CARTOONIST'S MEMOIR

David Sipress

MARINER BOOKS
Boston New York

marinerbooks.com

Library of Congress Cataloging-in-Publication Data has been applied for.
ISBN 978-0-358-65909-9

Portions of *What's So Funny?* were first published in slightly
different form as essays in *The New Yorker*:
https://www.newyorker.com/culture/personal-history/my-father-and-sandy-koufax
https://www.newyorker.com/culture/personal-history/no-questions-the-russian
-revolution-my-father-and-me
https://www.newyorker.com/culture/culture-desk/fine-ill-drink-more-water
https://www.newyorker.com/books/page-turner/nineteen-fifties-jewish-american
-christmas-story
https://www.newyorker.com/culture/culture-desk/lunch-at-gitlitzs
https://www.newyorker.com/culture/culture-desk/my-november-22-1963

All cartoons © David Sipress, and unless otherwise specified first appeared in *The New Yorker*.
Photos on 9, 21, 49, 68, 138, 184 courtesy of David Sipress.
Cartoons on pages 66 and 125 © David Sipress first appeared in *Air Mail*.
Cartoons on pages 99, 148, 221, 224 © 1987 David Sipress first appeared in
Wishful Thinking (Harper & Row).
The Little King © King Features Syndicate, Inc., World Rights Reserved.
Photograph on page 23 courtesy of Getty Images.
Photograph on page 170 courtesy of Valerie Reyes-Jimenez.

Book design by Martha Kennedy

Printed in the United States of America
21 22 23 24 25 LSB 5 4 3 2 1

For Ginny

Chapters

Introduction

I WAS BORN and raised in New York City. You could say that there's nothing particularly special about that, but deep down I've always felt that there is. Perhaps it's the simple fact that almost all the New Yorkers I know have come to the City from somewhere else. I'm from Here. Being a New Yorker from the get-go has permanently shaped my worldview.

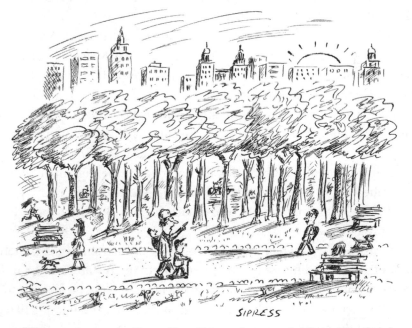

"The sun rises on the Upper East Side and sets on the Upper West Side."

This cartoon was published in *The New Yorker* in 2001, making it one of the first I sold to the magazine after twenty-five years of submitting and being rejected. The idea came to me in the summer of 2000, when I was walking south on Fifth Avenue after an afternoon visit to the Met. Somewhere around Seventy-Second Street, the memory of another, long-ago walk on Fifth Avenue popped into my head and out popped the cartoon. It works that way sometimes — the out-of-the-blue arrival of a fully formed idea.

The memory in question involved my parents, my older sister, and me. I was eight years old. The four of us had gone out to dinner one early summer evening at my parents' favorite restaurant, Gino's, on Lexington Avenue, across the street from my father's jewelry shop. There were always well-known people dining at Gino's. A few weeks before, we were there with a friend of my parents and he pointed out Charles Addams, sitting at the bar. I remember thinking that he looked just like one of his drawings (something people would say about me one day). That night we also saw the actor Montgomery Clift, who was a customer of my father's, sitting at a small table with Arthur Miller, whose literary accomplishments paled, as far as I was concerned, beside the fact that he was married to Marilyn Monroe.

As we were on our way out of the restaurant, my father stepped back and reverently held the door for the arriving Bess Myerson — famous television personality and the first Jewish Miss America. My family's relaxed, primarily secular Jewishness was a complicated and sometimes confusing affair. As a kid I understood that Jewish was just one thing we were — more fundamental perhaps but not all that different from our being New Yorkers, or Democrats, or Brooklyn Dodgers fans. On the other hand, we were always quick to root for and celebrate members of our tribe who broke barriers and made it big — athletes, scientists, writers, artists, actors, diplomats, and smart, talented beauty queens like Bess Myerson.

It wasn't dark yet when we walked out onto Lexington Avenue. There was a fancy black limousine parked in front of the restaurant. The uniformed chauffeur was leaning against the fender holding a leash at the end of which a little French poodle leapt back and forth, barking like a maniac at the door of Gino's.

"He's funny," I said to my mother. "I wonder who he belongs to?"

"Whoever it is, they better own a pair of ear plugs," my father said.

The poodle came over to me, looked up, and barked at me like I was the problem.

"Don't get too close," my mother warned. "It's the little ones that really bite."

"Let's *go*," my sister pleaded. She was always impatient, especially when the four of us were out together.

My mother suggested we take a walk on Fifth Avenue before getting a taxi back to our apartment on the Upper West Side.

"All right, but I just hope we can find a cab," said my father, suddenly sounding grumpy for no apparent reason, as so often was the case. "They aren't so frequent on Fifth," he explained.

"Fifth goes downtown," my sister chimed in. "They won't want to take us."

"All we can do is ask," said my mother.

"Maybe we can ask Fifth to go uptown," I said. My mother laughed.

We walked in spite of my father's misgivings, still hearing the poodle halfway to Park Avenue. When we turned on to Fifth, as taxi after vacant taxi sped by without my father lifting his hand to signal, I looked up and was startled by the sight of the dreamy, sparkling skyline of Central Park South and Midtown Manhattan, silhouetted against a dusky, pink sky, and I felt a powerful surge of desire: When I grew up, I told myself, I was going to escape the New York of my parents and find a way into the New York I saw glittering above the treetops of Central Park. It would be a New York full of cool, amazing, talented people like the actors and famous writers and artists I saw dining at Gino's — people who didn't need to worry about every little thing. I would be an artist too, I decided. What kind of artist would I be? I knew that I loved to draw. I also knew that I was funny — at least my mother thought so.

I did the calculation:

drawing + funny = cartoonist

When we returned to our apartment on West Seventy-Ninth Street, I went straight to my room, took out my crayons, and got to work. I had had an idea on the way home, and five minutes later, I turned it into my first *actual cartoon*:

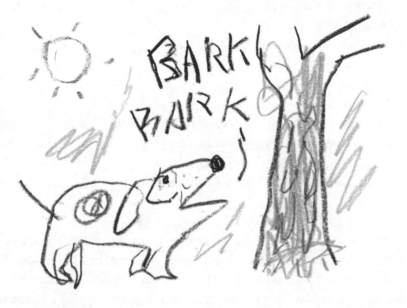

I have been telling myself stories about my family, in some cases, since I was a small boy. My father Nathan Sipress, my mother Estelle Sipress, and my sister Linda have all been dead now for many years. But I spent much of my life trying to escape what I thought of as "their clutches," and they continue to tug on my consciousness like the insistent under- tow that tugged on my little-boy ankles as I stood, small feet planted in gritty sand at the water's edge on the beach in Neponsit, the four-block- wide beachfront community wedged between the Atlantic Ocean and Jamaica Bay, Queens, where we spent every summer of my childhood. When I sit in my studio squeezing my brain for cartoon ideas, it is of- ten thinking about the three of them that gets me going. When I visit my therapist, they are always in the room. There is unfinished business between us.

Are all the stories in this memoir one-hundred-percent true? Who knows? My only primary source on my childhood is *me* — all other pos-

sible sources are long gone. My parents and my sister left little in the way of first-person evidence besides a few brief missives, a small collection of photographs, and in the case of my mother, a single travel diary covering trips she took with my father after he retired. However, since telling funny stories about me as a boy was a family tradition, I do have that oral history to fall back on.

I'm on firmer ground the closer I get to the present. In a few cases, I have been able to check in with friends, and with my wife, Ginny. But in the end, I've decided that the best course is to go with my subjective version of the past, since the stories I've been telling myself forever have their own kind of truth, a truth undoubtedly different from, but no less valuable than, whatever truth might be contained in a thoroughly fact-checked version of my history.

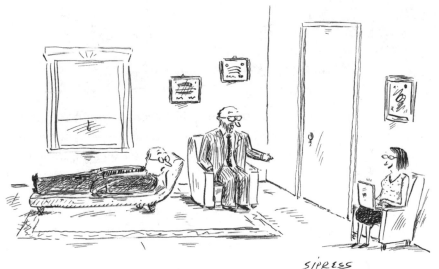

SIPRESS

"That's Eleanor. She's a fact checker."

Along the way, I've discovered that my memories tend to wander around — long-ago events stubbornly push their way into the realm of recent events, and vice versa. So I've decided against a consistently linear personal history, in favor of one that also wanders around a bit. I realize this approach risks confusion, but that's what editors are for.

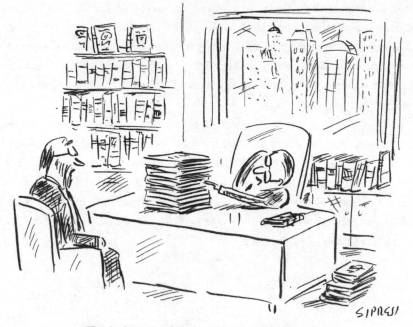

"Right here is where you lost the narrative flow."

As is already obvious, this memoir will include cartoons. It's also *about* cartoons — about where and how the ideas for them come. After all, like most cartoonists I know, the border between my life and my work is flimsy at best.

PART ONE

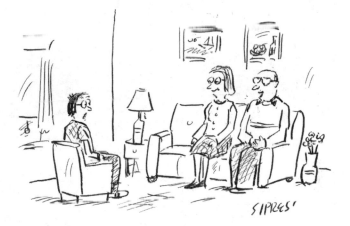

"We've been thinking about what we want to do with your life."

Happy Accident

I WAS BORN AT Women's Hospital in Manhattan on January 16th, 1947. The doctor who brought me into the world was named Dr. Frost. I always pictured him as a snowman with a stethoscope and a fistful of frozen Tootsie Roll pops. According to my mother, I "arrived right on time and didn't cause Dr. Frost any problems." (God forbid I should cause a doctor any problems.) That was all I knew about the matter of my birth until one afternoon in October 1995, several weeks after my mother died at the age of eighty-nine.

My wife Ginny and I had been married for five years. We were living in a tiny apartment in Brooklyn Heights. My cartoons were appearing in many magazines and newspapers in 1995, but not in *The New Yorker*. I had been submitting my drawings to that mecca of the art of cartooning for almost a quarter of a century without even a nibble. Every Tuesday, I would show up at the magazine's offices clutching my manila envelope full of drawings. Tuesday was, and still is, the look day, the day the cartoonists bring in their batches and meet with the cartoon editor. (The cartoon editor at the time was Lee Lorenz. There have been two cartoon editors since — Bob Mankoff, from 1997 to 2017, and Emma Allen, the current editor.) During those twenty-five years I was submitting and getting rejected, only the artists who had successfully sold to the magazine could get in to meet with the cartoon editor. Cartoonists like me who had never sold to the magazine could only penetrate as far as the receptionist's desk. I would hand him or her the envelope containing my babies, my precious ideas I had spent all week thinking up and drawing,

while the in-crowd cheerfully filed through the door to the inner sanctum. Every Friday I would return to the magazine to pick up my envelope, and after a little prayer to the cartoon gods, I would peek inside, only to see the ubiquitous rejection slip clipped to my batch of drawings.

It was after one of those weekly Friday rejection rituals that I took the subway to the Upper East Side to visit my father in the apartment to which my parents had moved in 1971. The move from West Side to East Side had been the culmination of my father's lifelong quest to reach his personal mountaintop — an apartment in the neighborhood where many of his wealthy customers lived.

He had called me that morning and more or less commanded me to visit him. "We have to have a talk about the future," he told me, "in case, God forbid, something should happen." He was ninety at the time, and sooner rather than later, whether God forbade or not, something was definitely going to happen.

We sat at the dining room table eating tuna sandwiches prepared by Maeve, the nurse who took care of my mother in the last years of her life, and now looked after my father several days a week. Maeve was a recent immigrant from Ireland in her twenties, with a charming brogue, blond hair, and a pretty, angular face. My father thoroughly enjoyed the way she linked arms on their short walks in Central Park, or sat beside him on a bench, hanging on his every word while he gathered his forces for the challenging walk home.

Now after Maeve left the apartment to run a few errands, my father brought up the subject of our inheritance — mine and my sister's — and for the umpteenth time, he assured me that everything was going to be "even-steven."

"And for the sake of my peace of mind," he added, "I need to know that everything will go smoothly between you and your sister."

I told him it would. There was reason to doubt this, but I didn't elaborate.

Then he said he wanted to tell me about the dream he'd had several nights in a row about my mother:

"She arrives in her nightgown and smiles down at me. Then she bends over. 'Don't forget to take your blood pressure medication, Nat,' she says in my ear."

He smiled and shook his head.

"Then I reach out to take her hand and she bursts into nothing, like a soap bubble."

"Oh no," I said.

He nodded, sighed, and stared down distractedly at his half-eaten sandwich. Then he said, "Sometimes I don't know . . ."

"Know, what?"

"Never mind."

"Are you OK, Dad?"

"Of course, I'm OK. Why shouldn't I be OK?" He picked up his sandwich, then put it down again without taking a bite. He looked at me — his dark green eyes were viscous and diffuse behind the thick lenses of his black-framed bifocals — and said, "It's just that sometimes I feel like my bag is packed and I'm sitting at the station, just waiting for my train."

I sighed.

We were quiet for several seconds while he stared at the blank wall behind me and fiddled with one end of his thick, white moustache. Not for the first time, it occurred to me that I had never laid eyes on his upper lip.

Eventually, he blinked a couple of times, smiled, and said, "Here's something you didn't know — did I ever tell you that you were a mistake?"

"*What?*"

"Like I said, you were a mistake. Your mother and I never discussed it again, but truth be told . . ."

A mistake? *I was a mistake?*

"Don't look so worried," he told me. "You were a mistake, but you were a *good* mistake. After all . . ." (he made a circular gesture with one hand, encompassing my entire mistaken existence) ". . . the proof is in the pudding."

"Thank you very much," I said under my breath.

"What was that?"

"Nothing. Couldn't you call it . . . me . . . something else?"

"Like what?"

"I don't know. 'Mistake' is pretty negative, Dad, like maybe I don't deserve to live."

"Don't exaggerate."

I shook my head and muttered an exasperated profanity.

"What?"

"Nothing." Then, to lighten the mood and let him off the hook, I said, "I know — instead of 'mistake,' what about calling me 'a happy accident'?"

"A what?"

"'A happy accident.' It comes from drawing."

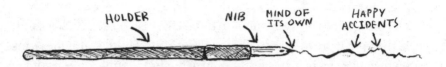

I draw with a rigid crow quill pen nib attached to a holder. I dip the point into a pot of ink and start drawing. What's wonderful about this tool is that it is really, really hard to control. Every line is an adventure, every mark its own boss. This unpredictability is what I love about the crow quill, and the spontaneous, straggly surprises it produces, the fortuitous mistakes, I think of as "happy accidents."

"Fine," he said, "I don't get it, but have it your way — you were a happy accident. In any case, what it boils down to is, we weren't expecting you. Your sister was six and already a tempest in a teapot, always rocking the boat. Believe me, I had my hands full. A baby was the last thing we wanted. Furthermore, we couldn't afford it. My business was barely getting on its feet and I wasn't sure I was going to make it. I asked your mother if she thought we should . . . you know . . ."

"Get rid of me?" I offered.

"Well, you see, for one thing we were going to have to move to a bigger apartment, and affording that was going to cause some problems for me . . ."

"Sorry to inconvenience you."

He reached over and put his hand over mine. "David, like I said, you were a good mistake."

I frowned.

"OK, a happy accident. It's just that with your sister . . ."

"Of, course," I muttered, "my sister."

". . . and all the other *mishegas* . . ."

"I understand."

"We discussed and discussed. But your mother was over the moon about the whole thing — lucky for you, she wouldn't budge. And once you came along, naturally, I was also happy."

"Naturally."

"Now you look angry. Are you angry?"

"No," I said, trying to look less angry. "It's OK. Eat your sandwich."

"It's no good. She doesn't make it like your mother."

"It's a tuna sandwich, Dad."

He slipped into another staring contest with the wall, fiddling again with his moustache.

"David," he finally said, "listen to me: You know that I love you, don't you?"

"I guess," I mumbled.

"What?"

"*Yes!* I know you love me."

"Good," he nodded. "That's settled."

He gazed down at his plate and absentmindedly moved his sandwich around with his forefinger. Finally, he looked up and said, "Speaking of the past . . ."

"Uh oh," I mumbled.

". . . do you ever regret not pursuing your Russian history?"

"Not again, Dad. *Please.*" I had dropped out of graduate school in 1969, nearly twenty-five years earlier.

"You could still go back. Why should you have all your eggs in one basket?"

"Two baskets, Dad." At the time I was pursuing two careers, as a sculptor as well as a cartoonist.

"Be that as it may . . ."

"I know you'd rather you could tell people I'm a professor of Russian history, or international relations something or other, or what? A diplomat? A CIA agent? A spy who makes funny drawings in his spare time, maybe in invisible ink?"

"Never mind. I never interfered, did I? It's just that I always wanted the best for you. We gave you such a terrific education. I just thought . . ."

"You thought . . . think . . . that I've made a big *mistake* — to use your favorite word. Right?"

"Well . . . the proof is in the pudding."

"Hold on — a minute ago, you made that expression sound positive."

(What's with that expression anyway? A great favorite of both my parents, it figured in a possibly apocryphal story about me at age four or five. My mother claimed to have come into the kitchen one afternoon and found me standing on tiptoe, leaning into the refrigerator. I was digging around in the bowl of My-T-Fine chocolate pudding she was planning to serve at dinner. When she asked me what I thought I was doing, I supposedly said, "I'm looking for the proof.")

"There you were," my father went on, waving away my pudding objection, "before Ginny came to the rescue, living for years like a pauper in the same kind of crappy neighborhood I spent my youth trying get the hell away from . . ."

"The Lower East Side is very fashionable now, Dad . . ."

"Never mind that. Thank God you met Ginny and she got you out of there."

For this reason, among others, my father was always a big fan of my wife.

"Listen, Dad," I told him, "I'm never going back to *my* Russian history. I'm never going to be a professor. That horse left the barn a long time ago."

"You could change it in midstream," he suggested, grinning.

"Very funny. Hilarious. Maybe that's where I got my sense of humor."

"*That* you can thank your mother for." We were silent for a beat, acknowledging the truth of this.

"David," he said, "you can't blame me for speaking my mind. I know that you're doing what you love . . ."

"I am. Which is what you always told me *you* did, no matter how hard things got."

He nodded. "You're right. I'm sorry. If you're happy . . ."

"I *am* happy. And I'll tell you something else, Dad — just like you, I'm good at what I do — *really* good. My cartoons are smart and funny. I never run out of ideas. I honestly don't think there's anybody better, and . . ."

He held up his hand. "What have I always told you?"

"What?" I puzzled, not knowing what was coming next.

"From the time you were a boy, I've said it over and over: *Don't get too big for your britches.*"

"I give up," I sighed.

"If the shoe fits . . ."

"Anyway, it's boxers, Dad. Not britches. Nobody's worn britches since the Middle Ages."

"Don't get smart, mister-better-than-anybody. And by the way, as far as work is concerned, there's such a thing being *too* happy. It shouldn't all be fun and games. If you're too happy, maybe you should look into that. Maybe you're not pushing yourself enough."

I sighed again.

"So, answer me this," he went on, "if you're so happy, maybe you can explain to me how come you see a psychiatrist . . ."

"A *psychologist.* He's a psychologist. And it's not about . . ."

"Your sister too," he interrupted, "with her it *is* a psychiatrist. *Her,* I worry about."

"Of course," I grumbled.

"What?"

"Nothing."

"Listen — we both know your sister's always been a little bit differ-ent — with her moods and all her ups and downs. Anyhow, she makes me worry about what will happen someday when she's on her own."

She's good at that, I thought for the thousandth time.

I stood up. I needed a break. I said, "If you're not going to eat that sandwich, I'll get you something else. How about some fruit?" I went into the kitchen.

"What about Ginny?" he shouted. "Does she need a psychologist? She's so calm, and she's not Jewish, so probably not."

This, I ignored.

"I guess you and your sister tell them that it's all our fault — me and your mother!"

I didn't respond. I found a bag of potato chips and came back and showed them to him. "Are these yours?" I asked.

"The girl got them for me," he said — meaning Maeve.

"You want some?" I shook the bag.

"No. I'm not supposed to eat that sort of thing — the salt."

"They're unsalted, Dad." I shook the bag again.

"So, what — rules are rules."

I went back into the kitchen and cut up an apple. When I returned to the table, he smiled at me and put a slice of apple in his mouth.

"Delicious," he said. "just like your mother used to make."

"Very funny. Are you sure I didn't get it from you?"

He smiled. After a moment, he sighed, "All right — no more crying over spilt milk. Let's change the subject."

"Good idea."

"OK — so, tell me this: After all this time, you being so good at it, how come they still don't want you in *The New Yorker*?"

"Then, I thought, Hey, hold on a minute—maybe failure is an option."

Red Racer

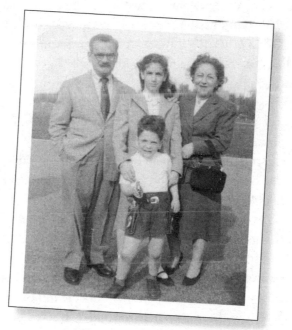

WRITTEN ON THE back of this snapshot, in my mother's capacious cursive hand, are the words, "Afternoon in the park, May 1953." My father, dapper as always, is staring directly at the camera, one hand casually, yet very much by design, tucked inside his trouser pocket. He is clearly comfortable in his own skin — a proud, self-satisfied, first-generation immigrant who only looks out, never in — and has achieved his great ambition of becoming a totally assimilated American success story. He appears somewhat aloof, and perhaps a bit proprietary, particularly as far as my sister, Linda, is concerned, judging by the way his

hand lightly grasps her shoulder. (It's possible I'm reading more into this than it deserves.) My sister, not yet a teenager, but definitely on the brink, is smiling, but it's not a joyful smile — more of a smirk. The way she holds on to me with both hands smacks of dominance, rather than affection. Her expression is supercilious, with a frisson of judgment.

My mother, by contrast, is fully engaged in the picture-taking moment, and smiling joyfully. She is wearing her outside face, a face so sweet, open, and guileless that it could disarm a huffy, overworked salesperson, a condescending doctor, or a sullen fellow passenger on the crosstown bus who had no interest in having a conversation. It was a face that made it impossible for me to convince anyone that she could ever be anything other than sweet. A breeze is ruffling her normally immobile hairdo. She's wearing a tailored suit that was undoubtedly custom-made, as nearly all her clothes were, since at four-foot-ten she had a hard time finding clothes that fit at Saks or Lord & Taylor. It's hard to tell from the photograph how small we *all* were; my father, only five foot two, seems to tower over the rest of us.

The photograph must have been taken on a Sunday, my father's only day off. Sunday was the one day he loosened his sartorial standards and ventured out in a sport jacket and slacks instead of one of the elegant three-piece suits he wore every other day of the week. *Clothes make the man* was a cherished Nat Sipress maxim, and he imbued it with the solemnity and authority of a religious teaching.

He was physically with us on Sundays, but rarely completely present. After six days of standing for nine or ten hours behind the counter of his jewelry shop, he was often too exhausted and distracted to give any of us his full attention, with the possible exception of Linda, who, perpetually "upsetting the apple cart," was never shy about demanding it.

Another thing about my father: he was old, or seemed so to me. (He and my mother were about the same age, but I never thought of her as old.) Although he is only forty-eight in the photograph, he was at least a decade, in some cases two decades, older than my friends' fathers — men who played ball with their sons, rode bikes with them, roughhoused with them at the beach.

As for me, my murderous pose is a bit shocking when viewed from a twenty-first-century vantage point. But this was the 1950s, and parents

like mine had yet to make the connection between playing with toys and gun violence in the real world. My toy guns made me feel powerful, a feeling that I craved. I wore them all the time, indoors and out. I made sure to strap them on during my favorite cowboy shows on TV — in case they were needed. One afternoon, I watched Hopalong Cassidy lose his six-shooter in the middle of a gunfight. When it fell over a cliff, I tossed him one of mine. It cracked the screen of our very first television, purchased only weeks before so that my mother could watch Queen Elizabeth's coronation. This led to a permanent ban on guns and TV in the same room. I clearly had a lot to learn about what was real and what wasn't.

ONE OF MY most vivid childhood memories of my father is a Sunday memory. He is throwing open the door to my bedroom. His hair is going this way and that, his face so red it seems to glow, and his eyes — for once he isn't wearing his glasses — are dark, furious, and very scary. His seersucker bathrobe is untied and a wiry tuft of gray chest hair pokes out from his half-unbuttoned, pastel blue pajama top. When I glimpse this never-seen-before, disheveled version of my obsessively fastidious, never-a-hair-out-of-place father, I instantly realize that the world has turned upside down.

Directly behind him, filling every inch of the doorway, is a dark blue giant. He has one huge hand on my father's shoulder, and when I see his hat and badge, I understand that he is a policeman, and that he is going to arrest me.

I was five years old that morning. I was wearing pajamas and my gun belt and six-guns. When my bedroom door burst open, half of me was outside the large window on the far wall of my bedroom that looked north across the jingle-jangle rooftops of the Upper West Side of Manhattan, a crazy quilt of water towers, chimneys, pigeon coops, utility shacks, and TV antennas. My legs were inside the room, my feet dangling over the top of an overturned wooden box that had the word TOYS stenciled on the side; my stomach lay on the window sill, my chest on the ledge, my head inches from the rickety struts of the window guard that provided questionable protection against a child's tendency to explore limits. (Tragically, it was around that time that a little boy in a

Superman costume, convinced that he could fly, had crawled out the fourteenth-floor window of his Manhattan apartment building on Halloween, stepped easily over a window guard, and flew away.) Twelve floors down, I could hear the intermittent Sunday morning traffic moving up and down the gentle slope of West Seventy-Ninth Street. Out of the corner of my eye, I could just see the tops of the trees in the small Planetarium Park across Columbus Avenue where my mother took me to play most afternoons.

Out there with me on the ledge was Red Racer, a sleek toy racing car with the number 99 painted on the bonnet, real rubber tires, and a windup key.

Red Racer was always a "he" in my mind, not an "it." I loved to watch him shoot across the floor of my bedroom and smash headlong into everything in his path — bouncing off the side of my dresser, careening into the leg of my bed, crashing into a wall before ending up on his side, wedged under the radiator or the bookshelf, valiantly spinning his wheels until the key gave out, behaving from start to finish with the wild, unpredictable abandon that a good boy like me could only dream about. I was pressing Red Racer firmly down on the brick window ledge with my left hand when I looked over my shoulder and saw my father and the policeman explode into the room; with the fingers of my right hand, I was gripping the wind-up key, feeling its insistent, grinding tension.

Vroom, vroom — Red Racer was ready to go.

MY MOTHER HAD begun to be sick two days earlier, on Friday afternoon. She never left her room that evening, or on Saturday. That morn-

ing, my father waited to leave for his store until Juanita, the housekeeper, arrived. He had called to ask her to come in on a Saturday to be with my sister and me until he got home for dinner.

Before he left, he reiterated the headache rules. "Remember," he told us, "you have to be quiet. Any noise — even a sneeze — hurts her like nobody's business. And under no circumstances open her door and let in any light. The light stabs her head like a knife."

When he got up from the kitchen table to let Juanita in, Linda flashed me a tight, derisive smile, stuck out the tip of her tongue, and crossed her eyes. "You better be a good, quiet little Pip," she whispered. "Pip," short for "Pipsqueak," was her name for me. Immediately after my father left, she retreated to her bedroom, where she stayed for the rest of the day. At one point, ignoring the rules, she turned up her record player so loud that I could hear it in my bedroom with the door closed. I heard Juanita tell her to turn it down.

I played alone in my room all day. On and off that afternoon, I crept to the closed door of my parents' bedroom and stood with the tips of my toes touching the baseboard, listening for a sound, any sound, and at the same time dreading the only two sounds I was likely to hear — a low moan, like the muffled howl of a hurt animal, or a desperate, strangled retching, which I knew meant she was being sick over the toilet in her bathroom. Through the keyhole, I could see nothing but blackness.

As only a child can do, I was holding two equally convincing but totally contradictory trains of thought in my brain: "No matter how much she loves me, she shouldn't open the door and come to me, because it would hurt her head / If she really loves me, she should open the door and come to me, no matter how much it hurts her head." By early evening, I was no longer able to restrain myself. I put my mouth to the crack between the door and the wall and tried making soft noises — first, a whispered call to her, and then some little moans of my own, as if I were also not feeling well. Just when I thought that I couldn't stand it anymore and was reaching for the doorknob, I heard my father's key in the front door and quickly retreated to my bedroom.

It had to have been my father who put me to bed after dinner Saturday night. I'm certain that I was instructed to say the prayer I said every

night, and I'm equally sure that I lay awake in the dark afterward, pondering the mysterious phrase, "And if I die before I wake..."

"It means be a good boy," my mother always answered when I asked her to explain those scary words. I received this same incongruous response to all kinds of questions, and the only part of the answer I ever understood was: *end of discussion.* So I was left to decipher the meaning of the prayer on my own. I knew from my cowboy shows that dying was bad — a kind of sleep that lasts forever, and you never again see the people you love, the very people you had just asked God to bless at the end of the prayer. Afraid that I might "die before I wake," I put off sleep as long as possible after the lights went out, and thus developed an early and persistent case of insomnia that is still with me.

"Try thinking about something else."

So when I woke on Sunday morning, I must have been relieved, as I was every morning, that I'd survived the night. On the other hand, the door to my mother's bedroom was still closed. She was still sick. I tip-toed to the living room and, sure enough, my father was asleep on the couch. The little travel clock balanced on the arm of the couch said 6:30. I retreated to my room, shut the door, pulled my toy box over to the window, turned it over, and dumped all my toys onto the carpet.

I chose a wooden pin from my miniature bowling set and tossed it as hard as I could against the wall between my room and the living room where my father was sleeping. I went to check. Still asleep.

Back in my room, I picked up the bowling pin again. This time I closed my eyes and threw it in the general direction of the open window. I waited a few seconds, then opened my eyes and confirmed that it was gone. I tossed out two more pins, plus the hard little wooden bowling ball.

After a minute or two went by and nothing happened, I grabbed a handful of marbles and a couple of building blocks. Out they went.

I waited . . . still nothing.

Next up, a few toy soldiers, more marbles, and a couple of Dinky toy cars; then, my toy fire engine with the ladder that you could raise and lower, followed by a half-full can of Play-Doh and a couple of unloved stuffed animals I had inherited from Linda.

More waiting and listening. I sat on the floor and drew for a while. Did I hear a siren approaching? I'm not sure, but if I did, I doubt I would have made the connection.

I picked up my box of Crayola crayons, but decided against. The same for my six-guns. Instead, I chose my Howdy Doody dolls — Howdy and Flub-a-Dub — and tossed them out, followed by Mr. Potato Head, more marbles, a bunch of Tinker Toys, my combination rocket ship and pencil sharpener, another couple of blocks, a few other toys that I don't remember. Then I spotted Red Racer wedged nose first into a corner of the room.

At that moment, I heard our front doorbell ring and then the *bang, bang, bang* of something hitting the door. I grabbed Red Racer, climbed onto the box, placed him on the ledge, and began to wind the key. I decided that Red Racer could drive himself over the edge.

THE GIANT POLICEMAN shoved my father out of the way, crossed the room in two strides, grabbed the back of my gun belt, and yanked me in from the window, just as I released the windup key. The three of us — my father, the policeman, and me — watched Red Racer shoot forward between the rusted struts of the window guard and disappear into space. There was a moment of silence during which nobody moved. Then my father pulled me down from the toy box and held me hard by both arms.

"David!" he shouted in my face. "What in God's name is the matter with you?"

"Nothing!" I told him, matching his angry tone.

"Nothing? Why the hell did you throw your toys out the window?"

"I didn't!"

"You didn't? So, they threw themselves out?" By now he was shaking me.

"Yes!" I replied, thinking of Red Racer and relieved to have an alternative explanation. "They threw themselves out."

"What?"

"They threw themselves out," I repeated, nodding.

Which was when my father pulled me to him so that my face was pressed up against his stomach; he reached around and hit my rear end — hard — once, twice, three times. My mother had spanked me on numerous occasions, but *never* my father. At first, I was just amazed, and then I started to cry.

When my father let go, I stumbled back and landed on the carpet among my few remaining toys. The policeman had been leaning out the window, waving his arms, signaling someone below on the street. Now he ducked back into the room and slammed the window shut. He looked at my father, then down at me. His head was tucked between hunched shoulders, squishing down his neck fat. His face was huge — sweaty and pink under his peaked hat. His nose curved out and down as if it was trying to touch his mouth.

Twenty years later, when I was transitioning from doodling to making actual cartoons, the memory of the policeman in my room proved useful when I needed to draw a cop for this, my very first "political" cartoon:

SIMPLESS

The policeman shook his head and muttered something like, "This is fucked up." Then he turned and strode out of the room.

My father lifted me onto my feet and, holding me at arm's length, said, "David. Listen to me — do you know why I hit you?"

I nodded.

"Why?"

"Because of my toys."

"No. Not because of that, although that was really bad. I hit you because you lied to me. Even after I saw you throw out the car . . ."

"I *didn't* throw Red Racer out . . ."

"What? *Again* with the lying? Do you want another spanking?"

I shook my head.

"What I'm mad about is that you lied to me. Do you understand?"

"Yes," I told him. But really, I didn't. Was it worse to lie than to throw my toys out the window? A lie seemed like such a little thing in comparison.

"Never, *ever* lie to me again. Do you promise?"

"Yes, Daddy." But I was distracted by the return of the policeman. Right behind him another large man entered, a thick-set bald guy in a gray suit.

The newcomer said to my father, "Let's go inside and talk, sir."

My father told me to sit on my bed and not move until he got back. As soon as I was alone, Linda appeared in the doorway. "Pip," she said,

"you're in big trouble. You better hope Daddy can stop them from putting you in jail."

Now, I was really crying.

"That was so stupid," she said. "What if you hit somebody? Maybe you did. Remember the penny at the Empire State Building?"

I remembered. My parents had recently talked at the dinner table about how you have to be careful when you live high up because someone threw a penny off the Empire State and it went right through the skull of someone on the sidewalk. Suddenly I felt even more scared. I cried harder.

"It killed that person. And that was just a little penny. *You* threw out your blocks!"

She left. I lay face down on my bed. I could hear the indistinct murmur of men's voices, from the foyer by the front door. *Are they going to take me away?*

The next time I looked up, I saw my mother standing in the doorway to my room. Ghostlike and tiny in her nightgown and bare feet, she looked like a pale marble statue. Her hair was disheveled, her eyes were murky and red. I jumped off the bed and ran to her. I threw my arms around her. She grunted, hugged me gingerly, and told me to stop crying. Then she asked in a hoarse whisper, "Why did you do that? Throw your toys out the window?"

There it was — the question no one else had asked.

"Because . . ." I began, but then I looked up and saw her eyes squeezed shut, wrinkling her entire face. *The light stabs her head like a knife.*

"Answer me, David."

"I don't know," I mumbled, worried about her head. I didn't want to make it worse.

"You don't know?"

I shook my head. My tears returned. She took a step back, and began to say something, but all that came out was a loud hiccup.

She backed away and reached behind her for the door to her bedroom, still not opening her eyes.

"I have to lie down," she told me. Then she sighed and murmured something that left me feeling more alone than I could ever remember: "How could you do such a thing to your father?"

After she disappeared into the dark cave of her bedroom, I sat on the floor of mine and cried some more. Eventually, I picked up a crayon and opened a pad of paper. Even as a boy, holding a drawing tool and touching the point of it to a blank page instantly calmed me, silencing all the noise in my head and releasing the tension that habitually grips all parts of my body. "Yoga means, still the fluctuations!" my yoga teacher often barks at me when my legs are shaking wildly in a standing pose and my trembling face is contorted in a *please let this end soon* grimace. And every time he says it, I think about drawing and the way it magically does just that — stills my fluctuations.

So I drew. At some point, I got up and stuck my head out my bedroom door. All I could hear in the apartment besides Linda's stereo was the rustling of newspaper — my father was reading the *Times* in the living room, and it seemed like he wasn't going to be returning to my room any time soon. Maybe nobody had been killed. Maybe nobody was going to arrest me.

I WILL NEVER know exactly how the situation was resolved. The building super fixed my window so only the top half would open from then on — too high for me to reach. I have a vague memory of being told — probably by Linda — that money was exchanged. Many other tales of my childhood exploits, like the gun I threw to Hoppy and the pudding story, were told and retold to friends — at dinner parties, during ladies' lunches at Schrafft's Restaurant on Broadway, under umbrellas on the beach in Neponsit. But the toys-out-the-window incident was never mentioned again.

This was the family pattern. We lived as if bad things never happened — even when they did. Upsetting subjects were not to be brought up or spoken about. (Only my sister refused to go along with the program.) Even the don't-speak-about-bad-things rule was unspoken.

Ditto for topics that were at all uncomfortable or nervous-making. I was sixteen and pretty much an expert on all matters sexual, although not from much first-hand experience, when my father invited me to meet him for lunch one afternoon to have a talk. Here's how it went:

"David. Maybe it's time for me to maybe talk with you about what

they call the birds and the bees? Maybe do you need for me to explain anything?"

"No."

"OK, fine. Let's order dessert."

All that silence on difficult topics has been hard to shake. It's been a bit of an issue in my relationships ever since.

"O.K., we'll try it your way—let's ignore any problems that come up in the next twenty years and see what happens."

So, when my mother finally emerged from her bedroom two days later, the headache was gone and forgotten, as if it had never happened. She was her cheery self again. The not-speaking rule most definitely applied to her headaches. Not mentioning them was a kind of pretending we all participated in because it made it possible to believe that there would never be another one — until there was another one.

It was several months before my toy box was replenished. I had thoroughly absorbed the don't-speak-about-bad-things rule by then, and since any request for new toys risked opening up the "out the window" can of worms I said nothing and instead found ways to improvise: I pre-

tended the chair in my room was a horse. I turned my empty toy box into a stagecoach, or a PT boat. I sat in front of the window, my knees pressed into the wall, pretending that the windowsill was the instrument panel of a rocket ship. (Small utensils purloined from the kitchen cabinets served as pretend controls.) I drew versions of my lost toys like Howdy and Flub-a Dub, as well as new toys that I saw advertised on television or in the window of Woolworth's. I suspect that it was during this period of toylessness, with mainly my crayons to play with, that I really began to draw in earnest.

My little stuffed bear, who sported a tiny bow tie and wore a gray suit much like the ones my father wore every day (the stitching under his nose even resembled my father's moustache), had survived the window debacle. He was the playmate I drew with, told stories to, and took along on my treks across the prairie and my journeys into outer space. I secretly named him Nat, the diminutive my mother always used. *This* Nat was always available. We talked about everything, and when I asked him a question — any question — he always answered.

THE AFTERNOON SHE finally came back to life, my mother and I went out to shop for groceries at the butcher shop and the small fruit and vegetable market on Amsterdam Avenue between Seventy-Eighth and Seventy-Ninth. As we left our building, she stopped for a hushed conversation with our doorman. I had a pretty good idea what they were talking about. I looked around — the sidewalk in front of our building was speckled with what looked like multicolored confetti. Near my foot,

I noticed a bright red plastic shard. I bent down and picked it up — half of a number nine was just visible along one edge.

"Drop that," my mother ordered, turning away from the doorman. "It's dirty — who knows where it came from."

The next day, when my mother took me to Planetarium Park, the red shard was still on the sidewalk. On the way home, walking a little behind her, I bent down and snuck it into my pocket. For years, I kept it in the bottom of my toy box, where it remained until my parents moved to the Upper East Side and gave away my toys, the toy box included, to the Salvation Army.

Good Boy

O N A C H I L L Y afternoon in October 1951, my mother took me to the New York University IQ testing center at the Battery on the southern tip of Manhattan. The IQ test was part of the application process for Hunter College Elementary School on the Upper East Side of Manhattan. I spent first through sixth grades at Hunter, the first elementary school for gifted children in the New York City public school system.

A few years before I started there, *Life* magazine did a feature on "The School for Little Geniuses." Here's a favorite photograph from the story, entitled "French Lesson." I love the assumption that the little geniuses would no doubt be making a trip to Paris someday, where they would need to know how to read a menu and how to order a bottle of wine.

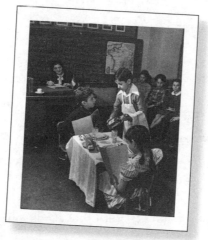

When I showed the photo to Ginny, she grinned and said, "As far as I can recall, we didn't have that particular class at Glen Iris Grammar School in Birmingham, Alabama."

After my mother died, I went through the small cache of important papers she left behind and found the letter from the New York University Testing Center informing her that my IQ was in the ninety-ninth percentile. I found my sister's letter as well, and I am ashamed to admit that I took some pleasure in the fact that she was only in the ninety-eighth percentile and was therefore denied admission to the school for little geniuses. My mother saved the *Life* magazine with the article about Hunter, and once I was admitted she left it open on a side table in our living room where it stayed on display for years.

Lest anyone think that I'm unaware of the unseemly nature of my IQ bragging, I offer this cartoon that I did many years ago, based on a real conversation with my wife.

"It's wonderful that you went to an elementary school for gifted children, Harold, but do you really think it should <u>still</u> be the first thing you tell people about yourself?"

I came to hate the whole IQ business, in fact, because in my parents' hands it was a tool with which to bludgeon me. If I brought home a test result of anything less than an A, I was routinely reprimanded by my mother with some version of, "With that IQ of yours there's simply no excuse."

That day in 1951 we were early for our appointment at the Testing Center, so my mother sat me down on a bench near the Staten Island Ferry terminal. Back then the Battery was a quiet corner of Manhattan — not like today, jam-packed with tourists and every five feet someone tries to sell you a tour of Ellis Island and the Statue of Liberty. My mother was wearing a stiff new green hat with a red cloth rose. She put her arm around me and told me how proud she was of me. I can still recall the velvety feel of the sleeve of her black felted wool coat on my neck, the tickle of its mini fur collar and the powdery softness of her cheek when she leaned over and kissed me, the faint trace of Chanel No. 5 that was forever for me the olfactory signifier of mother love.

She pointed to the Statue of Liberty and told me how amazed my father had been when he first saw it. "He was not much older than you when he sailed past it in a big boat that had crossed the ocean," she said.

I'd heard something about this before. One morning the previous summer, on the beach at Neponsit, my father and I stood by the shore holding hands as he pointed to the horizon and explained that he had sailed to New York from a faraway land that was way out there across the water. "It was the land where I was born," he added.

Now, my mother hugged my shoulders and pulled me closer to her. She said, "And he would have been even more amazed if someone had told him that one day his son would be sitting on a bench looking at the same statue, *about to show his Daddy that he was the smartest little boy in New York City.*"

When she said this, I thought, *What's this feeling? It's one I've never felt before.*

I recall next to nothing about the test itself, only that a man in a white shirt and black tie held open the door to a small, windowless room and told me to sit at a low table that was covered with an array of colored blocks in various shapes and sizes. And I remember that as he closed the door, I heard my mother say the inevitable, "Be a good boy."

A good boy, I came to understand, does well on every test (even on an IQ test, where *trying* to do well was very much beside the point). A good boy always remembers how hard his father works to make it possible for him to have the very best education; a good boy is grateful, and *never* brings home bad grades.

(Fast forward to the year I turned twenty-two: On a summer morning I boarded a school bus in Cambridge, Massachusetts with fifty other frightened young men and rode to the Boston Navy Yard for the dreaded Selective Service draft physical. The physical began with a written test. I've never forgotten the first question — pictures of a hammer, a screwdriver, and a wrench on the left side of the page, and on the right, a picture of a nail; the challenge was to choose the appropriate tool. I was fully aware that for the first time in my life I was taking a test that it was in my best interest to fail — to say the least. Nevertheless, it took a serious amount of willpower for this good boy to drag the pencil away from the hammer and circle the wrench.)

At Hunter Elementary, where grades were not emphasized, and tests were few, this message flew under the radar. However, it came through loud and clear once I entered Horace Mann, the highly competitive private school I went to next, where I was constantly reminded, starting in seventh grade, that the boys (and it was only boys in the late 1950s and early 1960s) who excelled would get into the best colleges. Everyone else, it was strongly hinted, might as well prepare themselves for a life of mediocrity, if not abject failure (I exaggerate only a little).

For the most part, academically speaking, I succeeded in being a good boy. I did well in my literature and language courses, but there was one subject in which I was an especially good boy — nobody had to pressure me to work hard in history because I loved it. From an early age, I obsessively devoured history books, and in high school and college I read way beyond what was required for my classes. History, for me, is the best kind of storytelling, and my interest in it has persisted, finding

its way into cartoons in which I use historic settings to comment on current events.

"I'm concerned about my legacy—kill the historians."

It was only in math that I struggled, never getting a grade above C minus. My SAT score in math caused my mother to insist that I take the test three times, but the results just kept getting worse.

Was this math problem a psychological block? A willful act of rebellion? A very particular kind of stupidity? Or something else?

"It's because he always has his head in the clouds," was my father's explanation.

I offered one possible answer in this cartoon:

"It may be wrong, but it's how I feel."

I stayed a good boy until I dropped out of graduate school. But even then, deep down inside, I was still a good boy.

And despite my best efforts, I remain one today . . .

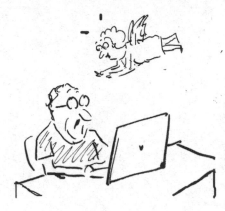

"Be a good boy and once in a while include a <u>nice</u> story about your mother."

So . . .

Something else happened the afternoon of the IQ test, and it made the day a favorite memory. After the test, we got on the subway at Wall Street. We were going to visit my father in his shop. It was rush hour. The train was really crowded, so we had to stand. As usual, my mother was a head shorter, and I was several heads shorter, than anyone else on the train. At Forty-Second, even more people got on and we were completely hemmed in by big men in business suits. Fifty-Ninth was our stop; when we arrived my mother gripped my hand and we squeezed our way through the crowd blocking the door. We got out just in time. Safely on the platform, we were about to walk away when my mother's hand shot up to her head.

"Where . . ." she began, and she whirled around just as the doors banged shut. Through the window we saw her green hat with the red rose wedged between the shoulders of two large, oblivious businessmen.

"Look, David," she exclaimed, "I walked out from under it!" She was laughing. "Good-bye, hat!" she cried, hugging me and waving at the hat

as it left the station. "That's one for the books, sweetie," she joyfully declared. "I can't wait to tell your father."

Flying Turtle

AFTER MY FATHER died in 1998, Ginny and I inherited a beautiful set of heavy silver flatware with a cursive letter "N" engraved on every knife, spoon, and fork. It was the silverware I had grown up with. My father had purchased it from a walk-in customer before I was born. The "N" remained a mystery — a disembodied initial without a name. (Although as a boy I just assumed that it stood for "Nat.")

Not long after the silverware came into our possession, we added a tiny, bow-legged Abyssinian kitten to our household. Over dinner, while he slept in Ginny's lap and Suwannee, our already-cat, sniffed suspiciously from under the table, we discussed what we should call the new arrival.

"I'm thinking that he could be the only cat on the planet with his own set of silver flatware," my wife said.

We named him Nigel. When it was time to go to sleep, he settled himself between us. From that night on, any attempt to dislodge him was met with fierce, feline civil disobedience.

We were lucky with Nigel for many reasons. For one thing, unlike Suwannee, who left us at a fairly young age, Nigel lived to be seventeen, an impressively long life for an Abyssinian cat, I'm told. After he died, our apartment seemed terribly empty. I kept expecting to see him stretched out by the window, admiring our view of the Brooklyn Bridge, or to feel him beside me on the couch — a soft, sleek, thermal purring machine jammed up against my thigh. Our bed was suddenly just the two of us again. The grief one feels when a pet dies has a curious

awkwardness about it. It's just a cat, after all. How can my loss of a cat compare with the losses people have been experiencing all around me the past few years — friends losing parents, friends losing siblings, friends losing friends, a good friend recently dying suddenly in his fifties, Ginny's mother dying just a couple of weeks before Nigel? And, yet, I really missed the lad.

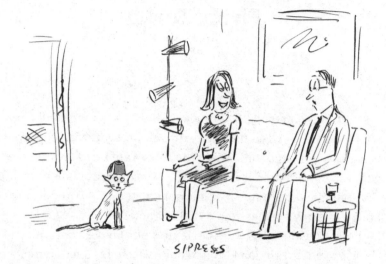

"He's an Abyssinian."

As a kid, I was unlucky with pets — or, more accurately perhaps, pets were unlucky with me. According to the "Our Baby" scrapbook in which my mother faithfully recorded my benchmarks, the very first word out of my mouth was "dog," and as soon as I could put a sentence together I began begging her to let me have one. To no avail; as far as my mother was concerned, it was "criminal" to keep a dog cooped up in an apartment in the middle of New York City. A dog needs somewhere to run around, like woods or a backyard. Furthermore, a dog should be able to go to the bathroom whenever it wants; it shouldn't have to sit around the apartment holding it in until somebody's mother is ready to interrupt her busy day or her relaxing evening in order to schlep downstairs in the elevator so she can drag the dog up and down the block in all kinds of weather until it makes up its mind to do its business.

"Speaking of which," my mother would add, "the sidewalk in front of

our building is already a *farshtunken,* germ-filled obstacle course. The last thing West Seventy-Ninth Street needs is another dog adding its business to all the business already sitting out there, just waiting for you to step in it." This, of course, was in the pre–pooper scooper era. The sidewalks of New York look very different nowadays.

"I don't know about you, but it always makes me feel kinda special."

"I could take care of the dog," I protested to my mother. "I could take him for walks. I could make him happy."

"You're six years old."

"What about Rupert? Rupert lives in an apartment and he is happy." Rupert was the adorable frankfurter of a dachshund who resided across the hall in 12B.

"Happy? That dog has a mental condition," she replied. It was true. Rupert was a nervous wreck who couldn't sit still if his life depended on it. "The last thing I need is another mental case in this apartment," she added. Who was she referring to? My sister, I decided. They fought a lot.

(It has to be said that for all her negativity about Rupert — and dogs

in general — my mother could never resist bending down and giving Rupert a loving rubdown whenever we ran into him.)

I was not getting a dog. Case closed. If I wanted a pet, it would have to be something low-maintenance. "You can have a parakeet, for example," she offered. "As long as you don't lose it, like with the turtle."

The turtle was my first pet. And I didn't *lose* it — not exactly. My mother's close friend Ida had carried it back for me in a little square terrarium when she returned from a vacation in Hawaii. I immediately named him Rupert. Not much bigger than an Oreo cookie, Rupert had the word "Hawaii" painted on his shell, above a picture of a palm tree. I carried the terrarium into my room and placed it on the dresser near the window so Rupert could enjoy the view of the treetops in Planetarium Park. To keep him company, I arranged a couple of G.I. Joes on the rubber island in the terrarium, along with a toy replica of Tonto on a pony. When I fed Rupert his first meal of turtle-food pellets, I watched with fascination as he chewed with leisurely relish and gazed blankly out the window, as if he didn't have a care in the world.

About a week after Rupert's arrival, my mother went shopping and left my sister and me in the care of Juanita. Linda was six years older than I and had never been terribly happy about my being an addition to the family. At the time, she was going through what my father was always assuring my mother was "just a phase."

"Five years is some long phase," my mother would sigh.

It was a hot June afternoon. At the time, our only air conditioner was in my parents' bedroom, and since my window had been permanently closed on the bottom, I had to get someone to help me open it from the top. I asked Linda. After she opened it, she stared at Rupert in his terrarium for a moment and then said she'd be right back. She returned with a book of engravings that my father had acquired at an estate sale and given to her. The engravings, I would learn much later, were a series of fantastic images of an imaginary "China" drawn in the seventeenth century by an armchair traveler. But when Linda opened the book that day and began to turn the pages, she told me they were pictures of a *real* country, and that the man who drew them had actually traveled to it a few hundred years ago.

"He made drawings of everything he saw. See, Pip?"

I was fascinated. There were pictures of jungles, tall mountains with giant lizards crawling over them, all kinds of wild animals, weird birds, giant fruits, and strange pointed towers.

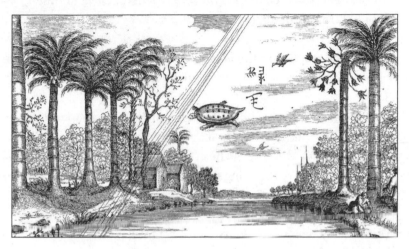

From *China Illustrata* by Athanasius Kircher, 1667

Linda stopped turning the pages when she found the engraving she had been looking for. She asked, "He thought he was in China, but can you tell where he really was?"

"No."

"Look — see the palm trees — they're just like the one on Rupert's shell."

I glanced at Rupert, then back at the engraving. "He was in Hawaii?"

"Right! And look there in the sky. What do you see?"

"A turtle in the sky?"

"Yes! Turtles from Hawaii can fly!"

It was a flying turtle all right. "But they don't have wings," I immediately objected.

"They don't need them. They use their flippers."

"Oh."

I was dubious. But then I remembered the special tour my mother had arranged for me and a few friends at the Museum of Natural History for my birthday in January. It ended with a visit to the museum's small collection of rare live animals, including, of all things, a flying squirrel.

"It's right there in the picture, Pip," Linda said, pointing at the engraving. "Why would he put it in the picture along with everything else he saw if it wasn't true?"

I guess that convinced me. *Maybe they're jet-propelled,* I thought.

"Should I try it with Rupert?" I asked.

She nodded.

I positioned Rupert on the edge of the dresser. "Fly!" I commanded him. He gave me a skeptical side glance and pulled his head into his shell.

"I bet you have to throw him high in the air, like a paper airplane," my sister said. I did this, and he landed across the room on his back. "Try again," she instructed. This time he crashed into the radiator.

"I don't think you're throwing him hard enough, Pip. And throw him toward the window — he probably needs fresh air to fly."

I gave her a questioning look.

"Don't worry," she said. "Put some of his food on the floor. That way he'll turn around and fly right back."

I did as she suggested. The pellets definitely got his attention.

"Now, throw him," Linda told me. *"Harder."*

I threw. Out went Rupert.

"Whoops," said my sister.

That was how I "lost" the turtle.

I started to cry. On her way out of my room Linda said, "If you tell Mommy, you'll be in big trouble. After all, it was *you* who murdered him."

Was that right? Linda had tied me in knots, like always. She was a puzzle I couldn't solve. I never knew what she was going to do next.

A second later she stuck her head back in and hissed, "And you're supposed to be so *smart.*"

I curled up on my bed and asked myself a little-boy version of the question, why did Linda do the things she did? Doing them didn't seem to make her happy. Sometimes they made her smile, especially when she was teasing me, but it was never a happy smile. The only time she had a happy smile was when she was with my father, listening to him or talking to him as if no one else was around, usually at top speed about all kinds of stuff, interrupting herself now and then to laugh at something she'd said that only she found funny.

What I did know was that I was a little afraid of her. From now on, I told myself, I would be more careful.

IT TOOK MY mother a full day to notice Rupert's absence. I told her he must have gotten lost. Her theory was that he had crawled under the bed or the dresser and the housekeeper had sucked him up in the vacuum cleaner. She scolded me for being so careless and letting him "run wild." For days afterward I avoided looking down when we walked out of our building, for fear I would see Rupert's tiny body smashed to bits on the sidewalk.

The parakeet didn't last long, either. My mother picked him out at the pet store. He was green and yellow and had a brown kidney-bean-shaped protrusion on his head that looked like a jaunty French beret. I named him Maurice after the only French person I'd encountered, the singer Maurice Chevalier, whom I'd seen perform on *The Ed Sullivan Show*. For two weeks he sat in his cage, dazed and lethargic, barely uttering a peep, moving around only to eat a few seeds, take a drink of water, or peck at a slab of cuttlebone that came to us gratis from our good friend and upstairs neighbor, who was known as the Cuttlebone King of New York. Then Maurice dropped dead right in front of me. My mother decided that the beret had been a brain tumor. She put him in a shoebox, and we carried him together to the pet store so that she could demand her money back. I can't remember whether she was successful. Next, we carried him to Planetarium Park, and I buried him near the back wall of the Museum of Natural History while my mother admonished me not to step in anything.

After that I stopped asking for a pet, dog or otherwise.

My Christmas Story

SIPRESS

THIS CARTOON OF mine, from 2006, is among my most auto-biographical. Not that my father and I ever actually went into any woods together, unless you count Central Park, and I don't think he ever chopped down a tree. What's autobiographical is the confusion I felt as a child over the fact that my family, like many Upper West Side Reform Jewish families in the 1950s, celebrated both Hanukkah and Christmas.

As a young boy, I was aware that my mother's parents, Ben and Anna Klausner, weren't particularly religious. I knew nothing at all about my father's religious background — at least not then — but whatever it had been, he and my mother were on the same page now in the religion

department, entirely comfortable with a Reform Judaism that was flexible and open, and even optional at times. I once overheard my mother tell a visitor that she and my father were married in 1937 in a civil ceremony at Brooklyn City Hall; I asked my sister what that was, and she replied, "No religion, no rabbi."

We celebrated the two holidays in separate rooms — Christmas in the living room and Hanukkah in the kitchen — so that we wouldn't get them mixed up, I guess, or perhaps to prevent contamination. In the kitchen, on a baking sheet so the candles wouldn't drip on anything, was our gold-painted tin menorah. I loved lighting the orange "Jewish" candles and saying the blessing, mainly because it was the only time I was ever allowed to get anywhere near fire.

In the living room, presents were piled under the piano until Christmas morning. Even for dedicated assimilators like my parents, a Christmas tree would have been a bridge too far. On Christmas Eve, over the presents, my mother would play Christmas carols while I sat beside her on the piano bench and sang along, often mystified by the strange, incomprehensible lyrics, for instance "bells on bobtails ring," or "round yon virgin," or what sounded to me like "deck the halls with boughs of *challah*."

The two weeks before Christmas were the busiest of the year for my father. He would open his jewelry shop on Sixty-First Street and Lexington Avenue at eight a.m. and stay until the last customer finished shopping at nine or ten that night. My father was proud that Revere Jewelers was renowned for the beauty of the pieces he bought and sold, and that his exemplary taste and personal charm attracted so many wealthy and famous customers — "the cream of the crop," as he called them. Until I was ten or eleven, I spent a little time every few weeks in the store while my mother shopped or ran errands, and over the years I had been introduced to lots of celebrities — Oscar Hammerstein, Richard Burton, Zero Mostel, and Cyd Charisse are a few that I remember. Marilyn Monroe once pinched my cheek.

And although I never met her, Jackie Kennedy came in every now and then. My father always called her "Mrs. Kennedy," and he described her to us as "a lovely human being," and "the pinnacle of class." He rarely missed one of President Kennedy's news conferences; eyes glued to the

screen, he would follow every gesture of the president's hands, hoping to catch a glimpse of the gold ring that Mrs. Kennedy had bought for him in the shop.

The fact that the Christmas season was so busy for the store made my father's Christmas shopping for my mother a bit of a challenge. She would have been happy to shop for her own presents and save him the trouble — saving him the trouble was her life's work — but, to his credit, he wouldn't cross that line. So, every year, for an hour or so, my mother would hold down the fort at the shop while my father hurried out to get her gifts.

The year I was six about to turn seven, I was with my mother when she arrived at the shop, ready to take over. We had been to Blooming-dale's to see Santa — just to "see" him, because I wasn't allowed to sit on his lap. (The reason was some version of "We don't know where it's been.") It was decided that I could go along with my father while he did his shopping.

The details of what I said on this outing quickly became one of those "cute" stories about me that, unlike the story of the toys out the window, was told and retold in the coming years. My father was still telling the story at the age of ninety, recounting every detail for Maeve one Decem-ber morning as I sat on the couch pretending to read a magazine.

IT WAS A cold late afternoon. We were heading for the shop of a Japa-nese dressmaker who, barely five feet tall herself, specialized in clothes for tiny women like my mother. My father wore an elegant camel hair coat and a cashmere scarf. I wore a miniature replica of the same coat, wool mittens attached to the sleeves by metal clips, and a peaked wool hat with ear flaps covered by earmuffs — my mother insisted. My father was hatless as usual, oversized ears turning bright red after a few sec-onds in the cold, his thick, gray moustache frosty and stiff.

This excursion was special for me. I rarely spent time alone with my father — on Sundays, his single day off, he was exhausted and preoc-cupied. As we walked east on Sixty-First Street and turned down First Avenue, he did the one thing that reliably dissolved any questions I might have had about where I stood with him — he took my hand and held it as we walked.

The dressmaker greeted us warmly in her small shop. After a brief exchange of pleasantries and some mutual commiseration about running a small business during the holidays, my father said, "I want to get something nice for Estelle."

"Oh, yes," the dressmaker said, making a show of giving the matter some thought before plunging into the overstuffed rack and pulling out a dress that my mother had selected weeks before. My father said that it was perfect. The dressmaker wrapped it up nicely and then placed it in a brown paper bag, so that my mother "wouldn't know what it was."

It was already dark when we stepped outside.

"Mission accomplished," my father said, mainly to himself. "And I've got that jade necklace I've been saving for her all year back at the shop."

"Let's take a little walk," he then suggested, and we turned at the next corner. In the middle of the block was a small, red-brick church. Behind a low, wrought-iron fence was a garishly floodlit nativity scene. "O Come, All Ye Faithful" or something similar was playing. We stopped. The nativity scene reminded me of the dioramas I loved at the Museum of Natural History, with cavemen and wild animals. My memory of the nativity scene is vivid, because it was my first. It included life-size statues of the standard three humans and, more exciting for me, a cow, a sheep, a goat, and real straw and hay.

"Why are they in a barn?" I asked my father. I took off my earmuffs so I could hear his answer.

"It's all they could afford," he said. "How should I know? Let's get going. It's cold and it's getting late."

"Isn't it smelly?" We had recently visited my mother's cousins in Connecticut, and they had taken me to a farm where you could pet the animals. What had most impressed me was the smell. "Don't the animals go to the bathroom right there?"

"Yes. No. They probably go outside. Let's hope so, at least."

"That's Jesus," I said, pointing to the baby. He was chubby and pink, and reminded me of the phrase "tender and mild" in "Silent Night," one of the songs my mother and I sang together at the piano. The words made the baby sound like something good to eat.

"What are the parents' names?" I asked.

"Joseph and Mary. And those guys in the background, on the cam-

els . . ." He pointed to a painted backdrop, leaning against the wall of the church. "Those are kings . . . supposedly."

"What are 'kings supposedly'?"

"I meant it's just a story."

"Did they have countries? Why are they coming there on camels?"

"They're bringing presents for the baby."

"Where is Santa?"

"What? The North Pole, I guess. Come on, David, let's vamoose."

He took my hand, but I didn't budge. "When Jesus grows up he gets crucified," I told him. "They hammer nails into him."

"What? How do you know about that?"

"The movie. The one about the bathrobe."

"The what?"

Last Easter, I had watched *The Robe* on television one afternoon with Linda. There is a wonderful scene in which Richard Burton, playing Marcellus, a Roman tribune, arrives at Pilate's palace, along with another soldier, a centurion. As Marcellus walks in, Pilate is washing his hands. Pilate says that he has a final task for Marcellus before the tribune goes off on a new assignment on Capri. *An execution . . . three criminals. One of them is a fanatic. There might be trouble.*

Pilate says that he's had a "rough night" and, looking dazed and distracted, requests a bowl to wash his hands. A slave tells him that he just washed them a minute ago. *So I did,* Pilate says, and he exits, zombie-like.

Then the centurion asks Marcellus perhaps the most hilarious, deadpan question in the history of cinema:

Your first crucifixion?

Yes, Marcellus mumbles, staring down at the scroll containing his orders.

What? the centurion says. *Never driven nails into a man's flesh?*

"The movie where they make Jesus carry the big cross up the hill," I explained to my father, "so they could hammer the nails into his flesh and hang him up on it." Linda had given me a graphic description of the crucifixion, with spurting blood and splintered bones.

"You mean *The Robe,*" my father said. We were both silent for a few seconds, contemplating the pink plaster infant in his mother's arms with the very bad death in his future.

"Linda says Jesus was Jewish, but the Jews wanted to kill him anyway. What was he, Daddy, Jewish or Christian?"

"He was Jewish," he replied. "Christians hadn't been invented yet."

"But the Jewish people wanted him dead?"

"We have to go, David," my father said, pulling on my arm.

"But . . ."

"I'll tell you all about it, but now we have to mosey."

"Do they kill the camels to make our coats?" He didn't reply to that one.

We started walking. "Here's the deal with Jesus, in a nutshell," he said. "When he grew up, he started telling everyone he was the son of God, and . . ."

I looked back toward the church and pointed. "But wasn't he the son of Joseph and Mary? Didn't he come from his mommy?"

"Yes, but he kept saying otherwise. He kept saying his mommy was a virgin."

Round yon virgin, I thought. But she hadn't looked round.

"He told everybody that God sent him directly to Earth to be his son and save the world. Supposedly."

"Then what happened?"

"He started wandering all over the place in Israel, teaching people about religion and collecting a bunch of followers who started claiming that he was performing miracles . . ."

"What's 'miracles'?"

"Tricks. Like magic tricks. Like walking on water."

"But you can't do that," I said. I was already thinking that I would give it a try the next summer at the beach.

"That's why they're miracles. But you're right — it was all a bunch of baloney. Anyway, the other Jews, the ones in charge, started hearing he was saying he was the son of God, and they got mad."

"Why?"

"He got too big for his britches." This I understood. I had been scolded many times for the very same crime.

"So when he wouldn't keep his mouth shut, they complained to the Romans, who were in charge of the Jews and everyone else back then, and the rest is history. But nobody blames the Romans. Everyone blames

the Jews, which is why we've had so much trouble from the Christians. Even today."

"They hate our guts. Linda told me."

"Not all of them. Some do, but not all of them."

For a couple of blocks, I thought about the Christians I knew — my teacher, a few friends at school, our housekeeper, our elevator man — wondering which ones hated my guts.

At Lexington Avenue, we turned uptown. In front of Bloomingdale's, we passed a Salvation Army Santa. "Is Santa God?" I asked. "Is he Jesus' father?"

"What? No. Enough with the questions, David."

Now we could see the shop a block away, and my mother's head in the window.

"Is he Christian?"

"Yes, he's Christian. He's based on some saint. The one in charge of presents. Speaking of which . . ." He held up the paper bag and smiled at me. "Don't tell your mother what's in here."

"Is that how he can get into our apartment when we don't have a chimney and all the doors are double locked? Is it a miracle? Like walking on water?"

"I don't know. Ask your mother." He pulled me along as he picked up the pace.

"Why do we have Christmas, since Santa is Christian and we're Jewish and some of them hate us?"

"Because we're Americans," he answered. His eyes were on the shop.

"But if they hate us . . ."

"Enough with the questions, David!" He looked at me and gripped my hand tighter. "It's just a holiday. So we can have presents, understand? That's it. Case closed."

"But Hanukkah has presents."

"*Oy,*" he sighed. "Hanukkah's too long. Doing it all in one day makes more sense. Some of us have to work."

"What's a virgin?" I asked, as I stumbled after him across Sixty-First Street.

"Someone from Virginia."

* * *

IN 2011, I joined a one-book book club, the one book being the New Testament. I was an enthusiastic participant in the contentious, ultra-serious arguments about historical revisionism, the meaning of parables, fiction versus non-fiction, the political Jesus versus the non-political, etc. But every once in a while, when I took a step back, I found myself thinking that much of the actual New Testament story was no less silly than my father's truncated version from all those years ago. In any case, I wound up getting some good cartoons out of the whole thing:

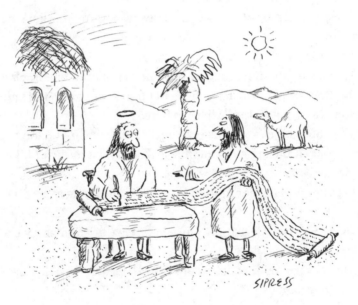

"Quit worrying about corroborating your sources—it's not as if anyone's going to take this literally."

The Meaning of Money

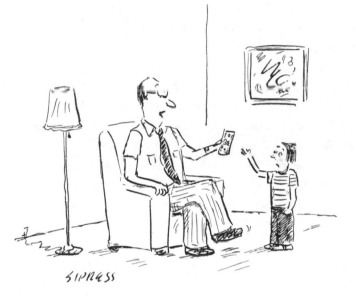

"This is money—get ready to worry about it for the rest of your life."

EVERY YEAR, ON the last Friday in June, my mother would get our building super to schlep our large cardboard moving barrels up from our storage cage in the basement. She would spend the whole day packing them with dishes, pots and pans, summer clothes, toys for me — everything that we would need for the next two months in the country, the country being Neponsit, which was still technically the city since it is located in the borough of Queens, only a one-hour drive from our apartment on West Seventy-Ninth, depending on the traffic

on the Belt Parkway. The next morning the moving men came and took the barrels, and my mother, my sister (until she started to refuse to go and insisted on staying in Manhattan with my father), and I would follow the truck in our rented car. The issue with the rented car was always which phone book to use. My four-foot-ten-inch mother had to find a compromise between the need to reach the gas pedal and brake and the need to see over the steering wheel. She would bring the Manhattan, the Queens, and the Bronx phone books to the car rental place and test each one out on the driver's seat of that year's car.

We drove past big ships at the docks on the West Side, sometimes even famous ocean liners like the *Queen Elizabeth* and the *Queen Mary*. Just before we crossed the bridge over Jamaica Bay, we passed Floyd Bennett Military Airfield, and I got to see fighter jets, seaplanes, and huge cargo planes. When we arrived at our rented bungalow on Beach 144th Street, there was always a welcoming committee of the other mothers and kids who rented on our block for the summer months. The menfolk were absent, at work in the city; they arrived in bunches on Friday night, or in my father's case, on Saturday evening.

After closing his shop on the early side, my father would take a taxi and arrive in time for dinner. On Sunday morning, my mother served him breakfast and packed his lunch, and literally at the crack of dawn, he walked the four blocks to the beach where Mike the Chair Guy would already have set up my father's rented chair and umbrella. He stayed at the beach until the sun went down, reading, walking, swimming, turning brown, and confabbing with the other weekend warriors — to a man, Jewish professionals and small businessmen like himself. The wives arrived late morning with the kids and stayed until it was time to go home and fix dinner. My mother, a redhead like me, was way ahead of her time in the sun protection department. With every bit of bare, freckled skin covered and wearing a broad-brimmed straw hat, she delivered our lunch, made sure I was thoroughly slathered with Coppertone, and sat under the umbrella for a half-hour at most before fleeing the harmful rays and heading back to enjoy a quiet, shady afternoon on the porch.

I made sure to wake up early on Sunday so I could accompany my father to the beach. At the beach we would take off our shirts and I would

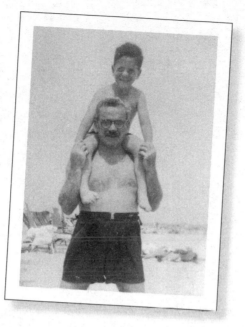

compare his hairy brown chest to my own freckled, white version. My father was an inveterate high tucker, his pants always belted or suspendered somewhere around his navel, and ditto for his bathing suit. We always started with a swim — he did laps from jetty to jetty, and I dunked and rode waves. My father loved to swim. The building Ginny and I live in on Pineapple Street in Brooklyn Heights was once part of the St. George Hotel. The hotel had a famous pool where immigrant men of my father's generation came from all over the city to swim. My father once told me he swam there almost every Sunday in the years before he was married, "to keep myself fit in case I met a young lady."

After the swim, we took a long walk, most often up to the tall chain link fence and the jetty separating the residents-only Neponsit beaches from the public beach at Riis Park, famous for the occasional early-morning nudism. "Don't gape," my father would warn, but I could usually manage a quick peek.

The fence between Neponsit and Riis Park made me hyper-aware of our special status in the world, at least in Queens, and the memory of it was in the back of my mind when I came up with this cartoon during current immigration controversies:

"I'm sorry, but this beach is for residents only."

Back at our umbrella, my father read a book or listened to his porta-
ble transistor radio while he waited impatiently for the very undepend-
able Sunday *Times* Guy. One morning, after a second swim, having de-
cided by ten o'clock that the *Times* Guy wasn't going to show, he asked if
I would like to go to the candy store by myself and buy the paper.

"You're a big boy, David — almost nine years old. Can I trust you to do
this? I want to dry off in the sun and maybe grab a few winks."

I nodded vigorously. He took a dollar bill out from his wallet and
tucked it into the pocket of my damp bathing suit.

"Don't lose it," he said. "It's a lot of money. It's all I brought with me
today."

I was thrilled with my mission, and not just because of the responsi-
bility. I loved that candy store. When you walked in, there was a small
soda fountain on the left, where every once in a while, on a hot day, my
mother would buy me an egg cream or a single-scoop ice cream cone,
and once, in what was a true highlight of my childhood, she amazingly
said yes when I threw out my pro forma gambit and requested a banana
split.

Across from the soda fountain the various newspapers were dis-
played, including, of course, the Sunday *Times*. Next to the papers was
the baseball card display. I was an avid collector and was allowed to

spend my entire allowance on them, as long as I promised to throw out the bubble gum.

Next to the baseball cards was the candy, all of it enticing and wonderful, and all of it verboten. As far as my mother was concerned, candy was synonymous with cavities. I stood in front of the candy display, mesmerized as usual, until at some point I mouthed some child's version of *fuck it* and I reached up and grabbed a Milky Way and an Almond Joy, and for dessert, a fruity packet of Chuckles. I knew all about consequences but, not for the first time, I decided to ignore their existence.

SIPRESS

"How am I supposed to think about consequences before they happen?"

I paid the cashier, got my change, and turning a blind eye to the pile of Sunday *Times,* went out the door, sat down on the steps of the candy store, and ate all three items in rapid succession. When I had finished everything except the despised licorice-flavored Chuckle, I allowed myself to consider what I was going to do next. My first problem was the change from the dollar. I couldn't have it jingling in my pocket when I saw my father. I was too full to buy more candy, having eaten more in a single sitting than I had the entire summer. There was no sense buying baseball cards, because how would I hide the evidence? So I walked to the trash can on the corner and threw in the change. Then I headed back to the beach. On the way, I tried to come up with a strategy vis-à-vis my

father, but my head was buzzing with sugar and I was feeling an unfamiliar surge of speedy, devil-may-care confidence.

"That's my little brother. He's all messed up on Skittles and Mountain Dew."

So I decided to let fate take a hand.

"None left?" my father asked when I arrived empty-handed. I nodded. I knew this was not out of the question — the store had run out before.

"Give me the dollar," my father said, "maybe the *Times* Guy will still show up after all."

"I don't have it."

"What?"

And then, for some reason even I didn't understand myself, instead of saying I lost it, I said, "I threw it away."

My father sat straight up. "You threw away the dollar that I gave you?"

I nodded, looked down at my toes and said, "Since there weren't any papers, I didn't need it, so I threw it out."

"You what?"

"It was all wet anyway."

"Come here," he demanded. He stuck his hand in each of my pockets. Coming up empty, he looked at the sky and said, "I don't believe this."

"Sorry."

"First of all, stop smiling, David. Why are you smiling?"

"I'm not," I insisted. But I was — I couldn't help it — my face was kind of frozen.

"Maybe you think money grows on trees?"

Is that possible? I thought. *All that candy . . .*

"Answer me, David!"

"I'm sorry."

He stood up, put on his sandals, grabbed my hand, and said, sharply, "Let's go."

"Where, Daddy?"

"Where do you think? To find it."

We retraced my walk to the candy store. I knew we couldn't get too close to the store because he might look in and see the papers, so after we walked about a block I pointed to the sidewalk and said, "I threw it here. Someone must have stolen it."

"Stolen it? Do think it's stealing when you just left it here for any Tom, Dick, or Harry?"

"No." And then, having run out of options, I decided to cry.

"All right, all right," he said, "stop with the tears and just listen. This is very important. You're not too young to understand the meaning of money. As you get older, you will have big trouble if you don't under-stand it. You must never, *never* take money for granted, let alone throw

it away like you did. You never throw it away *period.* They call money the root of all evil — I don't know about that — but I worry about it all the time because without enough of it you've got nothing but trouble. So, every dollar counts. That's why I never buy or sell anything until I get my price. Every dollar you earn that you hold on to and don't waste, or gamble, or fritter away, means you don't need to worry about *that* dollar and you can concentrate on worrying about where the next one is coming from. *Fershtay?*"

I sniffled and said I did, although, I didn't — not really. Mainly I was amazed that I had managed to devour all that forbidden candy and had told a great big lie — *two* great big lies — and apparently gotten away with all of it.

My mother arrived at the beach later that morning, and he told her what had happened. When he got to the punch line — me throwing the dollar away because it was wet and I didn't need it anymore — she laughed and laughed and gave me a big hug. The story immediately joined the pantheon of her most retold, cutest David stories.

But now my father asked me, "What is the lesson of today?" as we walked back to the beach.

"The meaning of money?" I murmured, repeating the phrase I would be lectured about countless times over the years, a concept so elastic and vague that it would be used to cover all kinds of situations and transgressions.

"Good. At least you learned something," he said, nodding.

I *had* learned something, but it wasn't the meaning of money. It was this: The bigger and crazier the lie I told, the more likely I was to be believed.

Chicken Counting

I'M A YANKEES fan, but I wasn't always a Yankees fan. Growing up in in the 1950s, I was a Dodgers fan and a Yankees hater — the two went hand in hand. Then came the Great Betrayal of 1957. The Dodgers left Brooklyn for the West Coast and, suddenly, I was a boy without a team. I tried supporting the hapless Mets for a while, but my heart wasn't in it. And, despite living in Boston for fifteen years, in the seventies and early eighties, I could never form an attachment to the exquisitely disappointing Red Sox — I had more than enough existential suffering as it was.

SIPRESS

"Rooting for them is a disease, Ben. It's nothing to be ashamed of."

Then, in the early fall of 1996, Ginny found herself watching a Yankees game on television and fell in love with Bernie Williams. By the seventh-inning stretch, she was a Yankees fan. After a brief, mildly painful struggle with my conscience, I hopped on the bandwagon, just in time to see Bernie, Derek, Jorge, and company win the World Series. Winning, as they say, cures everything.

In 1955, the year I was eight, my father also fell in love. That year, the Brooklyn Dodgers signed Sandy Koufax, a super-smart and handsome Jewish flamethrower from Bensonhurst, and Nat Sipress, a strictly secular Jew in the religion department, became a strictly observant one in the baseball department.

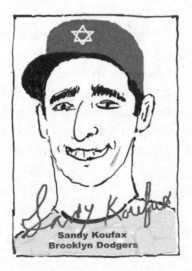

Sandy Koufax
Brooklyn Dodgers

That summer, my maternal grandfather, Ben, was having serious health issues. My mother's parents lived a one-hour drive away in New Jersey and my mother stayed with them for most of the next four weeks to help take care of her father. This meant that we didn't go to Neponsit until the first week in August when he was feeling better. One Sunday morning in July, my father came into my bedroom and announced that we were going to the second game of a doubleheader between the Dodgers and the Milwaukee Braves. I couldn't believe it! I jumped up and hugged him.

My mother arranged for her cousin Pete to drive us to the game in his

taxi. My father had long ago sworn off the subway, explaining whenever the subject came up that he'd "had enough of the hoi polloi in steerage" and wasn't interested in "rubbing shoulders with every Tom, Dick, and Harry." When Pete picked us up in front of our apartment building my father, wearing an elegant summer suit, announced that he and I would ride in the back of the cab "in case someone should see." I had on a brand-new blue and white satin Brooklyn Dodgers jacket. Pete wore his usual plaid lumber jacket and flat brown newsboy cap. Like my father, Pete was just an inch or two over five feet tall. His most prominent feature was a large, doughy nose that appeared as if it had been stuck onto his otherwise normal face by mistake. He was always getting stopped on the street by people who mistook him for the comedian Jimmy Durante, a.k.a. "The Schnoz."

Pete was a sweet, taciturn man. A graduate of DeWitt Clinton High School, he owned his own cab. If he had a reaction to my father's occasional condescending behavior, he didn't let it show. Although he lived in the Bronx, in the middle of Yankee country, Pete was a diehard Dodgers fan, so I'm sure he was happy just to be going to the game, and on my father's dime to boot.

I remember being as excited as I had ever been on that ride to Ebbets Field. I have now lived in Brooklyn Heights for the past thirty years and have walked across the Brooklyn Bridge thousands of times — but that trip to the ballpark, in 1955, was my first crossing. My father lifted me onto his lap so I could see the towers and the cables and the boats on the East River far below. He told me that he first saw the river, with the Brooklyn Bridge emerging from the fog in the distance, when he was a small boy, through the window of a trolley as it crossed the Williamsburg Bridge, upriver from the Brooklyn Bridge — the last leg of the long journey from Russia.

Driving through Brooklyn, we listened to the final innings of the first game of the doubleheader. When the Dodgers won, 9–7, I declared that they would win our game, too, and that the star slugger Duke Snider would hit two home runs.

"Don't count your chickens," my father said. Not counting my chickens was something he warned me about on a daily basis. But he wasn't beyond a little chicken-counting himself. Getting to see our Sandy pitch

that day was a definite long shot, since, at that early point in his career, he tended to be extremely wild and was used only sparingly by the Dodgers, in relief. However, as soon as we sat down in the second deck behind home plate, my father, with an unlikely touch of boyish excitement flashing behind the thick lenses of his glasses, told Pete and me, "He's going to come in today — just you wait and see."

"Let's just hope he doesn't screw up and walk everybody," he quickly added, catching himself.

We couldn't know that 1955 would be the magical year when the Dodgers would win their first World Series, finally defeating the hated Bronx Bombers, in seven games. In our game that July afternoon, they looked more like "Dem Bums." The Dodgers scored two runs in the bottom of the first and then nothing after that, and were soon trailing, 7–2. The mood in the ballpark turned sour, as did my father's. During the first few innings, he'd been cheerful and talkative, sharing insights with Pete, explaining aspects of the game to me, buying us popcorn and sodas. Now he sat stiffly beside me with his arms crossed, saying nothing. His grumpy expression made me nervous, so I finally asked if everything was all right. In reply, he pointed to the Milwaukee Brave stepping into the batter's box and said, "This guy's going to hit a single."

After that, every at-bat produced a prediction:

"Here comes a pop-up."

"He's going to hit a double."

"Get ready for a walk."

Soon, I was watching two games at once — the one on the field and the one in my father's head — and each time a prediction came true I had to wonder if he had some sort of agency as far as the future was concerned. When he was right, he took no apparent pleasure in it. When he was wrong, he merely nodded and went on to the next prediction. Pete began quietly harrumphing and, when my father correctly foretold a two-run homer by the great Hank Aaron, Pete shot my father an uncharacteristic dirty look and said he was going to the restroom.

The Braves tacked on two more runs at the top of the ninth, and people all around us started to leave. Pete returned, put on his jacket, and asked us if we wanted to get going. Before my father could answer, the Brooklyn manager, Walter Alston, climbed out of the dugout and strode

to the mound. A moment later, the P.A. announcer bellowed, "Coming in to pitch for the Dodgers, Sandy Koufax!"

"Yes!" my father shouted, and hugged my shoulders.

Our hero did not disappoint, retiring the three men he faced in short order. My father helped me stand on my seat so I could follow each pitch as it streaked across the plate. One pitch in particular remains in my memory as a vivid film clip. I can close my eyes and replay it to this day. The Milwaukee batter, thinking the ball was headed directly for his head, jumped back and fell outside the batter's box just as the pitch dropped on a dime and slid across the middle of the unoccupied plate, belt high — a perfect strike. There it was — an early sighting of what would one day be regarded as the most devastating curveball in the history of baseball.

"Did you see that?" my father cried, gripping my arm. "Did you see that, Duvid?" (This Yiddish ish version of my name was an endearment that only popped out when he was really emotional.) "He landed on his *tuchis*!" he exclaimed. "Right down on his *tuchis*!"

After the game, I walked between Pete and my father, each holding a hand, as we made our way through the crowd to Pete's parked cab. My father wanted to keep pretending we were passengers, but I begged him to let me sit up front so I could see the bridge better on the way home, and he relented. As soon as we were settled, Pete looked in the rearview mirror and asked, "Tell me something, Nat — how come it's only bad things you predict?"

"What do you mean?"

"All along, every time one of our guys came up, you predicted a double play or a strikeout or a pop fly. Then Aaron came up in the eighth for the Braves, and you predicted he'd hit that homer." He turned to face my father: "Always with the bad things. It's like you want them to happen."

"You don't know what you're talking about."

We sat thinking for minute or two. Then Pete started up the engine, grinned at me, took off his cap, and placed it on my head. As we drove down Flatbush Avenue, I studied Pete's astounding profile, thinking that he had it wrong — my father predicted the things he *didn't* want to happen. I was far too young to understand why. I just figured he was testing some dark superpower.

After that day at the ballpark, I began to notice more and more how he tested this superpower all the time — on everything from the weather (*It's going to rain all day tomorrow, no matter what they say*) to impending doctor visits (*This pain in my back will turn out to be back cancer*). Over the years, I came to understand that this was a form of self-protection: he tried to inoculate himself against the inevitable bad by always giving himself a preemptive shot of pain and disappointment in advance. In theory, he could cushion the blow and never be blindsided. And if by some miracle nothing bad happened? Well . . . better safe than sorry (another favorite aphorism).

SO WHERE DID it come from, this unshakable belief that bad things were bound to happen?

As an eight-year-old boy riding home in Pete's cab that afternoon, I knew almost nothing about my father's history. That changed only a little in the years to come, mainly because throughout his life my father maintained a nearly impenetrable silence about the past. Questioning him was out of the question. When he didn't want to talk about something, he simply didn't answer. Questioning my mother on the topic of my father was also useless; she would look away and tell me to ask my father. However, he did let drop a few bits and pieces now and then, and by eavesdropping on several relevant conversations between him and my mother, plus some historical research at the Public Library and a bit of clandestine snooping, by the time I was a teenager, I'd managed to learn this much:

My father was born in 1905 in a Ukrainian town with the consonant-crammed and barely pronounceable name of Medzhybizh — a center of Jewish culture since the 1600s and the site of several bloody pogroms over the centuries. He lived there with his mother, his three older brothers, and a younger sister. As for his father, nothing was ever mentioned. They were poor and must have lived in constant fear of persecution — the early years of the twentieth century saw a wave of pogroms throughout the Russian Empire. There was also the imminent threat of forced conscription into the Russian army for the older boys. So in the winter of 1914, a few months before the outbreak of World War I, the family departed Medzhybizh in a horse cart, eventually catching a

train that took them to Bremen, Germany, where they boarded a ship, endured a dreadful, jam-packed passage in steerage, and arrived at Ellis Island in the summer. The family settled in the Orthodox Jewish enclave of Williamsburg, Brooklyn, where they remained poor, so much so that my father was forced to leave school after the fifth grade and go to work to help his mother out. Then, a few years later, when he was barely grown up, he left his mother's home and went off on his own; a few years after that, he started a career and became a new person — the person I knew.

With only this collection of facts I was left to wonder: How did he feel about all of this? What happened to the other members of the family? Did he love them? If he loved them, why did he never see them? How come I didn't know them? Why did he want so badly to be that new person?

But the stuff I *did* know was enough to lead me to suspect that his perilous, uncertain past was the explanation for his gloomy view of the future.

IN SPITE OF his relentless effort to assimilate, Nat Sipress was still a Jew who swelled with pride when his hero refused to pitch Game One of the 1965 World Series because it fell on Yom Kippur (a holiday the Sipress family observed with a perfunctory fast and some pro-forma atoning at the synagogue, followed by a lavish lunch at King Dragon Chinese Restaurant, including my father's favorite *trayf* extravaganza: jumbo shrimp wrapped in bacon).

"*Top three of all time? Moses, Einstein, and Koufax.*"

Still, like any Jew living in the middle of the twentieth century, assimilated or otherwise, my father had learned to expect the worst. Wherever it came from, his gloomy predicting was contagious — I did it on my own the very next time I watched the Dodgers on television. It was fun, especially since I didn't confine myself to predicting bad things. Predicting made me feel like I was in the game — more than just a passive observer. It's a baseball-watching reflex that's still with me today. Only my own deepest assumptions about the worst usually coming to pass has saved me from a gambling problem.

One early prediction nearly convinced me that I, too, possessed the dark superpower. On October 8th, 1956, my fourth-grade teacher set up a television in our classroom so that we could watch the fifth game of the World Series between the Dodgers and the Yankees. By the fourth inning, the Yankees pitcher Don Larsen had retired every Dodger he faced. I turned to a classmate and announced, ominously, "He's going to pitch a no-hitter." Which Larsen famously did — a perfect game, in fact. Many years later, at an elementary-school reunion, the classmate told me it was his clearest memory of fourth grade.

Today as a Yankee fan, I know that my team is almost guaranteed to do well. Even so, whenever I begin to fantasize about the World Series, a familiar voice in my head warns, *don't count your chickens.* So I shut my eyes and ears to any pundit who forecasts that the Yanks will go all the way, paying attention, instead, to those who argue that injuries and questionable starting pitching could very well derail their playoff hopes.

"He died from looking up his symptoms on the internet."

And this year, like every other year for as long as I can remember, on the day before my annual physical — never mind the fact that I have never felt better — I will undoubtedly manage to find several horrible things online that are probably wrong with me.

At the risk of getting way ahead of myself, the last time I ever spoke to my father was New Year's Eve, 1997. Ginny and I were leaving to spend a two-week holiday in London. When I called him from JFK to say good-bye, I mentioned our excitement over the great lineup of plays we'd booked.

"Don't count your chickens," he reminded me.

"I won't, Dad," I sighed.

Three days later, my father died, peacefully, at home, at the age of ninety-four. We flew back to New York with four pairs of unused theater tickets.

"I always thought this would happen."

Robbery

A S A KID I loved cartoons. We lived directly across Central Park from the Met, and my mother took me there often. The paintings and sculpture were a source of endless fascination, but seemed far out of reach for the aspiring boy artist. Cartoons looked like something a kid could do, and I couldn't get enough of them. Monday to Saturday, we were strictly a *New York Times* family, but on Sunday, we also got the *Herald Tribune*, and I looked forward all week to the Sunday funnies. I loved *Popeye* because it was so totally ridiculous and I shared his dislike of spinach, but my favorite strip was *The Little King*, since the character of the king, with his moustache and impervious outer shell, reminded me of the king of Apartment 12A, 118 West Seventy-Ninth Street — Nat Sipress.

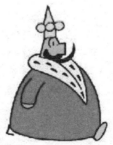

I was a fan of comic books too, but my father considered them pernicious carriers of the twin plagues of stupidity and delinquency and would not allow them in the apartment, so I only got to see them at

other kids' houses, and at the barber shop, on a shelf in the back near the small pile of girlie magazines.

The cartoons that most captured me, the ones that made me think, "I can do that," were the drawings I saw every week in my parents' *New Yorkers*. Once I decided that I was going to be a cartoonist (after the dinner at Gino's and the barking poodle) I began drawing my own versions of *New Yorker* cartoons, cutting them out and pasting them onto the pages of the magazine, on top of the Steigs, the Addamses, and the Sogolows.

At Hunter Elementary, art was granted equal status with what used to be called "the basics," so I got to indulge my passion for drawing. Now and then, people with interesting jobs were invited to come and talk to us about their professions, and when I was in fourth grade, one of the guest speakers was a cartoonist. I don't remember his name, but I do remember that he said that he drew for *The New Yorker*. He spoke to us in the school library, standing beside a large newsprint pad propped up on an easel. He started by showing us how to draw cartoon faces, and how, with just a few strokes of the pen, to make them express various emotions. It's a lesson I've never forgotten:

"Now, that wasn't so hard, was it?"

I noticed that as he created each face, his own face would involuntarily adopt the expression he was drawing. Years later, watching a film of myself drawing, I realized I do the same thing. I like to think of it as evidence of my empathy with my characters.

Next, the cartoonist asked a few of us to come up and draw random abstract doodles on his pad. As each kid finished, the cartoonist stepped back, studied the doodle, turned the pad this way and that, and finally went in with his marker and turned the doodle into a recognizable thing, and then that recognizable thing into a cartoon. I was transfixed. It was like a magic show, only better. I went up to him at the end and shook his hand and told him that I was going to be a cartoonist too.

I revealed this plan to a few school pals who shared my passion for drawing, as well as to a couple of my teachers. Who I didn't tell, were my parents. I somehow understood that they wouldn't approve, even though my mother thought the cartoons I drew and pasted into her *New Yorkers* were hilarious, and she was always full of praise for the greeting cards I made for her:

However, the idea that drawing anything, including cartoons, would ever be more than a hobby would never have occurred to her. She

herself was a wonderful artist who loved to draw and was also a talented painter. For most of her married life, she took painting classes at the Art Students League; several of her charming still lifes decorate the walls of our apartment.

She was also an accomplished pianist, and sang beautifully, but these artistic pursuits were secondary and could never take precedence over her primary vocation — keeping our apartment clean and beautiful and cooking delicious meals that featured all my father's favorite dishes, including the boiled tongue that no one else could stomach. In my Mother's Day card, the nine-year-old me didn't depict my mother with a paintbrush in her hand or sitting at the piano; instead she is holding what I clearly thought of as the tools of her trade — a frying pan and a broom.

But even cooking and cleaning and organizing took a back seat to her one true *raison d'être* — ensuring that my sister and I never did anything that might upset my father when he came home each night, exhausted after a long day of standing on tired feet behind the counter of his shop, working his fingers to the bone to provide for the secure, privileged existence we should never take for granted. My father's constant watchword was "peace of mind," as in, "All I ever ask for is a little peace of mind," and Estelle Sipress dedicated her life to ensuring that he had it.

As for my father, he seemed barely to notice my obsession with drawing, remaining unimpressed by my stellar grades in art. He made it clear that only "serious" subjects counted in the Nat Sipress scheme of things, and anything less than an excellent grade in those subjects was totally unacceptable. And yet, he was a kind of artist himself. At the back of his shop, beside the safe, stood a library-style card cabinet that contained his inventory — thousands of index cards, each card displaying a graceful pencil drawing of every piece of jewelry, every precious object, he ever bought or sold.

And then there was his eye — his amazing ability to spot and acquire beautiful things. This eye extended to his life beyond the shop. He had exquisite taste in everything from clothes to paintings to furniture. This was an innate talent that nothing in his impoverished history or fifth-grade education could account for. He began his career by accident, when he was hired as a delivery boy for a jewelry shop in midtown Manhattan in the 1920s. Somewhere along the way, his natural ability emerged and he thrived.

ONE MORNING IN the fall of 1996, my father called to say he wanted to have another talk with me about the future, and he wanted to have it at his bank.

"Why the bank?" I asked.

"Because I want to visit the box."

Over the year since my mother's death the previous October, he had lost a good deal of weight. Eating had gradually ceased to interest him. In addition, his gait had deteriorated — he had begun to resemble an awkward robot when he walked, propelling himself forward on stiff, shaky legs, his flat feet never lifting off the ground, his progress disrupted every now and then by a series of perfunctory, mechanical gyrations involving all four limbs. An inveterate walker his whole life, now he rarely went out, and never without Maeve, or sometimes in the company of Linda, who lived a few blocks away.

What dismayed him the most about his limited mobility was that he could no longer walk to his bank on his own when he wanted to "visit the box" — his safe deposit box — which contained all the things he hadn't sold when he'd retired and closed his shop two decades earlier.

When I arrived at his apartment that afternoon, he surprised me by promptly answering the door himself.

"Where's Maeve?" I asked.

"Since you were coming I sent Intoxicating Woman home." (When Maeve was first hired, the building super, an Irishman, came up to the apartment to fix a leak, and after Maeve took my mother out for a walk, he explained what Maeve's name meant "in Irish," and this had amused my father.)

I bent down to kiss him — a journey that seemed to get longer each time I visited, something I commemorated years later in this cartoon:

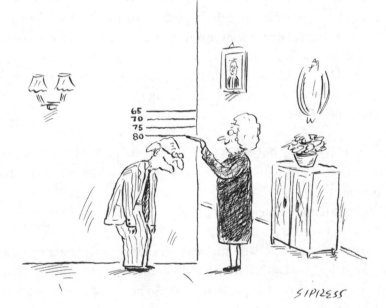

As always, he smelled faintly of Old Spice. There were patches of white stubble on both cheeks that he'd missed with his old-fashioned safety razor, the same one he'd been using since the fifties. His long ears with their pendulous lobes had begun to look too big for his head; with my mother no longer around to do the trimming, each ear now sprouted an impressive crop of incongruously dark hair.

He was wearing a dark blue suit and red silk tie. Although his exacting sartorial standards had slipped considerably since my mother's death, there was no way he was going to go to the bank in anything but

a suit. But the suit jacket hung forlornly from his diminished shoulders, and the knees of his trousers had a shiny, worn patina. Most alarming, his waistband was bunched up in front and he had secured the folds with a safety pin.

As we waited for the elevator, I suggested that we stop on the way to the bank for a sandwich.

"Nah," he said, dismissing the suggestion with a wave of his hand, "I had a can of Ensure this morning and I'm still full. Besides, you can't get a sandwich in this neighborhood for less than twenty dollars."

This was true. I gave up on the sandwich.

Tremulous fingers gripping my forearm, head thrust forward, gaze fixed steadfastly on our slowly approaching destination, he made his fitful way down Madison Avenue, while I struggled to match his herky-jerky pace. At one point, I noticed he was fiddling with the safety pin, and I said, "Maybe one day we should go to Saks and get you a new suit."

"I got plenty of suits," he answered.

"But a new one that fits you . . ."

"This fits," he assured me. "Anyway, I can't possibly afford it."

"Not again, Dad. We've talked about this."

Lately, he had decided that he was running out of money. Like many of my own worries, this one of his was totally at odds with reality.

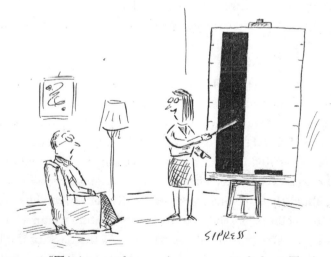

"This is everything you're ever worried about. That's everything you're ever worried about that actually happened."

The cause of his nonsensical anxiety was his choice to pay all of his monthly bills out of his checking account, fed monthly by his Social Security check and a few bond dividends. The checking balance slipped nearly to zero once he had paid all his bills at the start of each month, at which point, like clockwork, he would call me to complain that he was running out of money. This ignored the fact that he didn't have all his eggs in his checking account alone.

It would be disingenuous for me to claim not to understand his suffering over nonexistent money problems, since I have been known to freak out about financial matters in much the same illogical, myopic way. In my case, I've concluded that it's a kind of twisted motivational technique; in my father's case, I suspect that scaring himself about money in his last years allowed him to feel as if he was still in the game — as if he still had big problems to solve.

"Believe me, Dad," I said, "you can afford a new suit. You can afford ten new suits. One phone call to your broker and you could get all the cash you need."

"That's not for new suits. Anyway, I don't want to bother him. He wants it left alone, so it will earn."

"But . . ."

"Besides, he'll think I'm desperate."

I gave up on the suit as well as the sandwich.

"Anyway," he added, after several seconds, "I'll probably be dead by the time they finish the alterations."

FINALLY, WE ARRIVED at the bank. The place was a throwback, grand and somber, with marble floors, polished counters, and tall, paned windows. Well-heeled customers leaned over desks, waited patiently on the striped silk upholstered furniture in the waiting area, or chatted quietly with smiling tellers. Red velvet rope dividers delineated the lines for the teller windows. Everyone was white, most were senior citizens, and all were going about their business with polite discretion; the hush of the place made it feel more like the New York Public Library than a bank.

"We go to the back," my father instructed. At the back of the bank there was a marble staircase and an elevator. The elevator was barely big

enough for the two of us. My father pressed the button that said "vault," and we headed down.

An elderly bald man sat behind a desk in the small foyer across from the elevator. The name plate on the desk read "J. Moses." He stood and nodded at my father. Tall and stick-figure thin, he wore an austere black suit, white shirt, and black tie. His face was long and very pale, and his head drooped forward so that his chin nearly rested on his narrow chest. He looked to me like a funeral director, but this thought may have been prompted by my father's "alterations" quip.

"This is Mr. Moses," my father told me. "He's been in charge down here since God knows when. Maybe since the Red Sea."

Mr. Moses lifted his chin in my direction and smiled a curt, uninterested smile. My father did one of his little jigs while Mr. Moses and I watched, and once he was back on track, we made our way past the formidable, heist-movie-worthy door of the vault until we were standing face to face with a wall of safe deposit boxes.

"I want my son to see how it works," my father said to Mr. Moses. He showed me his key and then handed it to Mr. Moses. "Just in case," he added.

The safe deposit boxes were uniform in size, except for two rows of larger boxes at the bottom. It was one of these that Mr. Moses crouched down and unlocked with my father's key. He slid out the box and stood, cradling it against his chest with both arms. It was much bigger than I had expected — like a tall, longish shoe box.

"We'll take the big room," my father said.

We followed Mr. Moses and the box out of the vault and across the foyer to a dark wood door. Mr. Moses opened the door with a free hand, carried the box across the thick carpet, and set it down in the middle of a large mahogany table. On his way out, Mr. Moses flipped a switch that turned on a standing lamp in one corner, and a second lamp that sat on a small antique writing desk, above which a large, muddy impasto painting of a New York skyline hung on the dreary gray wallpaper. There were pads of paper and a small vase filled with pens and pencils on the desk. Four cracked leather armchairs were tucked under the table, two at the sides and two at the ends.

"Are we expecting someone else?" I joked to my father.

"I always take the big room," he replied, solemnly. "It's better."

I instinctively picked up a pad and a pen from the desk.

"What's that for?" my father asked.

"Just in case."

As we sat down across from each other at the table, the leather cushions of the chairs gasped and deflated, causing my father to sink so far down that the table came up to the middle of his chest. I was tempted to peer under the table to see if his shoes were touching the ground.

He sighed and then, for the first time that morning, he smiled. "It's very peaceful here," he said.

I nodded. The silence was absolute. We were hermetically sealed.

"I find it makes all my concerns seem a million miles away," he added.

I could definitely relate. It's the way I feel every day in my studio — like I'm on my personal desert island.

"I'll tell you a secret, David. Sometimes, when I'm finished with my business, I put my head down on this table and take a little nap."

I could relate to this as well:

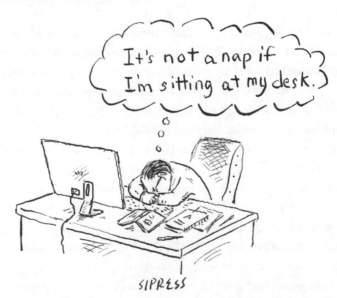

He wriggled forward and adjusted his height by perching on the edge of the chair. Then he reached out and tapped the top of the deposit

box. "What's in here are the most beautiful things, the ones I loved the most. The ones I decided to keep no matter what," he explained. "Some things in here go back more than forty years. Before the problem with the walking I used to come here once a month just to sit and look at them."

He sighed again. Then he sat up a little straighter and said, "OK, first things first." He reached into the inside pocket of his suit jacket and pulled out a small stack of index cards held together with a rubber band. He shook the stack in my direction.

"My inventory," he explained.

Now he took off the rubber band and began spreading the cards out on the table, each with its own pencil drawing.

"What are you doing?" I asked.

"Just making sure."

"Of what?"

"Of whether everything is still here. Without the cards, I might forget about something that should be here, but isn't."

"Why wouldn't everything be here?"

"You never know."

"We're in a bank, Dad. In the vault. Who would take something? Mr. Moses?"

"Better safe than sorry."

When he had spread out all the cards he flipped open the top of the box and reached in. One by one he pulled out a series of small navy-blue velvet string bags and one large gray string bag. When the box was empty, he peeked into each string bag and then placed it on the appropriate pencil drawing.

"All present and accounted for," he said, as he reached for the bag closest to him and removed a string of pearls. He held them up and fingered them tenderly like worry beads. "These are South Sea whites," he told me. "Maybe you remember them. I always put them in my front window, with all the most precious things, in a spot where they were sure to catch the light. Not that they needed it. Even here you can see that they make their own light." He held them out to me, gesturing for me to take them, but I leaned back and shook my head.

"Your mother loved them," he said, "but after a while I had to take

them back. When she started forgetting I was afraid she was going to lose them."

Next, he opened the large gray bag and pulled out something I recognized — an icon — a painting of a Madonna and Child encased in an elaborate silver frame.

"Have I ever told you how I got this?" he inquired.

"Probably, Dad." I knew what was coming — some version of his *I always get my price* speech.

"This guy came into the shop. I recognized him immediately. He lived with his mother on Sutton Place. I had done a little business with the mother over the years. He told me she had recently passed away and I said how sorry I was. He had a bundle wrapped in newspaper under his arm. He unwrapped it and out comes this. . ."

He held up the icon.

"I was taken first by these eyes . . ." He pointed to the Madonna's face in the center of the icon. "See how sad? And then by the colors — the blue and the gold."

It *was* beautiful. I recalled admiring it a million years ago, on a shelf in the safe in my father's shop. The two figures were graceful and serene. The painting had the unalloyed, primitive honesty that I've always loved in art of any kind.

My lifelong obsession with Russian history kicked in. "How old is it?" I asked him.

"Old. Maybe two hundred years. Probably more."

I thought, *Catherine the Great, Pugachev's rebellion, the Pale of Settlement . . .*

Then, not for the first time, I wondered if my father ever made the rather obvious connection between my interest in Russian history and his being born there. But bringing up Russian history risked creating another opportunity for him to bemoan my giving it up, so I kept the question to myself.

"So, anyway . . ." my father said, patting his chest, "sometimes I get a feeling."

"I know, Dad."

"I told him, 'This is what I'm willing to pay.' The guy shook his head. Then he told me how much he wanted. It was too much. And he wanted

cash. That's a funny thing about rich people — they always need cash. Anyway, back and forth we went for ten minutes. But he wouldn't budge.

"The whole time I was looking at it and more and more I didn't want to risk losing it. Even so, I finally said, 'Fine. Take it somewhere else.'

"That was when he relented. Not much — still not my price — but close enough so I could feel that I'd done a good enough job for myself. And, like I said, I had a feeling. So I went back to the safe and got him his cash. We shook hands and I never saw him again."

He paused to look at me. "You're not interested?"

"I'm interested," I replied. I had been reflexively drawing on the pad, turning the bank's square logo into a robot with a pillbox hat and earrings. I put down the pen and said, "So, go on."

"Well, afterward, I immediately started to wonder, did I do the right thing? 'Time will tell,' I reminded myself. And guess what? Time has told. Today it's worth a hell of a lot more than I paid."

"So, you wound up getting your price after all. Isn't that what you're telling me?"

"That's right. And then some."

The whole time he was speaking, he had been taking things out of the velvet bags. I stared down at my robot, up at the awful skyline painting, then at the blank gray wall behind my father. Anything to avoid looking at the jewelry spread out between us.

This was nothing new. My entire life I had been averting my eyes from his "beautiful things."

MY FATHER'S SHOP, Revere Jewelers, occupied the ground floor of a four-story brick building one block north of Bloomingdale's on Lexington. The building housed a doll hospital on the floor above the shop. Dolls of every shape and size in need of repair sat bunched together in the grimy display window, gazing dolefully down at the slow-moving downtown traffic on Lexington Avenue. Around the corner on Sixty-First Street, next door to Revere Jewelers, there was a liquor store where Woody Allen's father worked for a time. According to my father, after his son became rich and famous, the father arrived to work each day in a limousine.

The space formerly occupied by Revere Jewelers has gone through

many iterations in the subsequent almost fifty years. Today it is a shop that sells soaps, creams, and sundries. The store appears to have been widened. My father's shop was a narrow space thirty feet long and no more than nine or ten feet wide. The short end opened onto Lexington Avenue with its showcase window containing the most valuable pieces, such as the pearl necklace. Hanging from the top of the window was an antique weathervane of Paul Revere riding on a galloping horse, arm outstretched, lantern in hand. Paul Revere, the midnight ride to Lexington, the shop's location on Lexington Avenue — all combined to inspire the name Revere Jewelers. I suspect the name was also inspired by Nat Sipress' relentless quest to assimilate; after all, many of his wealthy WASP customers called him "Mr. Revere," and I never heard him correct them. As a young boy, this confused me; later, I felt embarrassed, and eventually, ashamed. "With his genealogy written all over his face, who does he think he's fooling?" I asked myself. Maybe it's just a harmless charade and both sides know what's what. But what if they're mocking him? Laughing behind his back?

I often make drawings, just for myself, to encapsulate and clarify my thoughts and feelings concerning a particular issue or event. The cartoonist knows better than anyone that a picture is worth *at least* a thousand words — hence this one about the Mr. Revere conundrum:

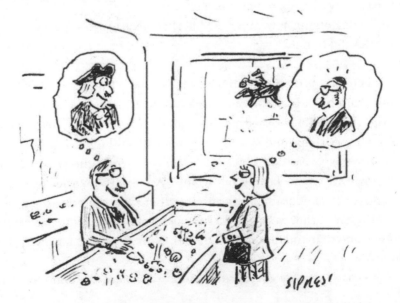

The shop had additional display windows along the Sixty-First Street side. Inside, running down the middle of the shop, was a long, glass-topped counter that doubled as a display case. A small room at the back of the store contained the card cabinet with my father's inventory, a small desk that doubled as a work table on which my father redesigned pieces, did repairs, and polished silver, and the safe — a tall, formidable, double-door affair, with rows of grooves running up and down the sides; every night the last thing my father did before closing was to remove the felt-covered trays of jewelry from the windows and the display cases and slide them into the grooves in the safe.

The front door of the store could be opened only by my father, who unlocked it from behind the counter by means of a buzzer button. In the middle of the door's glass pane was an oval sticker that faced in and out. It featured a helmeted warrior goddess with a silver sword and a gold shield emblazoned with a large "H." Directly behind her, floating on a cloud, was a large safe, much like my father's. Lightning bolts shot out from her helmet and gold letters above her proclaimed, "HOLMES ELECTRIC PROTECTION." As a boy, without really understanding what I was feeling, I found her extremely sexy.

When concerned friends or curious customers asked my father if he worried about being robbed, he would dismiss the idea, saying, "To begin with, I've got Holmes, but that's mostly for show. The thief would be long gone by the time Holmes got here. On the other hand . . ." Here he would pause dramatically, raise his index finger, tap one lens of his bifocals, and declare, ". . . I have *this* — my security system — if you don't look right to me, you don't get buzzed in. End of story."

I never got scared when the possibility of a robbery came up, because I believed that my father was invulnerable — that his "security system" was another superpower, like his predicting. But all that changed one evening in late December 1959.

THAT AFTERNOON, ALONG with two school friends, I went to the Loews Eighty-Third Theater on Broadway to see the biggest movie of the year, *Ben-Hur.* Built in 1921, the Loews Eighty-Third was a classic twentieth-century movie theater with red velvet upholstered seats and carpeted staircases leading up to the balcony where we kids loved to sit in

the front row with our boxes of candy, occasionally tossing a Nonpareil or a Raisinet onto the people in the orchestra below when the elderly uniformed usher wasn't looking.

Ben-Hur made a huge impression on me, continuing to figure in my dream life for years. The movie featured the first Jewish hero I'd ever seen on screen, Judah Ben-Hur, played by Charlton Heston, a classic gentile if there ever was one, who made a career partly from portraying monumental Jews. (Many years later, staring at the face of Michelangelo's *Moses* in San Pietro in Vincoli in Rome, I marveled at its resemblance to the famous gun enthusiast and star of *The Ten Commandments*.) I never forgot the chariot race, and the slave ship scene really stuck with me, reappearing as a setup in several of my cartoons:

"Always remember—it's about the journey, not the destination."

The two things that fascinated me the most in the movie, though, were the depictions of a leper colony and the crucifixion. I couldn't wait to get home after the movie so I could do some research into both.

It was dark and quiet in the apartment when I walked in, except for my sister's hi-fi playing Edith Piaf behind the closed door of her bedroom. She was home for the holidays from college. At this point she and I had little or nothing to do with each other. But I was surprised that my mother wasn't home. I had expected to find her in the kitchen, making dinner. I knew my father wouldn't be there since he kept his shop

open until seven or eight o'clock the week before Christmas, for last-minute shoppers.

I went into the kitchen and opened the refrigerator. There was my mother's meatloaf, assembled but uncooked. Why wasn't she home? I knocked on Linda's door. She stuck her head out and said there had been a phone call and our mother had rushed out a couple of hours ago.

"What for?" I asked.

"How should I know?" she said, and slammed the door.

I picked up the L and C volumes of our encyclopedia and retreated to my room. I was simultaneously disappointed and relieved that the leprosy entry didn't include any pictures. Perhaps I fantasized about my sister coming down with the disease (it wasn't the first misfortune I'd wished on her), including, if possible, her nose falling off.

After Linda and I had watched *The Robe* on television when I was six, she'd insisted on reading the entry on crucifixion out loud to me. I'd only half listened, making a humming sound inside my head whenever she got to the nasty bits. Now I gave the article a close read. It traced the history of crucifixion as a form of torture and execution down through the ages and, with the aid of a nifty diagram, explained in detail how it worked. I had seen plenty of images of *the* crucifixion in the Metropolitan Museum, including Salvador Dali's bizarre version that haunted my imagination with its frightening juxtaposition of naked suffering and cold geometry — Christ pinned to a colossal modernist cross made of symmetrical stacked cubes than hangs in the air above a murky, barren, apocalyptic landscape. That image also figured in my dream life for years, sometimes in combination with a mushroom cloud, sometimes in a mash-up with scenes from *Ben-Hur.*

My reading done, I sat at my desk and drew until I heard my mother's key in the front door. I rushed to the foyer and kissed her hello. She took off her mink coat and threw it on a chair by the door instead of hanging it up, which was highly unusual. I tried to start a conversation with her about the movie, but she said we could talk about it later. Now, she had to fix dinner. She went directly into the kitchen and took the meatloaf out of the fridge. Her eyes were doing a fluttery blinking thing that they always did when she was nervous.

"Is everything all right?" I asked her.

"Everything is fine, David. Now, be a good boy and go read in your room while I make dinner. Your father will be home soon."

"Where did you go?"

"To the shop."

"To help out?"

"Yes. No. Your father needed me for something. He'll explain when he gets home. Now, go to your room so I can cook."

My father arrived an hour or so later. As far as I could tell, he was his normal self. He and my mother embraced and then they went into the kitchen where they had a quiet discussion, after which my mother called to my sister and we sat down at the dinner table.

The large foyer of our prewar apartment also served as our dining room. Every family discussion of importance happened at the dinner table. Proper table manners were strictly enforced; any protests were met with my father's signature dictum "rules are rules." The table setting was always a semi-formal affair. Everything on the table — the blue and white English china, the silver flatware, the silver candlesticks, the glassware, the silver platters and serving spoons — was chosen by my father and imported from the shop, purchases from individual customers or at estate sales.

What stands out most vividly in my memory are our silver napkin rings. Often when I think of a member of my family, I see a face, and immediately after, the image of their assigned napkin ring. Linda, who sat across from me, had the smallest, no more than a half-inch wide — a simple, feminine hoop with no decoration. My mother's was twice as wide as Linda's, and decorated all around with a delicate *fleur de lis* pattern that I always liked to imagine was her coat of arms. My father's was the biggest and chunkiest, with a raised crown of intersecting vines around the top and bottom; it was the king of napkin rings. And finally, mine — about the same size as my mother's, with three indented loops and a star pattern along the top and bottom edges.

As soon as we sat down and placed our napkins on our laps, my mother looked at my father, still in his suit and tie, and said, "Tell them, Nat."

And before he could open his mouth, she announced, "Your father was robbed today."

My stomach flipped over.

"Oh, my God!" my sister cried, clasping her cheeks. "Are you all right, Daddy?"

"He's fine," said my mother.

"I'm fine," agreed my father.

"What happened?" Linda asked.

My father, as he did every time we sat down to dinner, took a sip of his Miller High Life, waited a split second, and then quietly belched. I searched his face for any evidence of upset or stress, and when I saw none, I stopped feeling scared. I just wanted to hear the story.

"This is what happened," he began. "Around three o'clock this afternoon, I sold a pair of emerald cufflinks to a regular customer — a Christmas gift for her husband. Just after she left, as I was putting away the other pieces she had considered, the doorbell rang. Two guys were standing outside, both wearing good suits, both with nice overcoats. One was perusing the front window while the other smiled at me through the door. He was carrying a Bloomingdale's shopping bag. Nothing looked suspicious, so I buzzed them in."

I remember at that moment thinking, *But what about the security system?*

"When they came in, I asked them to wait a moment while I finished recording the sale of the cufflinks for my file. When I finished, I looked up, and lo and behold, I was staring straight into the barrel of a gun."

"Oh, my God!" Linda exclaimed again.

"The guy holding the pistol — he had red hair, and bad teeth; to me he looked Irish. Anyway, he was short — the same height as me — and the way he was pointing the pistol, it was practically in my face. The first thing I thought was, 'It's so small — not big, like on television.'"

My father raised one hand, made a gun with his fingers. "And it was shaking back and forth . . ." he shook his hand ". . . like this."

Sitting across from him, my mother quickly looked away. He lowered his hand. "Sorry, Estelle," he said.

"It's all right, Nat. Go on."

"In any case, the shaking let me know right away the guy was nervous. Maybe not as nervous as me — I was shaking too — but on the *inside*."

He sat back and took another sip of beer.

"Next, like he thought he was on *Dragnet* or something, the guy says, 'Just do what we tell you and you don't get hurt.'"

Linda was staring at him, wide-eyed, her hand covering her mouth.

"Meanwhile," he continued, "the big guy — Mister Strong and Silent — backs away and stands in front of the door so nobody can see in."

"Then the guy with the pistol places his Bloomingdale's bag on the counter and says, 'Get the stuff out of the front window. Bring it in. Quick! And put it in the bag.'"

"I look right at him and I don't budge."

"'C'mon,' he says, waving the pistol in my face. 'What are you waiting for? Do it!'"

"'*No*,' I tell him."

"'No, what?' he says."

"'No, I'm not going to take the stuff out of the window and put it in the bag.'"

"You should have seen the look on his face. His mouth dropped open like this." My father made a stupefied expression.

"Then the big guy speaks up for the first time. 'Do what he says, you *blah blah* effing kike!'"

"'No,' I say again."

"'Are you crazy?' says pistol guy."

"'Crazy? I'm not crazy. I worked my whole entire life for what's in that window, and I'm not about to hand it over to *you*.'"

Wow! I thought.

"'What?' says pistol guy."

"'You heard me,' I tell him."

"Next thing I know he's got the pistol right up against my chest. He says, 'You better do what I say or I swear to God, I'm going to shoot you.'"

"'Then, go ahead,' I tell him. '*Shoot me*.'"

"What?" my sister exclaimed. Her eyes got really big and she clawed the table with her fingers.

The look on Linda's face frightened me. My mother must have noticed this, because she said to me, "Don't worry. Everything is fine." But she looked worried too, I noticed.

"So," my father went on, "again I tell him to go ahead and shoot me.

'You'll have to do it,' I say to him, 'because I'm not giving you one single thing from out of that window. Not one!'"

For emphasis, he picked up his napkin ring and banged it like a gavel on the table.

"Take it easy, Nat," my mother cautioned. "Your face is beet red. And you're upsetting them."

He nodded and wiped his forehead with this napkin. "I'm sorry," he said to me, and then he touched Linda's hand and repeated the apology. She took his hand and held it.

"Weren't you scared, Daddy?" she asked.

"Sure, I was. But I wasn't about to give in."

"Go on, Nat. Hurry up and finish the story," urged my mother.

While he took another sip of his beer, I snuck a peek at Linda. She no longer looked scared. Before I could turn away, she noticed I was looking at her. Still holding my father's hand, she squinted, wrinkled up her nose, and stuck out her tongue at me. I shut my eyes. The change in her was like a magic trick.

"So, pistol guy looks over at his partner," my father continued, "and then back at me. Again he says how he's going to shoot me if I don't do what he says. 'I'm *serious*,' he tells me.

"'Me, *too*,' I say right back to him. 'I'm also serious.'"

"Now the big guy by the door pipes up and says to hurry up. Pistol guy looks at him and runs his hand through his carrot top like he doesn't know what the hell to do next. Then he pushes the pistol into me, hard, right here . . ." He picked up his napkin ring and pressed it against the paisley pattern on his necktie. "He pokes me a couple of times and practically shouts, 'I mean it! I *really* mean it!'"

"'So do I!' I say right back to him. And before I know what I'm doing, I reach out and push that pistol aside with my hand."

"No!" Linda cried.

"'Hey!' says pistol guy, and he puts the pistol back where it was and rams me one more time. Again, he turns to look at his pal. The big guy shrugs. Then, pistol guy points down at the showcase between us where I keep my second-best things and says, 'OK, forget the window. Give me what's in here. Right now.'"

"'The answer's still no,' I tell him. 'This stuff you can't have either. This also, I worked my whole life for.'"

"Then the guy at the door says, 'We need to get a move on. This is taking too long.' Maybe he suspected I had already pushed the alarm button for Holmes, which I hadn't, because it was too far from where we were standing."

"So, now pistol guy doesn't know what to do. He looks all around and runs his hand through his hair again, and then he whines like a crybaby, 'C'mon! You gotta give us *something*.'"

"'Fine,' I say. '*Here* . . .' I reach into the showcase behind me on the Sixty-First Street side and take out a gold chain with a diamond pendant. Nothing too good, but not terrible. Maybe worth a hundred dollars. Maybe less."

"'Take this and get out,' I tell him."

"'That's *it*?' he whines."

"I'll throw in a ring," I say, and I take out a twenty-five-dollar wedding ring from the showcase and drop it into his shopping bag. He looks at me like he can't believe it — almost like I hurt his feelings."

"Meanwhile the big guy comes over from the door, leans across the counter and says, 'Eff you, you effing goddamn kike.'"

"'Yeah, eff you,' says the other one, and he puts the pistol back in his coat pocket and grabs his shopping bag."

"'Go on,' I tell them, pointing to the door. "'Get going.'"

"'You cheap bastard,' Mister Pistol hisses in my face. 'Someday . . .'"

"'Come on!' his partner tells him. He's back at the door, holding it open. And next thing I know, they're gone."

I have no memory of what my mother and my sister said next, or exactly what else my father reported about the robbery, about calling the police or anything further, because by then I was trying to sort out the awful confusion I felt. At first I had only pride for the way my father had stood up to the bad guys, like my cowboy heroes. It didn't even sound like he had been afraid. But even as I gazed at him with amazed admiration, other thoughts were seeping into my brain, spreading and growing until they couldn't be ignored.

Daddy could have died, I thought, *really died!*

I pictured my father slumping to the floor behind his counter, with a

terrible, gaping hole in the middle of his chest, right where his tie met the top button of his suit vest. At the same time, I recalled the trampled bodies from the chariot race in *Ben-Hur.* My stomach lurched and I blinked away both images.

And then, I thought, *What about me?*

I felt my eyes start to sting. I was holding my napkin ring in my lap; I pressed the edge of it as hard as I could into the top of my thigh while I clenched my other fist. I was not about to cry in front of my sister.

What about me? Why didn't he think about *me* before he told the guy to shoot? Didn't he care that if he died, he would never see me again? Why didn't he worry about how sad I would be? Why was he willing to die and leave me alone without a father?

And for what? For those *things*?

I covered my eyes with one hand. *It's those things that he really loves,* I told myself. Between my fingers, I looked at him, still talking to my mother and my sister. *He loves the watches and pearls and diamonds and stupid cufflinks,* I thought. *He loves them so much that he was ready to die for them and forget all about me.*

I asked to be excused. I went to the bathroom, closed the door, and cried until my mother came in and hugged me and told me not to worry. She said that there was nothing to be upset about because my father was fine.

That evening I began to hate the jewelry, hate it so much that for the rest of my life I could barely stand to look at it.

ONCE MY FATHER had removed each piece of safety deposit box jewelry from its velvet bag, he sat back, placed both palms on the table, and said, "Listen, David — there's something we need to discuss."

"OK."

"I recently had a conversation with Ezra."

"Uh, oh," I muttered.

Ezra was my father's accountant. Their relationship, professional and personal, went back many years. I had always despised his perpetual smarmy grin, his cloying, phony attentiveness. In a word, I didn't trust him. Lately, I'd become increasingly concerned because it seemed like every other time I called my father, Ezra was there. A month after my

mother died, my father informed me that he had made Ezra his execu-tor. He said it was too complicated a job for "an amateur" like me. "You don't know about those sorts of things," he had explained. "We both know you've always had your head in the clouds — I don't know where you get it from, but you don't have a practical bone in your body. And as for your sister, that's a whole other can of worms."

Now he tapped his forefinger on the table and said, "Ezra has made a suggestion. He suggests that before it's too late, each of you should choose which things you really want." He spread his arms to encompass the glittering display on the table. "Just a few things each, to take — you know — afterward." We both shifted uncomfortably on our chairs. "That way, there's no *tsuris* later. The rest you can split even-steven. *Fershtay?*"

"I *fershtay.*" Lately he had been dragging Yiddishisms out of moth-balls, something I attributed to the influence of Ezra, an observant Jew who tended to slide back and forth between languages.

"Now, as for your sister, she already has a list."

"Linda has a *list*?"

"Take it easy."

"When did she give you this list?"

"A while ago. What are you worried about?"

"I can't believe this. What's on it?"

He leaned forward, picked up a diamond and ruby brooch in the shape of a peacock, and put it to one side, like a chess player removing a piece from the board.

"That was Mom's!" I exclaimed, barely concealing my outrage. The brooch had been my mother's favorite piece of jewelry. To this day, I can-not picture her dressed for any special occasion without also seeing the brooch pinned to her dress.

"So, what?" he countered.

We both know Linda hated her, I wanted to reply, but didn't.

Instead, I asked, "What else?"

He removed two more pieces, one of which was also my moth-er's — her antique Cartier wristwatch. I'm no expert, but I had no doubt that Linda's choices would turn out to be extremely valuable.

"That's it?" I asked.

He took a ruby ring off the board. "That's it now," he replied.

"Fine," I said. "I'll take this . . ." I indicated my father's nineteenth-century Patek Philippe gold repeater pocket watch. Once, back when he wore it every day in the vest pocket of his suit, he told me what it was worth, so I knew that it could make things "even-steven" with my sister all by itself.

"And this . . ." I reached out and touched the icon.

"*That* you can't have," he said.

"What do you mean?"

"Like I said — you can't have it."

"Why not?"

"Because."

"Because, why?"

"Because it's already promised."

"*Promised?* To who? To Linda?"

"No. To Ezra."

"To *Ezra*?"

"That's right."

"You're giving the icon to *Ezra*?"

He shook his head. "Not giving. Selling. He's coming over for it later this week. I need to get the ball rolling."

I stared at him. He looked down and began fiddling with the pearl necklace. "He's always wanted it," he added.

"How much?" I asked. The words just popped out.

His head snapped up. "What?"

"How much is he paying you for it?"

"How much?"

"That's right — how much?"

"Let me think." He paused while his fingers twiddled with the pearls. "Forty-five hundred," he said.

"I'll give you forty-eight," I blurted out.

Where would I get forty-eight hundred dollars? Ginny and I barely had a thousand dollars in our checking account.

"I don't know . . ."

"Make it five," I said. "I'll give you five thousand."

His mouth fell open. He squinted at me from behind his bifocals, as if he were trying to figure out who I was.

Finally, he held up his palm. "All right, all right," he said.

"What?"

"You can have it."

"For five?"

"For nothing."

"What do you mean?"

"You can have it. It's yours. You don't have to pay me."

I exhaled. "Fine," I said.

"Fine," he said.

We stared at each other in silence for several seconds. Then, he said, "Fine," one more time, and started gathering up the jewelry.

When everything was back in the safe deposit box, I stood up and said, "I'll get Mr. Moses."

"Just a minute," he said. "Come over here."

I walked around the table and stood by his chair. He reached out, took my hand, and squeezed it with surprising force.

"Promise me something, Duvid."

"What is it?"

"Look at me."

"OK."

"It's your sister. You have to promise me that you'll take care of her after I'm gone."

"I don't know . . ."

"What?"

"I . . . I'm not . . ."

"Do you promise?" he interrupted. "You have to promise."

I hemmed and hawed, before muttering, "We'll see, Dad."

He let go of my hand.

"Anyway, she'll be fine," I said.

"No, she won't," he shot back.

I WALKED MY father back uptown to his apartment, said good-bye as soon as we got there, and headed home to our tiny place in Brooklyn Heights.

I lay down for an hour or so. I felt totally exhausted. Ginny was still at work. I couldn't wait for her to get home. She always helped me make

sense of my encounters with my father, whether she had been with me or not.

Over dinner that evening, I began with my irritation about Ezra, about how my father didn't trust me to be his executor. "Do you think I have my head in the clouds?" I asked her.

"David, how old are you?" And before I could answer, she said, "You've been taking care of yourself just fine, for what? Thirty years?"

"I know. But the thing is . . ."

"Besides," she said, "you're an artist — in the clouds is where your head *should* be."

I then recounted the rest of the conversation in the vault. Finally I said, "During that business about the icon he was looking at me like he didn't know who I was. I'm still not sure exactly what happened."

"I'll tell you what happened," she said, without hesitation. "For the first time ever, you spoke to your father in a language he truly understands."

"Meaning?"

"Meaning, you *negotiated* with him — toe to toe — like a fellow professional. As far as I know, you've never done that before."

"I kind of shocked myself."

"And him, too, it sounds like."

I nodded. It had suddenly occurred to me that during that exchange I'd felt something I'd never felt before. For that one moment, I felt like he and I were equals — even *steven*.

"No wonder he didn't recognize you," Ginny went on. "You were a David he'd never seen before. And here's what else happened — you got what you wanted. You got *your* price!"

"I *did*. I got it."

"Or, almost," she added, smiling.

"Huh?"

"The icon was yours for nothing. You thought the bargaining was over. And then . . ."

"He brought up that stuff about Linda."

"Yep. The thing to remember about your father is, he can't stop. Everything with him is a negotiation. The bargaining never ends. It's the

way he relates to the world. It's his first and last impulse in every situation. He can't help himself."

Ginny reached across the table and took my hand. "What have I always tried to tell you about the robbery?" she asked.

"That . . . that . . ." I raised my eyes to the ceiling. The cartoon lightbulb switched on above my head. I let the realization sink in: *He can't help himself.*

After a few seconds, I said, softly, "I *fershtay.*"

"What?" she asked.

"I understand."

"Good. Because it was never about whether he loved you. He wasn't thinking about you at all. He wasn't even thinking about the gun or about dying. He wasn't thinking, *period.* He was on autopilot — being Nat Sipress — doing what he always does . . ."

"Getting his price."

"Exactamundo."

"Omigod! It's my father!"

When I told the entire robbery story to my therapist for the first time, he surprised me by asking this question:

"Do you think that there are ways in which you're like your father?"

"What do you mean? No way. I'm nothing like him."

"Oh, yes?"

"Well, maybe just a little."

"Hmm."

"OK, you obviously have something in mind . . ."

"Do I?"

"So why don't you give me a for-instance."

"Why don't you give *me* a for-instance?"

"Of course," I mumbled.

"What?"

"Nothing."

Silence. Eventually, I said, "I've already talked to you about our similar fears about running out of money. And you could say that we both have a deep-seated resistance to change."

"Anything else?"

Another long pause while I ruminated. Finally, I said, "I guess there's the whole 'beautiful things' issue. The robbery wasn't the only reason I always hated the jewelry. I've always thought that his attachment to it, and all his 'beautiful things,' was shallow and materialistic. And yet . . ."

"Yes?"

"And yet, for years now, we've spent a good portion of our savings on our modest little collection of art, which I love. Every night when I come home I sit on the couch in our little apartment and gaze at the prints and drawings on the wall, and feel happy. Not that different, I suppose . . ."

"So, does that mean you also consider yourself someone who has an 'eye'?"

"Maybe not so much in the clothing department." I looked at my wrinkled, ink-stained khakis and ancient black T-shirt, and chuckled. "But, yes," I told him, "I would say I have an 'eye.' I know good art when I see it."

"What about his negotiating? Any similarities there?"

"Hardly. That's a compulsion, obviously — one that I clearly don't share. I'm a *terrible* negotiator. I avoid negotiation at all costs. My issues with deserving and self-worth — as you well know — always leave me at a disadvantage in any negotiation. And by the way, Nat Sipress never spent a millisecond worrying about stuff like self-worth."

"Are you sure?"

"From the day he was born he never spent a millisecond *working on his issues.* Whereas I have been in therapy . . . well . . . forever. In fact . . ."

"What?"

"Sorry. I just thought up a cartoon."

"Tell me."

I told him:

"He's still in therapy."

"This brings me back to your father's negotiating. You describe it as a compulsion. Would you say that . . ."

". . . that the way I think up cartoons here all the time is a compulsion?"

Long pause.

"What are you thinking, David?"

"I *can't* help it. I think of it as my cartoon brain, which I never shut off, even in the most inappropriate situations, like in yoga class . . ." I described this one:

"Why so downward facing, dog?"

He laughed.

"Or in the middle of an argument with Ginny . . .":

"Well, if it really doesn't matter who's right and who's
wrong, why don't I be right and you be wrong?"

We *both* laughed.

Nobody said anything for a minute or two. Finally, I sighed.
"What, David?"
"Is it a problem? Do you think that I use it to avoid stuff?"
"Do *you*?"

"How should I know what I think?
I'm not a mind reader."

Anger Mismanagement

ONE EVENING IN July 2018, Ginny and I were having dinner at a restaurant when a piece of steak got stuck in my throat. Gagging and coughing, I leapt to my feet, knocking over my chair and attracting the attention of everyone in the room. A man at a nearby table told Ginny he was a doctor. He took my arm and guided me outside to a bench in front of the restaurant. A waitress hurried out and handed me a glass of water, but when I tried to swallow, the water wouldn't go down. I started to panic. The doctor put his hand on my shoulder and assured me that the fact that I was still breathing meant that the obstruction wasn't in my windpipe. "It's only a matter of time before it makes its way down your digestive system," he explained, adding, "it has nowhere else to go. Keep trying to drink." Ginny was scared too, but she did her best

to keep both of us calm. However, after ten minutes of watching me continually gag as I made one futile attempt to swallow after another, she took out her phone to call an ambulance, and that was when a gulp of water finally went down, taking the piece of steak with it.

From that night on, if I cleared my throat, let alone coughed, at the dinner table, Ginny would immediately exhort me to slow down and finish chewing before I swallowed. My standard response to this perfectly reasonable request tended to be an angry look, and when she reacted to the look, to deny that I was angry, which only made her angrier.

This pattern continued until one evening when a bite of fusilli went down the wrong way. I coughed a couple of times to help it along and immediately flashed Ginny a preemptive scowl.

She shook her head. "*Why*, David?" she asked, "why, when I'm only concerned about you after what happened in that restaurant, would you get *angry*?"

"I . . ."

"Please," she held up her hand, "don't give me your standard denial. I'm asking you because I really want to understand."

I nodded and paused to give her question serious thought. That was when I remembered "Safety Songs."

"OK, listen," I said. "For my birthday — I think I was turning seven — my mother gave me a Victrola record player, and along with it, a record called "Safety Songs." It was a collection of tunes like 'Let the Ball Roll,' a ditty about never chasing a ball into the street. A similar one was called 'Look Both Ways.' And there was one about not putting stuff in your mouth that had me imagining germs crawling over just about everything in sight."

"So what does this have to do . . ."

"I'm getting there. One of my mother's favorites was 'Always Chew Before You Swallow.'"

"OK," Ginny sighed, "I see where this is going."

"No, wait! She learned to play all the Safety Songs on the piano and we would sing them together. The lyrics to the chewing one went something like, 'These are words we all must follow, always chew before you swallow . . .' And from then on, if I made the mistake of eating too fast . . ."

Ginny erupted: "What a shock! You're about to tell me that when I ask

you to slow down and chew carefully so you don't choke to death like you almost did . . ."

"It wasn't in my windpipe."

". . . *like you almost did . . .* you immediately conflate me with the woman who, as you never tire of telling me, nearly smothered you to death with her worrying. Thanks a lot."

"That's not what I'm saying . . ."

Once again, she held up her hand. She told me, "Here's the very last thing I'm going to say on the subject — *cut it out.*"

I felt the usual defensive urge tighten my chest and lift my shoulders, but I closed my eyes, took a breath, and surrendered. "I will," I mumbled. Ginny frowned, so I repeated with more conviction, *"I will."*

"Until the next time," Ginny muttered. She picked up her fork. "Just eat your pasta, and please, *take . . . your . . . time.*"

"I will," I said for the third time, and then I reached for her hand. "I'm sorry, Ginny," I said, "and I promise — *really* promise — from now on, I won't conflate."

"Uh, huh."

THE EFFECT OF Safety Songs on me was not unlike the effect on me of the duck-and-cover nuclear attack exercises we practiced in school — it made me feel *unsafe.* The message of every Safety Song was the same: The world is a dangerous place, so be very, very careful, and whatever you do, don't take risks. All in all, I'm convinced that the record played a not inconsiderable part in fomenting the anxiety that has been the subject of so many of my cartoons, going back to my earliest published efforts:

But Safety Songs wasn't the only problem. There was also my mother's aforementioned perpetual worrying. When I was little, she worried that I would fall off the jungle gym, that I would get hit in the eye by a baseball, that I would be run over, that I would slip and fall onto the subway tracks, that I would be too hot and get sick, that I would be too cold and get sick.

"Are you sure you're warm enough, dear?"

When I was six, she decided, without any evidence, that I was having trouble seeing. She took me to the eye doctor, who declared my vision perfect. Undeterred, she got me a pair of glasses, "just in case." I never wore them.

The worrying didn't abate when I was a teenager, and the perpetual nervousness it created gradually morphed into a tight knot of resentment in the middle of my chest; remembering how embarrassing and infuriating it all was sparked a drawing from the 1990s, around the time cell phones started to appear everywhere.

But what I came to resent even more than the worrying was my mother's prying and snooping. Like every kid with a nosy mother, I felt trapped and invaded much of the time. The constant threat of stop and frisk forced me to routinely check my pockets for evidence — candy wrappers, cigarettes, etc. — before I walked in the door. Throughout my

childhood and into adolescence, my mother insisted on knowing exactly where I was going every time I left the house, who I was going to meet, what I would be doing, how long I would be there. She wanted me to call her at least once while I was out. Buoyed by my early success with lying, as a teenager I took to lying about my whereabouts as a matter of course — if I was going to a party, I would say I was going to the movies; if I was going to the movies, I would say I was going to a party — all just to give myself the illusion of freedom.

The surveillance at home was unrelenting. She insisted that I keep the door to my bedroom open. And she regularly listened to my phone calls on the extension. By the time I was in ninth grade, I was making most of my calls from the pay phone on the corner of Seventy-Ninth and Columbus. I didn't mind all that much, since this also offered an opportunity to smoke a cigarette. But there wasn't much I could do about the incoming calls. In high school I started hanging out with a crowd of not-so-good boys who were still much-too-good boys to do anything more illicit than make prank phone calls, arrange bogus deliveries to people we hated, and toss wads of wet toilet paper out apartment windows in

the hopes of hitting a convertible. At one point in ninth grade, an urban legend made the rounds that smoking a cigarette soaked in the popular men's cologne Canoe could get you high; we gave it our best shot, but only managed to make ourselves sick; the bravest among us abused Dexedrine nasal inhalers, with a similar non-result. We hung out with girls and played poker at the basketball courts on Riverside Drive; I regularly stole the money for my stake from my father's wad of bills while he was eating dinner. One member of our crowd achieved real notoriety when he dropped a box of Salvo detergent tablets into the Plaza fountain, flooding Fifth Avenue with soap suds. There was a picture in the *Daily News.*

One afternoon I got home from school and couldn't find my wallet containing my subway pass and allowance. A classmate who was in our bad-boy contingent, and one of my best friends, called gleefully to tell me that he had stolen it. We both knew he had no intention of keeping the wallet — he was calling to tease me, and to brag about how he had deftly lifted it from my jacket pocket on the subway ride home from school without my suspecting. Halfway into the phone call I realized that my mother was listening on the extension. I hung up and rushed to her bedroom just as she was about to call the principal of Horace Mann to report my friend. I begged and pleaded with her not to do it, and when she kept on dialing, I screamed at the top of my lungs that I wanted to die — which finally made her stop.

This may have been the only instance in my childhood — perhaps in my entire life — that I openly expressed anger to my mother. Fighting with her was my sister's department. My mother made it abundantly clear that she and my father had their hands full with Linda, who was now a junior at Vassar. My mother complained that she called my father several times a week, "at all hours, wanting advice about every little thing and keeping him on the phone until God knows when." She worried that Linda was upsetting him "with every little problem." Linda came home now and then on the weekends, and always on her breaks; when she wasn't out with friends, she stayed in her room all day with the door closed until my father came home in the evening. She and my mother fought less than they had when Linda was in high school, but when they did, their battles were ferocious. They argued about all kinds

of things, but the fights I recall most vividly were about my father and how much Linda was "taking advantage of his good nature." The arguments usually ended when Linda screamed so loudly that my mother, worried about the neighbors, had to walk away.

So, my job was to be a good boy, never argue, and *never* do or say anything that would have to be reported up the chain of command. Here's a comic I drew for no other reason than to help me remember how arguments with her usually went:

Neither of us wanted *that* to happen, so I would swallow my anger and comfort myself by drawing oblique revenge fantasies involving my leading an army into battle brandishing all kinds of scary sword and gun combination weaponry while my fighter jets and B-52 bombers attacked from the sky. Once, when my mother caught me in a lie, she

threatened to tell my father and then said the only thing stopping her was "all the *mishegas* your father has on his plate right now concerning your sister." Back in my room I furiously drew all the food items I hated most — chopped liver, canned peas, baked apple, fish (any kind) — all mushed up together in a big dish. Across the top I scrawled: "MISHE-GAS ON A PLATE."

Unsurprisingly, all that unexpressed anger had long-term, future relationship repercussions:

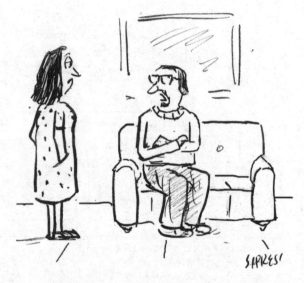

"I'm not conflict averse. I simply prefer to keep my anger to myself."

There was certainly nothing in my upbringing to demonstrate to me that anger was an ordinary, normal part of a healthy relationship. Linda's rages in those battles with my mother were more like scary, out-of-control fits, and far from ordinary. My father, on the other hand, almost never got angry around us; I mainly remember him losing his temper with strangers. And he and my mother simply didn't argue. I can only recall them having one serious fight — an argument about my mother's mother, whom we called Granny.

Granny moved in with us after the death of my grandfather, whose name was Ben, and stayed for a little over two years. Granny was tiny

and huge at the same time. No taller than her diminutive daughter, she must have weighed two hundred fifty pounds. The reason she moved in with us was the crippling arthritis in her overburdened knees that left her unable to manage on her own after the death of her husband. What was truly remarkable to the little-boy me was the size of her breasts. They took up the entire front of her upper body, and when I was very young I thought they were some kind of valise, because she carried everything she needed in there, pulling out at any given moment balled-up tissues, dollar bills, lists, even snacks.

Unlike my father, who never spoke about his mother or anyone else in his family, my mother would talk fondly to me about growing up with her parents in a small town in New Jersey with the wonderful name of Mount Freedom. Granny and my grandfather, whom I barely remember, arrived in this country from Vienna in the 1890s. Ben was in the clothing business and Granny was a housewife. They were comfortably middle class, and although neither had a college education, they made sure that their only daughter did. My mother graduated from Teachers College in 1926.

It was always apparent to me that my mother loved her mother. On the other hand, my father — there's no other way to say it — appeared to hate Granny. Granny never said much, but when something did come out of her mouth, it was often a complaint or criticism, and from the faces my father made, it was clear these comments irritated him no end. Apparently there was another thing he held against her, as I learned in a conversation I had with my father in 1995, around the time of my mother's death. "She didn't think I was good enough for her daughter," he told me.

"Good enough?" I asked.

"As if we didn't have enough trouble with prejudice already, fancy Jews from Vienna and the like looked down their noses at the rest of us."

Once in a while, when she was out of earshot, my father would make fun of Granny's weight. Although she never said anything, I could tell that this really upset my mother. Years before she met my father, while she was teaching first-graders in the New York City school system, my mother revealingly recreated her own version of a children's book written in the thirties called *The Plump Pig*. It's the story of a plump pig who

was constantly ridiculed by the other animals on the farm. But then a plump family, with a plump father, a plump mother, and two plump children, arrives at the farm. They immediately fall in love with the plump pig and decide to adopt him. They all live happily ever after. Here is one of my mother's wonderful illustrations:

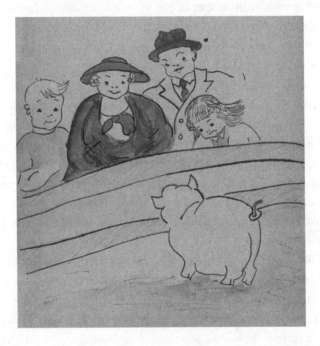

Then came the night I was awakened by something I'd never heard before: the sound of my parents screaming at each other behind the closed door of their bedroom. The next morning my mother was sequestered in the dark with a migraine. That headache lasted four days, at the end of which she emerged from her bedroom and joined us at the dinner table, where my father announced that Granny was moving across the street to a studio apartment in a residential hotel called the Clifton. Granny theatrically extricated a tissue from her bosom and wiped away a tear. The Clifton, apropos of nothing, had a famous Hungarian restaurant in the basement where I first tasted schnitzel and goulash, and where Granny ate dinner on the few nights a week when she didn't have dinner with us. She lived at the Clifton until her death while I was in college. Once she moved out, I never heard my parents argue about

her, or anything else, again, despite the fact that my father would grumble every now and then that her apartment at the Clifton was costing him an arm and a leg.

Ginny has some interesting expressions from her Southern upbringing, several involving food. For example, if she's served a piece of meat that's too rare she complains, "I've seen cows hurt worse than that get well." And if she tastes something particularly delicious she might say, "It's so good it makes you want to kick your grandma." Every time she comes out with that one, I immediately see my father at the dinner table, giving Granny the hairy eyeball when he thought no one was watching, looking for all the world like he wanted to give her a kick.

When I recall my father looking at Granny that way, I sometimes wonder whether someone from the past was in the back of his mind — in other words, *was he doing a bit of conflating of his own?*

NOW THAT I'VE gone on about my mother's suffocating worrying and infuriating snooping, it's time I told one more *nice* story about her — this one from the next to last year of her life.

On Thanksgiving that year Ginny and I went to my parents' apartment for turkey dinner. My mother's short-term memory loss was more or less complete, but she insisted on making the meal. We arrived at their apartment around two in the afternoon. I found my mother in the kitchen, standing motionless at the counter, staring down into a half-filled plastic bowl.

"Oh, good," she said when I came in and kissed her, "you're still here. Come and look." She pointed to the bowl. "I can't remember what's in here."

I inspected the contents and started to ask her some questions to prompt her memory. "Just a second," she said, walking across to the oven and opening it. "I forgot to baste the turkey."

"What time did you put it in? I don't smell anything."

"I'm not sure," she replied. "Ask your father." She shut the oven door.

I went into the living room, where my father was talking to Ginny and Linda.

"What time did she put the turkey in?" I asked him.

"This morning, around eleven. I turned on the oven for her — three hundred and fifty degrees."

"Weird," I said, and I returned to the kitchen. Less than a minute had gone by. The oven door was wide open again. I started to say something, but my mother held up her hand.

"Just a second," she said, "I forgot to baste the turkey."

When I pulled the whitish bird out of the tepid oven, everyone came in to see. "Mom's been basting . . . *a lot*," I explained softly, "like every two minutes."

"So much for three hundred and fifty degrees," my father grumbled. He put his hand on the stove. "Practically ice cold," he reported, unnecessarily.

"No wonder we didn't smell anything," Linda said.

"What are we supposed to do now?" asked my father.

"I know what we'll do," my mother said. She took my wife's hand in hers and said, "In honor of Ginny, this year we'll celebrate Christmas."

"What in God's name does that have to do with the price of eggs?" my father groaned, arms outstretched, eyes raised to Heaven.

"By then, maybe it will be done," she told him.

Never Again

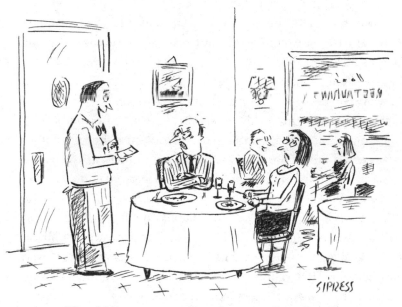

"Can I bring you something else to complain about?"

O N FATHER'S DAY my father got to choose where to have a special lunch, and for years he insisted on Gitlitz, a delicatessen on Seventy-Seventh and Broadway. Gitlitz is long gone, but fifty years ago it was a popular neighborhood restaurant that served excellent kosher fare. My father didn't choose Gitlitz for the food, however. He chose it for the arguing.

The last Father's Day that we ever went to Gitlitz, I was eleven. Walking down Broadway, my father was setting a brisk pace, and my mother

and I were having trouble keeping up. I was sweating like crazy under my sports jacket.

"Do you think she'll be there?" I whispered to my mother.

My mother shrugged.

When we walked into the restaurant, we immediately saw her — my father's battle-hardened nemesis, a waitress named Irene. She was standing in back by the kitchen, a cigarette dangling from her mouth, one hand on her hip, the other primping her rust-colored, tightly curled hair helmet. She and my father locked eyes, like two gunslingers stepping onto a dusty street.

"There she blows," my father muttered.

"Try not to excite yourself, Nat," my mother said.

It was still early. The restaurant was nearly empty. The manager showed us to our table and gave us menus. "We know what we want," my father said, handing them back.

"Irene will be right with you," the manager told us.

Irene took her time. She messed around with her pad and pencil, said a few words to the counter man — about my father, no doubt — and took one last puff of her cigarette before jamming it into an ashtray.

"It's about time," my father said when she arrived at our table.

"*Nat*," my mother pleaded.

Irene was a tall, middle-aged woman with long, freckled arms and a stiff, pointy bust. Her powdered face was ghostly white; her lipstick was the color of a maraschino cherry. She had pale-gray eyes that were very close together. Her skinny, dark eyebrows were carefully drawn with a pencil somewhere near the middle of her forehead.

"Well, look who's here," she said in her smoker's voice. "My favorite customer."

She smiled, her lips forming an inverted triangle that activated deep half-moon creases on either side of her mouth but left the rest of her face untouched.

"Happy Father's Day," she added.

"Never mind," my father said.

She greeted my mother and gave me a wink.

"Anything to drink?" she asked.

My father ordered Cel-Ray tonics for himself and my mother, and a

Coke for me. When the waitress walked away, he called, "Just a minute! We'd like to order."

"I'll bring you menus," she replied, without turning around.

"We don't need . . ."

But she was already at the deli counter.

"Bitch."

"Please, Nat."

When she returned with the sodas and the menus, my father put his hand around the Cel-Ray tonic bottle. "This is warm," he said. "Bring me a cold one."

"They're all the same temperature," Irene said. "So, what are we eating today? Do you need a minute?"

"Take mine," my mother said, switching sodas with my father. "Mine is very cold. And there's plenty of ice in your glass."

"I want . . ."

"*Please*, Nat."

He ordered me a hot dog.

"And French fries," I said.

"No," my mother said. "You had French fries yesterday."

"Make sure his hot dog's well done," my father told Irene. "He likes it crunchy."

"Sauerkraut?" she asked me.

"Yes, please," I replied.

"That will be extra," she said.

"*What?*" my father said, nearly shouting. Heads turned. I wanted to slide under the table.

"Just kidding," Irene said, winking at me again.

My mother ordered a turkey sandwich with Russian dressing, and my father, a corned beef on rye with coleslaw.

"Lean," he told the waitress.

"Extra-lean corned beef," she said.

"No," he said firmly. "Not extra-lean. Just lean."

"I'll see what I can do," she countered.

Here we go, I thought.

"Extra-lean costs extra," he said. "I want *plain* lean."

"I *said*, I'll see what I can do."

"Just do it," he said. "And there's no need to get nasty."

"Tell that to yourself."

"Wait just one minute . . ."

She left.

"She's got some nerve," my father said. And then, louder, "Some *god-damn* nerve!"

"Nat, you are going to give yourself a coronary," my mother said.

"It's all right, Estelle," he responded, his eyes fixed on the waitress. "I know what I'm doing."

By now, my stomach was in a total uproar. My father never lost his temper at home, never raised his voice or cursed. My mother did all the getting upset, all the yelling and scolding. Shielding Nat from upset was, as I've said, family priority No. 1.

Irene brought our sandwiches. My father lifted his top piece of bread. Nobody was surprised when he said, "You call this lean? It's loaded with fat."

"You didn't want extra-lean." She was still smiling and looking right at him.

"That's right. I wanted *lean*. Lean means lean. Not like this."

"Listen. You got two choices. You can have this, or extra-lean. There is no in between."

"So, you're a poet," my father said, mocking her. "What ever happened to 'The customer is always right'?"

"That only goes for customers who act like human beings."

"You listen to me, young lady . . ."

"Don't you 'young lady' me, smart guy."

My father's ears had turned bright red. "How dare you. You know what? You can take your extra-lean and . . ."

"Nat!"

Irene looked at my mother and smirked. She walked away.

"And where's my coleslaw?" he called after her.

"Get it yourself!" she shouted over her shoulder.

"Goddamn bitch!"

"Please, Nat. Everyone is looking."

"I just want my damn coleslaw."

"I'll get it," my mother said.

"And I bet she still expects a tip," he muttered.

"I have to go to the ladies' anyway, Nat. When I get back, I expect you to be calm."

We watched her cross the restaurant — tiny in her black dress and heels. She stopped to have a word with the manager on her way to the bathroom.

"Your mother doesn't like it when I get angry," my father said. He reached over and put his hand on my arm. "Don't worry. Maybe I'm also having a little fun."

He pulled on his moustache and looked up at the ceiling. "It's the golden rule," he said. "The customer is always right." He took off his glasses and rubbed his eyes. "Some of my customers I've had for over twenty years. I've sold them everything from their wedding rings to their silver tea service. I know the year they got married, I know the names of their children, what schools their children go to, where they go for the summer in Maine, how many rooms in their penthouse, the names of their maids and their doormen, the names of their dogs and cats. And in twenty years, they don't ask me a single question about myself. When I see them on the street, they look right through me." He reached over again and held my wrist. "But here is what matters, David: when they come into the shop, I treat them like kings and queens, even when I want to leap across the counter and wring their necks. Why? Because the customer is always right. *Always*. Do you understand?"

I did.

"You have to learn to live with things."

I nodded.

"When I'm sitting at this table, I'm the one in charge and she works for me," he said, with a sideways nod in Irene's direction. "The days are long gone when I had to take a bunch of *drek* from some nobody of a waitress. And here's one more thing — I went through the Depression. Nobody got tips in the Depression. Nobody expected them. You got paid, *period*. Why should you get something extra, just for being nice? It's your job to be nice. Understand?"

"Yes." At age eleven, this made perfect sense to me. As an adult, every time I left a restaurant with my parents I had to pretend that I'd forgotten something so I could rush back in and put more money on the table.

"You know that I love you," he said. "I'm sorry if I went a little over-board. Go ahead and finish your hot dog."

My mother returned and sat down. "Your face is all sweaty, Nat," she told him. She wiped his forehead with her napkin. "I spoke to the manager. He is going to wait on us now. Here he comes with your coleslaw."

"I'm sorry," my father said.

As we were leaving the restaurant, we walked past a smiling Irene, standing behind the deli counter. "Happy Father's Day, *Dad*!" she hissed.

"Go to hell," my father shot back. Then he looked at me and grinned.

"Never again," my mother said when we stepped outside.

THE OTHER PERSON who was a regular target of my father's wrath was the tailor who made his suits. Twice a year, the tailor arrived at our apartment in the evening to take measurements and discuss fabric, then came back a week or two later for the fitting, and eventually returned with the finished product.

"He costs me a fortune," my father said to me on more than one occasion, "but there's nothing like custom made. Never forget, David —*clothes make the man.*"

I can't recall the tailor's name, but I always had the feeling he and

my father went way back. A short, thin, elegant man with a full head of black hair, the tailor was all business. Although he was younger than my father, his face had a careworn look, and he had a pronounced limp and walked with a stick, all of which made him seem older. I can still see him, kneeling awkwardly on the carpet in my parents' bedroom with his measuring tape, his lips brimming with pins, while my father stood in knee-length black socks, sleeveless undershirt, and ballooning, boxer-style underpants (these, like his pants, he wore hiked up to his navel), imperiously eyeing the tailor's every move.

Each time the tailor came, I waited in my room for the inevitable, dreaded explosion. When it came, it always began with my father raising his voice and berating the tailor about something he maintained was different from what had been promised, or how long everything was taking, or something else. The tailor never raised his voice, and, as far as I could tell, unlike Irene the waitress, he never gave as good as he got.

Once, when he accidentally (who knows?) stuck my father with a pin, my father really let him have it. This was followed by a dispute about the bill, during which my father called the tailor a "goddamn *momzer*," among other things. (I asked my mother what a *momzer* was — she claimed not to know.) When the fitting was over, I stood beside my mother at the front door as the tailor left. As he limped past us, she mouthed a silent apology. He smiled, shook his head, and said, quietly, "Never again."

"But what about Daddy's suits?" I asked her, after he'd gone down in the elevator.

"He says that every time," she told me.

Many years later, while I was living in Boston, a woman I was dating invited me for dinner. She wanted to introduce me to a few of her friends. One of the friends, a young woman, asked me how I spelled my last name. When I told her, she inquired, "Are you any relation to Nat Sipress, the jeweler?"

"He's my father," I said. "Why?"

"My uncle was his tailor."

"Oh, no," I said, "I'm so sorry."

She told me her uncle, who had recently died, often talked about my father, about all the yelling and abuse.

I apologized again.

"Not to worry," she assured me. "He always said your father was one of his best customers."

"Is that why he put up with it? I mean, he never fought back."

"He was pretty mild-mannered. And I think he believed that the customer is always right."

I nodded. That sounded familiar.

"I guess maybe he'd put up with worse in his life," she added. "Did you notice his limp?"

"Of course. Was it polio?"

"Battle of the Bulge," she said. "They gave him the Bronze Star for bravery."

Resistance Movements

"I'M THINKING ABOUT that weird thing he did in restaurants."

Ginny said this as we were having breakfast one morning in 2017. What had started the conversation was the email I had received moments before from my doctor with the lab results from my annual physical. She reported that all my test results were in the normal range EX CEPT (her caps) for one, and in order to find out whether this was really a problem, she instructed me to "INCREASE YOUR INTAKE OF WATER" and come back in a month to recheck.

"What do I always tell you?" Ginny asked. It was barely seven o'clock, and she was already working on her third glass of seltzer.

"At least eight glasses a day."

"How many glasses did you drink yesterday?"

"I don't know," I mumbled, staring into my espresso. "At least two."

I went to the kitchen sink, filled a tall glass, and drank it down in one shot. I'm easily scared by doctors.

"Seven more to go," I said when I returned to the table. "The problem is, water is just so boring. I could care less about it."

"You get this resistance to it from your father," Ginny announced. "I never saw him drink a glass of water."

It was true. My father drank black coffee at breakfast, black coffee all day at the shop, a glass of beer with dinner at home, a last cup of black coffee after dinner, a scotch on the rocks at dinner out. Never water.

"He had a strange aversion to water," Ginny said.

As soon we sat down in a restaurant, my father would call over the waiter and demand the removal of the water glasses, angrily waving away the offending goblets as if the waiter should have known better than to put them there in the first place. "Nobody here wants water," he'd inform the perplexed server, deciding for the rest of us.

"Nobody ever objected," Ginny said. "I guess it would have been too embarrassing."

"It wasn't that. Something in his face told you that objecting was not an option. Even asking him why felt dangerous."

"What was that all about?" Ginny wondered. She thought for a moment and then said, "It reminds me of my parents' issue with fresh vegetables."

Ginny grew up in Birmingham, Alabama. Her father, a Methodist minister, and her mother, a housewife, were only a generation removed from growing their own peas and carrots. She'd told me how her parents thought that shopping at a farmers' market was lower class, preferring instead the frozen or canned vegetables from the supermarket.

"They considered fresh vegetables poor people's food," Ginny explained. "Maybe your father was too proud to drink water."

This explanation instantly felt right — in line with a number of other "weird things" about my thoroughly assimilated father. There was his steadfast refusal as an adult to set foot in Brooklyn (except for that game at Ebbets Field in 1955), the borough where he and his family had settled upon their arrival from Russia and that it seemed held only memories of hardship and poverty for him. There was also that aversion to taking the subway because it reminded him of his long-ago journey across the Atlantic in steerage. He insisted that my mother serve meat or fish at every meal — never chicken, which he associated with the impoverished old days. After my mother died and he was living alone, there was no one to cook for him on Maeve's day off. (I don't remember him ever entering the kitchen himself, except to ask how long until dinner.) No matter how many times I suggested that he order takeout, the answer was always the same: "Forget it — the neighbors would see. Getting food delivered is for people who can't afford to go to a restaurant."

"You're right," I told Ginny. "The thing with water had to be about the past — meaning, poverty."

We talked about how we both also harbor aversions to certain things because they remind us of difficult aspects of childhood. "For me, it's definitely organized religion," Ginny offered, without hesitation.

With its tradition of itinerant clergy known as circuit riders, Methodist ministers like Ginny's father were reassigned to a new church every two years. For Ginny this meant the unhappy prospect of moving from parish house to parish house across North Alabama and never feeling at home anyplace she lived. Every two years she had to change schools and make new friends. She spent every Sunday of her childhood in church and at Bible study, and every summer in church camp, where she despaired over her failure to have the expected "mountaintop experience," the moment of religious revelation that every other kid claimed to have had at least one time during the summer.

Once, when she was a young teenager, her father brought her to a dentist in Birmingham to have her wisdom teeth extracted. When she was lying in the chair, completely helpless and terrified, unable to move, her mouth pried open and numb, the dentist leaned down, forceps at the ready, and whispered in her ear, "Have you accepted Christ as your personal savior?"

"As for you," Ginny said, grinning, "I can think of one of yours in particular."

"Here we go . . ."

"You still hate being told what to do."

Except by doctors, it seems. Since that morning's unsatisfactory test results, I've changed my ways in the water department. I'm rarely without a glass or a bottle of water in my hand, from the time I wake up until the time I go to bed.

"So, from now on, I won't have to tell you what to do when it comes to drinking water?" Ginny asked.

"As of this moment, I'm a changed man."

However, as with so many things in life, this change for the better comes with a price:

"Have you considered sleeping in the bathroom?"

MY HATING BEING told what to do is perhaps a product of all the years I spent enduring my father's and mother's indiscriminate use of that tyrannical tenet of parental discipline — *Because I said so.*

As in: Why do I have to wear a jacket and tie to go to a friend's house for a birthday party when nobody else will? *Because I said so.* Why do I have to eat liver if I hate it? *Because I said so.* Why can't I watch *American Bandstand*? *Because I said so.* Why do I have to wait a whole hour to swim after lunch when the other kids only have to wait half an hour? *Because I said so.* Why do I have to be the one to help Granny across the street to her apartment every night? *Because I said so.* Why do I have to carry her pocketbook for her when all the boys on the block point and make fun of me? *Because I said so.* Why can't I buy things I want with my own allowance? *Because I said so.* Why is touching yourself down there bad for you? *Because I said so.* Why does Linda get to talk back at the dinner table and I don't? *Because I said so.*

On and on.

With so much resentment about all of that lurking in dark corners of my subconscious, it's perhaps not surprising that I preemptively and inappropriately get my back up when I'm told what to do. One day

perhaps I'll grow up, but as it stands, I still see versions of Nat and/or Estelle Sipress in all kinds of well-meaning, as well as not-so-well-meaning, authority figures — teachers, bosses, editors, senators, presidents, etc. (The list, as I've already mentioned, includes doctors and, last but not least, my wife.)

On one occasion (I'm hoping the statute of limitations has long since expired on this) my tendency to resist authority nearly got me into serious trouble.

My college, Williams College, was an all-male school until the year after I left. During my junior and senior years, I spent a lot of time at Bennington, the women's school seventeen miles north in Vermont. I would often hitchhike there from Williamstown, hang out until just before the midnight curfew, and catch a ride home with friends.

One night at the end of my senior year, I visited my on-again, off-again girlfriend at Bennington for the last time — she and I were both graduating in a matter of days and would be going our separate ways. I left her dorm a little past 11:30, feeling unsettled, confused, and a little angry at her for how cheerful she had been, even though our decision was mutual. I had arranged a ride home with a classmate and was making my way to the parking lot where he was no doubt waiting when I realized I had left a notebook in my girlfriend's room. I glanced at my watch — I had plenty of time before the curfew to go back and get it. I turned around and took a shortcut through a dark path at the back of another dorm, when suddenly an elderly night watchman — famous for his harassment of male visitors — literally leaped out from behind a bush. He held up one hand, shined his flashlight in my face, and barked, "You there, stop! Where do you think you're going?"

He was about my height and very skinny. He had on khaki trousers and a khaki short-sleeve shirt with cloth shoulder boards. His arms looked like leathery twigs. He wore a faded Yankees cap, and I remember thinking, *You don't see a lot of those around here.* There was a chain around his neck, at the end of which dangled a clock that looked like a giant pocket watch with a white face and big black numbers.

I started to explain about the notebook, but he was having none of it. "It's midnight," he told me. "You need to leave right now."

Again, I tried to explain, but he insisted again that I was breaking the curfew.

I checked my watch and then I pointed to his clock, which read 11:40. "Look," I said, "it's right there — I still have twenty minutes."

He said, "It's midnight, fella, and you need turn the hell around."

"It's 11:40!" I insisted. "Just look at it."

"I don't need to look at it."

"How can it be midnight when that clock of yours says it's not?"

"It's midnight," he replied, *"because I said so."*

Something snapped. I experienced what I had only read about in books — I saw red. In a flash, the good boy I'd always been stepped to one side to make room for an enraged thug who reached out with both arms, hissed, "It's not fucking midnight," and shoved the old man hard, sending him backward into the bushes.

Then, I ran. I raced across the campus, only stopping partway down the college drive, where I stepped into the woods and hid, expecting the campus police to come after me, or even the real police to arrive, sirens blaring. After ten minutes or so when nothing happened, I peeked around a tree and I saw headlights approaching from the campus. I recognized my friend's red Dodge Dart and waved him down just in time. For the next few days, right up until graduation, I fully expected to be arrested. I saw my entire future going down the drain. But nothing like that ever happened.

As for my notebook, my now ex-girlfriend put it in the mail, but by the time it was delivered to Williams I was long gone, so the college forwarded it to my parents' address. I had no doubt that my mother would read it from cover to cover, but fortunately it contained nothing more incriminating than a few random pencil sketches and some musings for a paper I'd nearly finished — the last of my college career — on nineteenth-century Russian resistance movements.

ONCE, AFTER I told this story to my therapist, he asked me if it was possible that my relationship to authority figures was a bit more complex than the story indicated. I just shrugged, but the next day, while sitting at my desk searching for cartoon ideas, I wound up drawing this:

Comedy

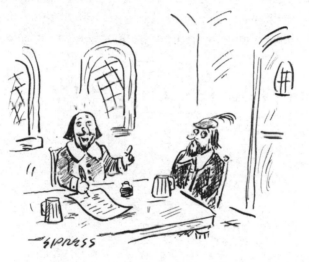

"Instead of a three-hour play with twenty performers, what about a single performer, alone on stage, telling jokes for thirty minutes?"

IT'S MY JUNIOR year at Horace Mann. I have just walked out onto the stage at the weekly all-school assembly. I am about to embark on my first and, as it happens, last attempt at stand-up comedy. In my right hand, cover facing out so everyone can see, is a copy of *Moby Dick*, required reading for every one of my fellow eleventh graders. There is a small table in the center of the stage, and on it sits a red rotary phone. I place *Moby Dick* down next to the phone. Then, I begin pacing around and around the table, growing more and more agitated, now and then

stopping to glare at the phone; each time I stop, random nervous chuckles break out at various locations around the auditorium. Now I stand perfectly still, facing the audience, arms held stiffly at my sides, my fists clenched, eyes squeezed shut, my face a frozen, frustrated grimace. I wait. I can feel the audience's anticipation, and this excites me no end. I feel powerful and in control, the way I felt in the days I sported a pair of six-guns, only better — I'm holding an entire auditorium of boys in the palm of my hand.

Finally, I think, *finally . . . everyone is paying attention to me.*

I make the wait last and last, drawing it out until I sense the time is just right, which is when I open my eyes, gaze up at the ceiling, then down at the phone, stamp my foot on the floor boards and scream . . .

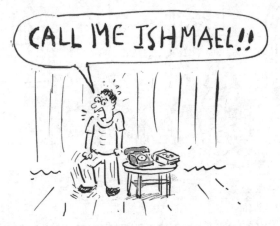

The auditorium explodes. Everyone is laughing, even the teachers standing at the back, and everyone goes on laughing as I smile and nod. I'm as happy as I've ever been.

Comic timing, I had just discovered, is a powerful tool that can take an audience where you want it to go. My stand-up career would be short-lived, but in my future career as a cartoonist, this lesson would be equally relevant. On the page, like on the stage, comic timing is intrinsic to the work. It lives in the space between the caption and the drawing. The reader cannot look at the drawing and the caption at the same time; the first choice is almost always the drawing. The eyes take in the image and register it. For a tiny beat, the brain asks itself, "What's coming

next?" Then, the eyes lower and read the caption, and what comes after that, the cartoonist hopes, is a smile or, best case, an out-loud guffaw.

Voilà! Comic timing.

I am often asked which comes first, the caption or the image? Sometimes it's one, sometimes it's the other, and sometimes they happen simultaneously. But when the drawing comes first, the cartoon tends to unfold for the cartoonist much the same way it will eventually unfold for the reader — it just takes a little longer. For example, several years ago, I sat down at my desk one day and drew this:

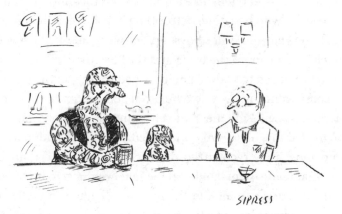

I tacked the drawing to my bulletin board and stared at it all morning. I knew there was a joke in the drawing, but for the life of me, I couldn't figure out what it was. I took a break, went out for coffee, returned, looked at the drawing for a while, looked away, and then ... *bam!* I had the caption:

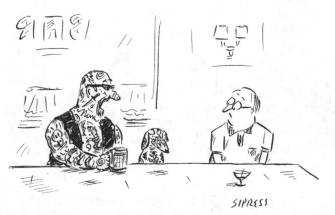

"I ran out of room."

And, as has been the case with many other cartoons that developed in this two-part, time-delayed, surprise-ending fashion, *"I ran out of room"* made *me* laugh, almost as if the cartoon wasn't my doing at all, as if it had thought *itself* up.

A second lesson I learned during my stand-up gig was about the source of the jokes themselves. That morning I told jokes about going to an all-boys school and being scared of girls; about how many members of our football team were out for the year due to nose jobs; about the mother who wouldn't permit her son to wear tab collars or tapered pants because he would look like a hood; about the mother who always seemed to know who had done better than her son on a final exam, and also precisely what the other boys' grades were; about the father who tried to tell his son about the birds and the bees years after the boy had learned all he needed to know from informed sources at the playground. All this came from my own, lived experience — from a very personal, even private, place inside me; and yet, to my amazement, hundreds of boys laughed at the jokes — *really* laughed. I suddenly understood what was happening: They recognized themselves in me, and that recognition was what made them laugh. All I would ever have to do to come up with funny ideas was to look in the mirror — laugh at myself. In fact, I now had my own golden rule: the more personal the joke, the bigger the laugh.

"Don't forget to call it a 'procedure'—makes it less scary."

It's always been a huge relief to know that the only place I need to search for ideas when I sit down at my desk is my personal reservoir of thoughts and feelings. I draw and write about what makes me mad, what I think is stupid, what confuses me, frustrates me, worries me, and above all, what makes me anxious. It's a weird kind of sharing, to use that awful word, but it's worked for me from my eleventh-grade stand-up routine until now.

IN 2018, GINNY and I decided that we would try meditation to manage our anxiety — but in my case I hoped not *too* much, my anxiety being my most dependable source of ideas. I hadn't needed to worry — even as I sat meditating, the cartoons were inappropriately flooding my chronically un-centered brain:

"Right now I'm thinking about not thinking about thinking about not thinking. Is that correct?"

And that, for better or worse, seems to be the way I like it.

"A Young Man Has Been Taken Into Custody..."

"Due to an incident at the Bergen Street Station, everything has changed and nothing will ever be the same."

WHEN I ASK people my age how they heard that President Kennedy had been shot, most tell some version of the same story: They are in school, in class, the principal enters the room looking shaken and pale, he or she walks over to the teacher, whispers something in the teacher's ear, the teacher's eyes well up, the terrible announcement is made, and everyone is sent home.

This would have been my story as well — I was sixteen then — but on that Friday morning I was excused from school early for a doctor's appointment. I had lots of doctor's appointments — not that there was

anything actually wrong with me — my mother was always taking me to some doctor or another on the *chance* that something was wrong, something she hadn't discovered yet, and it was better to catch whatever it was before it got worse. I really didn't mind all that much, if a doctor's visit meant skipping half a day of school.

Things were normal when I got on the subway at Van Cortlandt Park for the forty-five-minute ride home. There were just a few passengers reading their newspapers or staring into space. But at 168th Street, a large crowd — far too many people for late morning — streamed through the doors. Several were crying. One lady in tears made an announcement to the entire car that the president had been shot. People were frantic, shouting questions at each other. Nobody had answers. Everyone looked frightened. I felt scared and alone. As we headed downtown, this scene was repeated at every stop.

As soon as I rang the doorbell to our apartment, my mother opened the door and pulled me inside. "Are you all right?" she gasped. She slammed the door shut and double-locked it. (To keep out any assassins?)

"I'm fine," I answered, but without the usual sting of irritation in my voice.

"Are you *sure* you're all right? Your sister's called five times. She's a nervous wreck. She's driving your father crazy. He'll be glad you're back." Linda was now away at grad school.

"He's here, Nat!" she announced in the direction of the living room. "He's fine!"

"Go to your father," she said softly. "He's watching Walter Cronkite. I'll get you some lunch. He won't eat." She headed for the kitchen, where she had a small TV of her own.

The drapes in the living room were pulled shut. The only light came from our black and white Zenith TV. Ever since I could remember, the TV had resided in my parents' bedroom, affording maximum parental control. Now here it was, sitting on a card table in the middle of the living room. This was strange. Things in that apartment *never* moved — every piece of furniture was a monument to immutability, rooted to its particular spot for all eternity; my mother drew maps on index cards of

every surface in the apartment to indicate to the housekeeper exactly where each candy dish and china figurine belonged.

My father said nothing, just gestured with his hand that I should sit beside him on the couch while he continued to watch. Walter Cronkite was speaking, his face worried and sad. It was startling to see my father at home on a weekday. He worked ten-hour days, six days a week, at the shop. He never got sick. "Days off are for rich people," he often told me.

If my father's presence in the apartment in the middle of the day was unprecedented, his appearance was even more of a shock. As I have already mentioned, he was fastidious about his clothes to the point of obsession. Along with his closet full of three-piece suits made for him by his longtime tailor to fit his diminutive frame, he had a world-class collection of Hermès and Sulka ties. He rarely left the house in anything but a suit and tie, the gold fob of the Patek Philippe pocket watch I would one day inherit dangling from the left pocket of his vest. At home he might take off his jacket and vest, but he never undid his tie until after dinner, and never changed clothes until it was time for bed. A loosened tie at the dinner table was a sure sign that he was upset about something.

But now, early on a Friday afternoon, here he was, wearing only an open bathrobe, underpants, and knee-high black socks. (My mother explained to me at some point that he had taken off his clothes to move the television because he was afraid they might get dirty, and he had never put them on again.) His gray hair was going this way and that; he kept tugging on one end of his moustache like he was trying to pull it off, and one bare knee was gyrating up and down like mine did when I was taking a test.

Walter Cronkite was saying that the "rumor" that the president was dead was "unconfirmed." Hope faded moments later, however, with the report that a priest had delivered the last sacrament. Next he said that "regarding the probable assassin . . . *a young man has been taken into custody . . .*" My father leaned forward on the couch and mumbled something I couldn't catch. But Cronkite never finished his sentence; he paused, took off his glasses, and said, "We've just had a report from our correspondent Dan Rather in Dallas that he has confirmed that President Kennedy is dead."

Whoosh! It was as if everything solid and safe was sucked out of the world. My mother ran in and asked my father, who was holding the sides of his head, "What's going to happen? What's going to happen?"

Cronkite, struggling not to break down, quietly announced that it was "official," that the president had died at "two p.m., Eastern Standard Time."

This was when my father spoke clearly for the first time. Referring, as I understood immediately, to the assassin, he said, "I hope to God he wasn't Jewish."

I've always thought of the moment I heard those seven words as the moment when I fully understood for the first time how much, despite his determined self-transformation from uneducated *shtetl* boy to successful New York entrepreneur, my father's precarious youth still haunted him. As he sat in front of the television that afternoon in 1963, things that had happened several decades earlier — the threats of pogroms and conscription, the hazardous journey across half a continent and an ocean — must not have seemed very long ago; only twenty years earlier, the Nazis ruled most of Europe; 1943 was the year the Warsaw Ghetto was destroyed.

So when my father said what he said, something else became clear to me: Despite our celebrating both Christmas and Hanukkah, despite our breaking the Yom Kippur fast by eating shrimp wrapped in bacon at King Dragon, despite my father's customers calling him Mr. Revere and his not correcting them — despite all that, we were *Jews* — *that* was who we were. And being Jews, I realized, was nothing at all like being New Yorkers, or Democrats, or Brooklyn Dodgers fans.

WHEN HUGE NATIONAL tragedies happen, they are supposed to "bring us together" (not necessarily these days, sadly) and the events of November 22nd, 1963, did just that. The historian Robert Caro has called the assassination of Kennedy an unparalleled moment, when "a majority of all Americans were apparently looking at the same events and hearing the same words ... participating together ... in a great historical event." But these events also have a way of making us feel alone. The tremendous shared fear they unleash can also ignite our personal,

private terrors, and these are what preoccupy us even as the world is turning upside down.

Clearly for my father the Kennedy assassination awakened the ancient tribal anxiety he had probably convinced himself he'd long since left behind. My worry *that* Friday, beyond the generalized dread that I had caught from my father, was that the assassination would mean the cancellation of my date the next night with Christine, a pretty blonde girl I'd been working up the courage to ask out for months, proving once and for all that fate was against my ever getting anything I really wanted. I remember thinking, *Why is this happening to me?* As for my mother, I don't recall her sitting still for more than a minute that entire day. Her constant fretting over whether we were all right, whether we needed to eat something, what we should do about my doctor's appointment, was the fitful background music to everything that was happening on television.

By the late afternoon, Lee Harvey Oswald had been identified as the assassin. My father could finally eat, and we had our dinner — plates on our laps in the living room for the first time ever. During dinner there was a brief mention on CBS that Aldous Huxley had also died that day. We were reading *Brave New World* in English class, and I had the thought that wherever he was, this famous author must be feeling a little gypped in the attention department.

When I got into bed that night I could still hear the television through the wall. The next morning, my parents and I watched in horror along with the rest of America as Oswald was shot down by Jack Ruby. Then we learned that Jack Ruby's real name was Jack Rubenstein.

My mother turned to my father and asked, "Is that a good thing or a bad thing for us, Nat?"

PART TWO

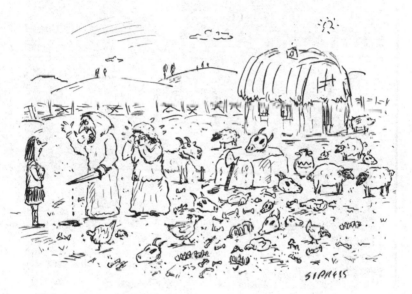

"You're quitting school? After everything we sacrificed for you?"

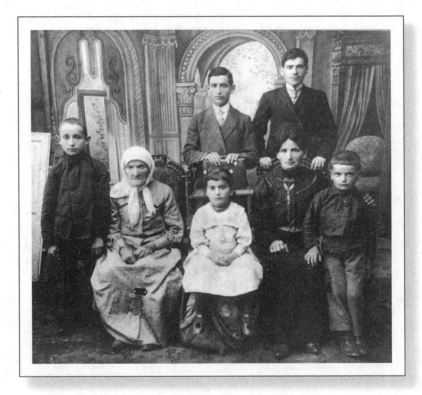

Russian History

THE YEAR 2017 marked the one-hundredth anniversary of the Russian Revolution. This photograph was taken three years before "the events that shook the world" and only a few months before the outbreak of the First World War, in a studio in Medzhybizh. It shows my father (on the lower right, his hand on his mother's knee) and his family, taken on the eve of their long journey to America. It's a grim and deeply poignant family portrait. Nobody is smiling. The sad trompe-l'oeil backdrop, with its flimsy illusion of prosperity, is thoroughly undermined by the random wooden board that encroaches at left.

The photograph was undoubtedly made for the one left behind — my father's grandmother, here in the white babushka, with her gnarled fingers caught in mid-fidget on her lap. Her expression is absent and sad, eyes gazing in two directions, as if she is looking simultaneously at a past filled with family and a future with none. Or maybe she is just bewildered by the whole photography thing, since it's possible that this was the first time she had ever seen a camera. My great-grandmother appears to be in her sixties or seventies, meaning she had lived through the Crimean War, the emancipation of the serfs, the pogroms that followed the assassination of Tsar Alexander II, the devastating famine of the early 1890s, the Russo-Japanese War, the revolution of 1905. When I look at her, I experience something that I first experienced as a boy, on a field trip organized by the Museum of Natural History to visit the oldest tree in New York City, planted, we were told, around the time the Dutch purchased Manhattan from the Lenape. When I touched the bark

of that tree, I felt the thrilling sensation of time travel — of being in direct, tangible contact with the distant past.

As I have mentioned, throughout my father's life he kept an impenetrable silence about his distant past, refusing to volunteer anything more than a few enticing tidbits about his childhood in the *shtetl*, his time living as an impoverished immigrant in Brooklyn, or virtually anything at all about his family. As a kid, all I was told about his mother, my grandmother, was that she died before I was born. I knew the names of his brothers and his sister (the three young men and the little girl in the photograph), but little else. His sister visited now and then, but almost never when I was around.

My grandfather, who is absent from the photograph, is a total mystery; the only thing my father ever said was that he "wasn't a good provider." (He might as well have called him a serial killer.) Once, as a child, I overheard something about his having worked in a cigar factory before he came to America, but when I Googled "cigar factory Medzhybizh," all I came up with was this headline: "Giant Cigar-Shaped UFO Filmed Flying Over Ukraine." Somehow I found out that his name was Louis. Louis is my middle name, and my father once told me, "I had to put the name somewhere, so I put it in the middle."

I also have a fuzzy memory of lying awake one night in Neponsit when I was six or seven, overhearing my father having a very angry phone conversation with someone. He was refusing to pay for something. I recall hearing the phrase "all these years later," and a few times the word "cemetery," and finally my father shouting, "Maybe he shouldn't have walked on purpose in front of that trolley!" Was he talking about his father? I don't know, but I've always thought so. On the other hand, the first time I mentioned this memory to Ginny, she pointed out that the whole thing could have been a dream.

A few years after he and his family settled in Williamsburg, my father not only left, but apparently cut ties altogether with the family. I only knew this because of something I'd heard my mother say to my father in that loud argument about Granny years earlier: "You may have had nothing to do with your family since you left Brooklyn, Nat, but my mother will always, *always,* be part of *this* family!"

I never found out the cause of the break. What I did know was that

from an early age my father was driven by a fierce desire to assimilate. All he ever wanted was to be an American and make his fortune in the shining city on the Hudson. While still a teenager, he moved to Manhattan from Brooklyn and never looked back. Every time I glance at the family photograph — these days, it hangs above the desk where I draw and write — and encounter my father's serious, determined, eight-year-old face, I imagine that I can see that single-minded intention to escape already decided.

His expression also brings to mind one of the only stories he ever told me about his arrival in this country: "It was the Fourth of July when the boat landed. Next, we traveled in a trolley across the Williamsburg Bridge. It was like a furnace inside that trolley car. When I looked down, I saw some boys skating around this way and that on a path by the river. I asked my mother, 'Where is the ice?' How could they skate when there wasn't any ice? What a little greenhorn I was. My brothers made fun of me, so I didn't say another word about it, and I decided then and there, *no more questions.*"

I discovered the photograph during a snooping expedition when my parents were out to dinner. It was hidden in an old hat box in the back of a closet. When I turned the photo over I saw written in my mother's unmistakable hand: *Nat's family/1914/Medzhybizh/Ukraine/Russia/ Nat 8yrs, bottom right.* I was eleven the night I found it. This was at the height of the Cold War, when the Soviet Union seemed poised to bomb America — and me personally — out of existence. My response to scary stuff has always been to hit the books. I had begun spending time at the Amsterdam Avenue branch of the New York Public Library, reading everything I could find about Russia and the Communists. (My other

142 * WHAT'S SO FUNNY?

favorite research topics were the Mafia and the Nazis.) I was captivated by the story of the Revolution — the hapless Tsar, the crazy monk who was killed five times and still wouldn't die, the protests and riots and blood in the streets, the fiery orators, the cruel and murderous Bolsheviks, the heartless assassination of the Romanovs and the possible survival of Princess Anastasia, the evil tyrants Lenin and Stalin, their ruthless, all-powerful secret police known as the Cheka (later the KGB), the brutal civil war with Reds versus Whites. Now I began to read whatever I could find about pogroms and marauding Cossacks and the forced conscription of every young male in the Russian Empire into the Tsar's army, where Jews were treated especially harshly — anything that might explain the long faces in the family portrait.

I continued to read about Russia in high school. If my father found my fascination with the country where he was born interesting, he never gave any indication. That would have impinged on the area of *no questions*. But my obsession with history seemed to please him no end, especially since my other boyhood obsession, drawing cartoons, disturbed him no end. Defying my father was unthinkable, so when it came time to apply to college, my fantasy of going to art school remained just that; the one time I mentioned art school to him he told me for the thousandth time to get my head out of the clouds.

In college, I majored in Russian history and confined my funny drawings to the margins of my notebooks. In my senior year, I produced a three-hundred-page thesis titled "Dynamics of Futility — Dilemmas of Political Authority in Russia, 1861 to 1917." As graduation approached, in June 1968, the terror of the draft left me with little choice — I opted for an educational deferment and the safe, familiar refuge of academia. I moved to Cambridge, Massachusetts, that fall and began a master's program in the Department of Soviet Studies at Harvard. My father was overjoyed. His own education ended after the fifth grade, but now he could tell anyone who would listen that his son was going to Harvard.

At Harvard, for the first time in my life, academics became a struggle. Anti-war demonstrations, drugs (psychedelics and otherwise), and women (after all-male college) were all successfully competing for my attention. The one course that held my interest covered those same

nineteenth-century resistance movements I had written about in college. (This time around, I wrote a paper about a group that proselytized and practiced free love.) I made it to most of my classes, but the funny drawings were spilling over the margins now, sometimes obliterating the lecture notes. By the end of first semester, I was feeling trapped in the wrong life. Even so, I looked forward to a second-semester course on the Revolution, taught by the eminent historian who had attracted me to the program. A week before classes began, however, a note in my mailbox informed me that he would not be teaching the course. No reason was given. His replacement was an unknown (at least to me) historian, on leave from a university in Yugoslavia.

The replacement professor — wearing a gray suit, white shirt, and narrow black tie — loped into the first class of the semester and dropped a huge loose-leaf binder onto the desk. He was tall and gaunt, with short, spiky gray hair, a large forehead, prominent cheekbones, a thin, dark mouth, and small, pointy ears. He wrote his name on the board and then, in a heavy Eastern European accent, said, "Welcome to course on Russian Revolution. This will be lecture course only — means, *no questions.*"

Hands shot up. "I repeat once again," he intoned, "rule is, no questions. Be sure to take excellent notes." He ran his palm across the cover of the binder, as if he were stroking a cat. Then he flipped it open and began to read. His authoritarian teaching style immediately earned him the nickname Uncle Joe. For the next twelve weeks, he droned on uninterrupted, advancing his theory that economic factors were the root cause of the Russian Revolution, and every other major event in human history. No great-man theory for Uncle Joe. He inundated us with statistics about the size of kulak land holdings and tonnage of steel produced in Ukraine between 1900 and 1917. The reading list was as dry as an actuarial table.

At noon before the last class of the semester, a group of us met at the Hong Kong restaurant in Harvard Square to discuss what to do about Uncle Joe. This was 1969, after all. We decided to force him to answer a question — any question would do. We cut cards. I can still see the three of clubs that won me the job. So, that afternoon, as Uncle Joe closed his binder for the last time, everyone in the class turned and looked my way.

I sheepishly raised my hand and said that I had a question. Uncle Joe ignored me.

"Louder!" one of my classmates hissed.

"Professor!" another demanded. "Someone has a question."

Uncle Joe turned and stared at me. Then he looked down at his list of students and asked, "You are Mr. Sipress, no?" I nodded. "I think your question must be very urgent, Mr. Sipress, to break the rule." I nodded again. "OK," he said, "in that case, proceed."

Having never believed that things would reach this point, I hadn't bothered to prepare an actual question. I said the first thing that came into my head: "Anti-Semitism, Professor," I began, "I have noticed that you never mention anti-Semitism — you know, under the Romanovs — the pogroms and such. Do you think that the history of anti-Semitism played a major role in shaping the course of the Revolution?"

Uncle Joe raised his eyes to the ceiling. Then he grabbed some chalk and quickly wrote a list of books on the blackboard. "Please read these, Mr. Sipress," he said, his back still turned. "All are excellent for your purposes." He picked up his binder and walked out the door.

That night, a few of us held a party to celebrate our victory over Uncle Joe. After two hours of bong hits and Boone's Farm, something strange happened. Several of my classmates in Soviet studies started coming out about their secret identities. One was Air Force Intelligence. Another disclosed that he was "affiliated with law enforcement" and "here on the government's dime." Three others exchanged sly smiles and said they worked for a government agency that they were not at liberty to name. As I stumbled home that night, I asked myself over and over, "What the hell am I doing here?"

I spent the next two weeks studying my excellent notes. Uncle Joe's exam was held in a large lecture hall where several other finals were being conducted as well. Professors wandered up and down the aisles looking for their students. Uncle Joe smiled when he spotted me, something I had never seen him do before. My stomach did a back flip. As he placed a blue book with the exam tucked inside it on my desk, he said, "Mr. Sipress. Because you are so urgently interested in the question

of anti-Semitism, and have no doubt done the reading I have recommended" — he tapped the blue book with his forefinger — "this is special examination, just for you, entirely on that subject." He smiled again and walked away.

My fingers and toes went numb. For a moment, I thought that I might faint. Then, I suddenly knew what I had to do. I collected myself, picked up my book bag, and walked out. I was free — my graduate school career was over. I can't recall if I thought about my father, but if I did, I must have pushed the thought away. Otherwise, I'm not sure I could have left.

A BRIEF DIGRESSION: In the spring of 2015, a friend who teaches the history of theater at Columbia University invited me to give a talk about my work to his seminar on comedy. When I got off the subway at 116th Street, I received a text from him saying he was running late. He gave me directions to his office on the third floor of a building on the edge of the campus and asked me to wait for him there.

The minute I opened his office door, a feeling of peace and well-being washed over me. His large oak desk was piled high with books and papers. The desk chair was wood and leather and looked comfy rather than ergonomic. Striking vintage Russian theater posters were hung salon-style on one wall, framed architectural drawings of various theaters on another. The floor-to-ceiling bookshelf was chock full, and there were three or four piles of books on the thick carpet along one side of the desk. Welcoming sunlight poured in through two tall windows and fell across a venerable, buttery-looking leather couch — the ideal venue for an afternoon nap; when I sat on it and sank down, all I could see out the windows was the top of a leafy tree and blue sky. The only sounds I heard were birds singing, and for a moment I imagined that I was in no longer in the middle of a bustling concrete campus in upper Manhattan, rather somewhere bucolic and rural — a place where a person had all the time in the world to sit and think, write and read. When my friend arrived and said it was time to go, I was more than a little sad to leave.

On my way downtown on the subway after my talk, I reflected on the end of my graduate school career and the road not taken. As soon as I got to my studio, I sat at my desk and drew this cartoon:

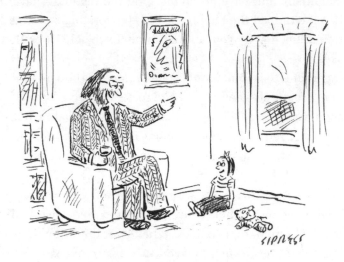

"Daddy works in a magical, faraway land called Academia."

The Call

O VER THE NEXT few weeks, the euphoria over my spur-of-the-moment decision to leave school began to fade, and an over-whelming anxiety about consequences took over. Insomnia kicked in big-time and when I did manage to sleep I kept having the same awful dream: I am riding on the subway, on the Number 1 train I took every morning to get to high school at Horace Mann, only in the dream it's late at night. Every seat is taken, so I'm forced to stand. As we emerge from a tunnel onto an elevated track, the train speeds up and begins to rattle and shake. Afraid that I'm about to lose my balance, I make my way to a door and lean against it. "That's better," I tell myself, as the door flies open and I fall backward into empty darkness.

Chief among my real-world worries was that by leaving school I had forfeited my educational draft deferment. This was at the height of the Vietnam War, and every day I expected to find my draft notice in the mail. I had been volunteering at the Draft Resisters office in Central Square, so I knew that my alternatives were Canada or finding a psychiatrist willing to state in a letter that I was mentally unfit. Perhaps in order to present a convincing case for the latter, I took regular advantage of the free tabs of LSD handed out willy-nilly on Cambridge Common every weekend.

But the draft was only part of the problem. Leaving school had landed me in the middle of an existential crisis: I had only ever been one thing — a student — so who was I now? The question left me feeling

shaky and lost much of the time, and more and more, as I had often done in the past, I turned to drawing to "still the fluctuations."

Perhaps I'm a cartoonist, I thought one morning as I sat in bed drawing on a newsprint pad. Why not? After all, the wonderful thing about deciding to call myself a cartoonist, I realized, was that no official validation was necessary. I had a pen, I had paper, I was drawing — that was all it took to make it official. "I yam what I yam," I told myself, quoting my old friend Popeye. Here is one of my earliest efforts, drawn a few weeks after I left Harvard:

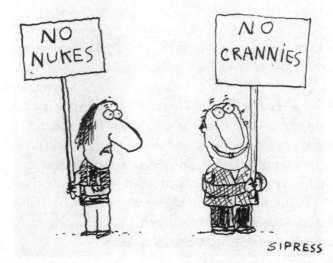

However, I was well aware that until I told my father what I had done, I would have only one foot in my new life. I called my parents a couple of times, intending to fess up, but lost my nerve and wound up reverting to my big lie strategy. Yes, I told my father, the new classes are going great. No, I didn't sign up for Henry Kissinger's lectures, but I might see if I could audit them. Yes, I will try to come to New York during spring break, if my schoolwork allows. And I thanked him for the check to cover my expenses for the semester.

At the time I was sharing a large apartment with a shifting assortment of eight or nine roommates, each of whom had his or her own loud stereo system and constant flow of visitors. My room on the second floor was directly across a narrow alley from an apartment occu-

pied by a pre-goth rock band fifteen years ahead of its time called The Dead Skin, which could be counted on to rehearse at any hour of the day or night. Seeking peace and quiet, I spent a lot of time in the local library with my drawing pad or writing in the journal I was keeping at the time — the product of an alternate plan to declare myself a writer. Movies were another dependable escape, and two or three times a week I caught whatever was playing at the Brattle Theater or the Orson Welles Cinema.

On a chilly Sunday afternoon in early February, I rode my bike to the Brattle to see Godard's *Breathless,* my favorite film of all time. I had seen it at least ten times, starting when I was thirteen at the Thalia Cinema on Broadway, where I sat through it twice in a row. *Breathless* consistently filled me with a longing for a more exciting and exotic life, much the way the skyline of Manhattan had filled me with longing on the long-ago night I'd drawn my first cartoon.

The summer of my sophomore year in college, my father had been so pleased with my grades that he gifted me a trip to Paris. The day after I arrived, I got myself a job selling the *New York Times* on the Champs-Élysées, following in the footsteps of Jean Seberg's character Patricia in *Breathless.* (She sold the *Herald Tribune,* but since the *Tribune* didn't need anybody, I decided the *Times* was close enough.) I stepped out onto the street with my shoulder bag full of newspapers, ready for my life to turn into a movie; it never did, but I did have some memorable adventures. A guy I met on the street invited me to a party where I tried opium and sat petting a shoebox that someone told me was a cat while naked people writhed around on a giant canopied bed and a woman played an accordion and did a passable imitation of Edith Piaf. That evening I met a pretty Danish girl with short hair exactly like Seberg's Patricia. She and I traveled around for a month together, ending up on the island of Formentera off the coast of Spain where I slept on the beach and got stoned day and night with an international crowd of peripatetic hippies. One morning I reached into my knapsack for a change of clothes and my airline ticket fell out onto the sand. I saw that I had only two days to get back to Paris for my flight home. I somehow made it, and next thing I knew I was sitting under an umbrella with my father on a very different beach, the one in Neponsit, making stuff up about the amazing

museums and churches and chateaux I had toured in Paris and the French countryside.

At one point in *Breathless,* Jean-Paul Belmondo's character Michel says to Patricia, "Being afraid is the worst sin there is." I walked out of the Brattle that afternoon having decided that it was time for me to stop being afraid. I would call my father, although I had no doubt that, for Nat Sipress, dropping out of Harvard would be the worst sin there is.

I couldn't call from the communal phone in my apartment — no chance of privacy — so I got on my bike and looked for a quiet phone booth. I tried one in Harvard Square, but it was broken, so I rode around the north side of Harvard Yard until I found a working phone, ironically within sight of the Russian Research Center, headquarters of my former academic department.

I took several deep breaths, put in a dime, and called collect. My mother accepted the call, and as soon as she heard my voice she yelled, "Nat! Pick up the extension! It's David." This meant that she was in the kitchen, and my father was in the bedroom, probably in his favorite armchair, probably still reading the Sunday *Times.*

"Hello," he said, "how's school? Have you gone to Kissinger yet?"

"Dad, Mom," I said, "I have something to tell you."

"What?" my mother said. "Are you all right? Are you sick?"

"No, I'm fine, but I have some news."

"Oh, yes? Good news, I hope," responded my father.

"Maybe. I don't know," I said.

"Yes?"

"OK, Dad," I exhaled. "Listen — I . . . I . . . dropped out."

"Dropped out? Dropped out of what?"

"Of school, Dad. Of Harvard."

What followed was the longest moment of silence in history, during which I heard only my mother's breathing. Finally, she said to my father, "Nat, please, don't — "

"I don't understand," my father sharply interrupted her. "Are you joking, David?"

"No."

"What exactly did you do? When did this happen?"

"A few weeks ago. During finals."

"A few weeks ago? *A few weeks ago?* And you didn't think to mention this in all those conversations about how well everything was going with your classes? When you thanked me for sending you the check?"

"I wasn't sure how to tell you . . ."

"So, you were lying the whole time?"

"I guess."

"You guess? Yes, or no — were you lying to me?"

"Yes, Dad."

Are you going to spank me for lying — not for dropping out? I thought.

"Why, David? Why would you do such a thing?"

"You mean lie?"

"You know damn well what I mean."

"I quit because I was unhappy — *am* unhappy," I muttered, replying with the truth, offering what, to any normal person, would sound like a perfectly good reason, but at the time sounded pathetically insufficient, even to me.

"Unhappy? You're unhappy? That's it? Listen, mister — who's happy? Nobody, *that's* who. You think that life is a bed of roses?"

"No . . ."

"Now you listen to me — here is what's going to happen: Today, you're going right over there to Harvard, and tell them you made a big mistake and you want to change your mind."

"I can't do that, Dad."

"Yes! You can. Now listen — you do that, and I'll make you a deal. If you're unhappy, maybe you need some more money — so you can afford to move out of that zoo you're living in and get a place of your own. Who could be happy in those circumstances? Every time you call I can hardly hear you for the racket going on. I'll send you another thousand dollars tomorrow. What do you say?"

"That's not what I want, Dad . . ."

"What about a car? Do you need a car so you can get away on the weekends and have some fun? Maybe drive down here once in a while to see us?"

"Dad! I don't want a car! I don't want more money! It's not about any of that. I'm unhappy because I don't want to *do it anymore!*"

My eyes filled with tears.

"Do what?"

"What I've been doing my whole life — studying and . . ."

"Your whole life? Now, all of a sudden, you're a big man who's lived a whole life?"

"Why?" my mother now asked. "Why would you throw away your future?"

"Because, as usual, he has his head in the clouds," my father told her.

"Please, please, listen to me — I'm not happy. Maybe I want a different future. I feel like I don't know who I am right now. I need to figure that out. Maybe I want to be someone different, *do* something different . . ."

"Like what?" asked my father.

"Well . . ." This was the moment I had been dreading the most. After another big exhale I said, "I think I want to try being a cartoonist. I am . . ."

"God in heaven!" My father shouted. "Is that what this is all about? What are you, five years old? Did you ever hear anything so ridiculous? I'll tell you one thing — don't expect another penny from me if you go ahead with this. We'll see how well you do out in the world without a practical bone in your body, mister cartoonist — you who throw away money at the drop of a hat and never once have understood the meaning of money. And don't come crying to me begging to help you out, because that's over — unless you stop this foolishness right now and go back to Harvard and apologize. My God! After all we've done for you — after the world-class education we gave you — and this is how you repay us? What right do you have . . ."

"I have a *right!*" I exploded into the phone, shocking myself.

"Oh, yes?" he shouted back. "You have a right, mister big shot? Is that what you think?"

"Yes! That is what I think!"

"Then, fuck you!"

"*What?*"

"You heard me." And he slammed down the phone.

"Nat!" my mother called. "Nat, please . . ." And then to me, "I better see if he's all right, David. I just don't understand how you could do this to your father." And she hung up too.

⋅ ⋅ ⋅

IN A KIND of frightened daze, my father's curse reverberating inside my head, I walked my bike halfway up the street until I could see seventy yards or so ahead the big intersection where fast-moving traffic funneled into Harvard Square from Harvard Street and Mass. Ave. Even today, fifty years on, I'm still at a loss to explain what I did next, but at that moment, it had a kind of irrefutable logic. I got on my bike and began pedaling as hard as I could, picking up speed until I was a few feet from the curb at the end of Quincy Street; then I shut my eyes, lifted my feet off the pedals, and glided blind, directly across the oncoming traffic.

Brakes screeched, horns honked, someone screamed, but I kept going until my front tire hit the curb on the far side of Mass. Ave. and I fell off. When I opened my eyes and sat up on the sidewalk, these were the words that went through my twenty-two-year-old head:

OK — I guess I'm supposed to keep living.

A driver who had pulled over opened his door and was yelling at me. I mouthed, "I'm sorry." A woman hurried over — perhaps the person who had screamed — put her hand on my shoulder, and asked if I was all right.

I was.

Eventually, I picked myself up and wheeled my bike up the street to Bartley's Burgers. I went in, ordered a cheeseburger, took out my notebook, and wrote down everything, from a verbatim recounting of the call with my parents to those words I said to myself after I landed.

Then I turned the page and drew this cartoon:

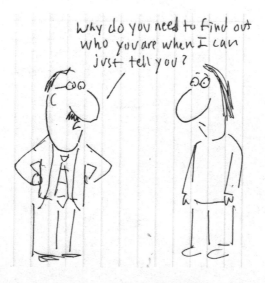

Why do you need to find out who you are when I can just tell you?

Happy Birthday

SEVERAL MONTHS LATER, in mid-summer, 1969, I secured a letter from a sympathetic shrink that I presented to the Army psychiatrist at the end of the draft physical and I walked out of the Boston Navy Yard a free man — officially "unfit for military service." For the rest of that year, I got a little lost, taking whatever drugs I could get my hands on until I started regular therapy sessions and returned to a sort of normal. At the same time, I discovered something new about myself — that there was nothing like a little opposition to get me going in the right direction, that being told not to do something only made me more determined to do it. It seemed as if everybody I knew was thinking along those lines. "There's something happening here . . ." Buffalo Springfield sang in an anthem of the era.

So I threw myself into drawing cartoons. Here are two of my early efforts, evocative of those times:

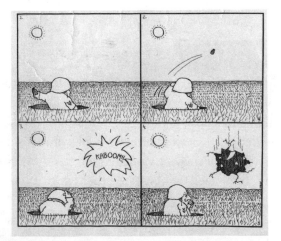

Perhaps this new mindset had its roots in my long history of chafing at *because I said so.* In any case, I started my first job ever, working in a Boston bookstore, only to be fired fairly quickly for my "attitude," something I tried to capture many years later in this cartoon:

"My boss is always telling me what to do."

In 1970 I got another job, shelving books in the Boston University Library. This was to be my very last "real" job. When I wasn't sneaking out of the building to smoke a joint, as often as not, I was hiding in the stacks reading history books or studying books of cartoons and books about drawing (some of these, I am ashamed to admit, are still in my possession — I rationalized that I needed them more than anyone else).

Although the library job lasted longer than the bookstore job, it ended for more or less the same attitudinal reasons.

I WASN'T HAVING any success getting my cartoons published, so I eventually came up with my own version of self-publishing: I made copies of my drawings and, taking a page from my Paris experience, several nights a week I carried a shoulder bag full of cartoons to Harvard Square, where I stood on the street and offered the copies for sale for ten cents apiece. I figured I wasn't going to get rich, but maybe I would get noticed. And then, one night in early 1971, a guy who wrote music criticism and was the editor of an underground newspaper bought a couple of drawings and offered to publish me. Encouraged by this, I decided to try my luck at the popular alternative weekly *Boston After Dark* (it would shortly morph into the *Boston Phoenix*). I showed up at the paper without an appointment, and to my surprise, the receptionist pointed to the editor's office and told me to go right in. The editor was there, along with a couple of writers and the art editor. The room was redolent with recently smoked weed, which perhaps explains why I was hired on the spot. I walked out of the office an hour later as the newly minted cartoonist for the leading alternative weekly in Boston, a post I held for more than thirty years.

Not long after I began appearing in the *Boston Phoenix,* I joined a group of artists who had started a cooperative business making silkscreen posters for everything from anti-war demonstrations to theater performances. In the mid-seventies I started a second career as a sculptor. I fell in and out of love twice, made many friends who kept me sane — more or less, had a few scary bouts of insomnia, and one or two serious spells of anxiety and depression.

My parents and sister knew almost none of this. My call and my father's curse had radically changed our relationship. I visited my parents in New York only a handful of times, and I never invited them to visit me. For a year or so, my mother attempted to keep in regular touch, but eventually even she settled into a mutually agreeable near-silence. When we did speak, I revealed next to nothing about my life in Boston.

My father retired in 1972. In our increasingly infrequent conversations, my mother's main theme was that after all the years of hard work

and tireless sacrifice in his shop, after the constant worry about another robbery now that the city was falling to pieces and being handed over lock, stock, and barrel to the criminals, after the decades of physical strain from standing on his feet ten hours a day, what my father deserved now was "his peace of mind." And she always made a point of reminding me that he still had his hands full with my sister. She reported that Linda was still calling my father every day — sometimes several times a day — for advice about work problems, or relationship problems, or for reassurance about whatever was worrying her.

Message received: We don't need any additional mishegas *from you.*

In 1972, my parents moved to the Upper East Side, and soon after, they began to travel — something they had never done before (unless you count Neponsit). During the seventies they went to Europe four times, twice sailing on the SS *France*. They toured the western United States twice and went on a cruise to Alaska. After my father's death, while cleaning out the apartment on Sixty-Eighth Street, I found my mother's travel diary, in which she recorded in great detail every meal they ate, every city, museum, castle, national park, and glacier they visited, and, of course, every jewelry shop. She recorded conversations with people they met. She gleefully described my father's pleasure at being recognized by former customers on the SS *France* and on the street in London, and by fellow jewelers in shops in Edinburgh and San Francisco. She listed the various objects they encountered in the Victoria and Albert Museum and the Louvre that were "similar to things that Nat had in the shop at one time." There were even a few entries not related to travel, describing dinners out with friends in New York during the seventies, theater and ballet performances, and exhibits at the Met. Reading through the diary I found several mentions of phone calls with my sister, and once, a description of a week the three of them spent together in Paris.

Who was not mentioned in the entire fifty-page diary, was *me* — except, that is, for one short entry, dated January 16th, 1977: "Back from London three days ago. David here now. Yesterday Nat had a heart attack." January 16th, 1977, was my thirtieth birthday.

That morning I had been in a small town in Tennessee, on a month-long gig conducting a silk-screen and drawing workshop for local chil-

dren. It was my third visit to the area and my friends in the town had planned a big celebration for me that evening. Then I got the call from my sister about my father, and a friend drove me to the airport in Chattanooga. I didn't get to my parents' apartment until early evening, where I found my mother alone. She had returned from the hospital an hour or so earlier. She was wearing a silk bathrobe that I immediately recognized as belonging to my father. It made her look even tinier than her actual tiny self.

We hugged and sat down beside each other in the den. She took my hands in hers and told me that my father was going to be OK. When she and my sister left the hospital Linda had returned to her apartment a few blocks away. My mother explained that it had only been a mild heart attack, that it had happened at home after breakfast, that since Lenox Hill Hospital was only a few blocks away the ambulance got my father there in a matter of minutes, that the doctors had determined that he didn't need surgery, and that he would be treated with medication and would only have to stay in the hospital another couple of days. Then she stood up and began pacing back and forth, her eyes blinking and fluttering, her hands clasping and unclasping, repeating some of the same details about my father and the hospital, mixed in with descriptions of various things that had happened on their trip to England.

"He'll be so glad to see you, David," she assured me, finally sitting back down. She asked if I wanted her to fix me something for dinner. I said no. Then she lifted one hand to her forehead and said, "I think I'm getting a headache."

"Oh, no," I gasped.

She looked at me strangely, then smiled and nodded and said, "Not one of those. They ended many years ago, after . . . you know . . ."

I nodded. I realized that the word she wasn't able to say was "menopause." Bodily functions of any kind were pretty much unnamable for my parents.

We sat in silence for a bit. Then my mother sighed, put her hand on my knee, smiled sadly, if such a thing were possible, and asked, "You had a happy childhood, didn't you, David?"

Stunned, I looked away. "I . . . I . . ."

"You did, didn't you?"

"Yes, Mom," I finally answered.

"I hope so," she said, nodding. "I think you did."

She said she was exhausted and was going to take a pill and lie down for a while. I poured myself a glass of scotch and watched the news.

When the broadcast turned to a fatal plane crash in Sweden, I shut off the TV and asked my mother, who was lying on her bed still in my father's robe, listening to his transistor radio, if it was OK if I went for a walk. She said yes and told me to bundle up. Then she said, "I didn't realize it until just now, but other than the month my father was ill, tonight will be the first time in forty years that Nat and I will sleep in different places."

It was freezing and damp out when I left the apartment. I realized that I hadn't eaten all day, so I walked a few blocks east and found a small Mexican restaurant. The place was empty, except for a couple sitting at the bar talking to a middle-aged waitress in a floral blouse and long red skirt. Three musicians, decked out in short, sequined jackets and bow ties, were sitting in the corner drinking beer, their instruments — a guitar, a fiddle, and an accordion — lying at their feet. I chose a table by the window and watched the snowflakes starting to fall on Third Avenue.

"Happy Birthday," I said out loud to my reflection, and shook my head.

"Whose birthday?"

"What?" I turned around. The waitress in the long skirt was standing behind me, smiling.

"Mine," I said sheepishly. "I was just . . . never mind."

"Well, happy birthday. What can I get you?"

I ordered enchiladas suizas and a beer. My beer arrived, and I sat drinking it and making invisible drawings on the tabletop with my forefinger. Next thing I knew, there was the sound of guitar strings being lustily strummed directly behind my head. I whirled around. The three musicians stood there, smiling broadly. The customers at the bar and the waitress were grinning from across the room. The accordion started up, then the fiddle, and when the guitar joined in, everyone began serenading me with "Happy Birthday," mariachi-style.

THE NEXT MORNING my mother and I met Linda at the hospital. When the three of us entered his room, my father was sitting up, eat-

ing some toast. He looked pretty much like his regular self—maybe a little paler than usual. The hospital gown he was wearing came down only as far as his knees; his nearly hairless legs splayed out on top of the bedclothes, transforming him into a gray-haired, bespectacled, moustachioed, seventy-something toddler. *Clothes make the man,* I thought.

"You came," he said, smiling and gesturing for me to sit beside him. "You want some?" he asked, holding up a piece of toast. I shook my head. "This is what they call breakfast," he added.

Linda paced nervously around, and finally said she had to get to the office. At the time, she was working at a management consulting firm. After she left, my mother reassured me that everything was all right with my father, and said she would go visit some of her nurse friends. My mother volunteered one day a week at Lenox Hill, distributing books to patients from the hospital library and visiting kids in the children's ward. When I later went down to the cafeteria for a coffee, a nurse from my father's floor came over and told me, "Everyone here loves Estelle."

When we were alone in his room, my father said, "I told you this was going to happen."

"What do you mean?"

"I told you I was going to have a coronary."

"Not me, Dad."

He blinked and tugged his moustache. "Well, maybe it was your sister. I told somebody. I know I told Dr. Rosenberg because I remember he was pooh-poohing the idea since I didn't have any symptoms. I didn't need symptoms, I told him—I just knew. He said, 'You've been saying the same thing for years, Nat.' And now, lo and behold . . ."

"But it wasn't so bad, Mom said."

"No, and since I was expecting a big one, I feel like I got away with murder. Until the next one."

"C'mon, Dad, you don't know." *Don't count your chickens.*

"Don't I? I hope not, because I'm not supposed to go before your mother. That's not my plan. So I better care of myself, lay off the salt in particular, they tell me. Take aspirin. This thing scared the hell out of me, if you want to know the truth. But don't tell your mother."

"But you're OK?" I asked.

"Sure. I guess I'm lucky."

He asked me a few cursory questions about what I was doing. I grunted my answers. Then he said, "I was just thinking about you the other day. In London."

"Oh, yes?"

"In the British Museum. We saw a terrific collection of Russian porcelain — much of it, believe it or not, from after the Revolution. In 1917. Like I said — it made me think of you."

"I know when the Revolution was, Dad," I muttered and shook my head.

Next thing I knew, he took my hand in his and squeezed. "Thank you for being here," he said, and then, for the second time in twelve hours, I was flummoxed by a question from one of my parents. He said, "You know that I love you, right? No matter what?"

"Yes, Dad," I mumbled, not meeting his gaze.

He let go of my hand and said, "I'm sorry this had to happen on your birthday."

I stayed in the city a couple more days. My mother, reminded by my father, ordered a birthday cake for me from Greenberg's Bakery, and she, my sister, and I had a sad little celebration. My sister, as usual, ignored my mother and talked a mile a minute to me about her recent trip to Belgium and the Netherlands, where I later learned from my father she had been accompanied by "a new boyfriend" — in fact, a married man from Argentina with children, with whom she would carry on a long-distance affair for the next twenty-five years.

Assured that my father was going to be fine, the next afternoon I flew back to Tennessee.

Another Happy Birthday

WHEN I WAS growing up, we usually celebrated my birthday at home as a family, but one year my mother announced that she had arranged a very special party for me. The location of the party was to be a wonderful surprise. On the big day, she and I took the bus downtown to Times Square, where waiting for us in front of a theater were six of my best school friends and their mothers. Big letters on the marquee read, "Harry Belafonte in Concert!"

"I know how much you love him," my mother whispered to me as we

entered the theater. It was true that we had his records at home and I used to do a silly dance for her to "Matilda, Matilda." But *love* him?

It quickly became obvious who *did* love him. I perused the audience — the place was filled with women, most of them versions of our mothers. When the curtain went up, Belafonte stepped onto the Jamaica-themed set, majestic in patched culottes that ended six inches above his bare feet and a blousy shirt that was knotted six inches above his navel. He launched into a jaunty version of "Mama Look at Boo Boo," his voice an unlikely mix of raspy and smooth. We boys giggled and nudged each other and made faces. We kept up our shenanigans through two or three more numbers, but it wasn't long before we were thoroughly bored and sank into a sullen funk.

Meanwhile, in the row behind us, our six mothers were spellbound, swaying and clapping and head-bobbing and mouthing the words, joyfully joining in whenever Belafonte invited the audience to sing along to "Banana Boat Song" or "Hole in the Bucket." Every time I turned around, there was my mother with an intense, blissed-out expression on her face unlike any I had ever glimpsed before — her eyes glued to the singer's bare midriff, following it wherever it went, whether he was lifting a "six-foot, seven-foot, eight-foot bunch," or reclining provocatively under a palm tree, bemoaning the loss of the little girl he "had to leave in Kingston Town."

Afterward, all of us returned to our apartment, where, happily for us boys, there was cake.

Never Happen

IN 1980, THREE years after the heart attack, I came back to New York. Once again the reason was a health scare. This time it was my mother. As it happened, I was visiting a friend in New Haven, so not far away when my roommate in Boston called me and said my father had phoned and sounded upset. When I spoke to him, he was in a state. My mother had been rushed to the hospital that morning for an emergency appendectomy. "There was some mention of gangrene!" he cried. I immediately got on a train. I met him at Lenox Hill Hospital that afternoon. My sister was traveling again with the boyfriend, so it was just the two of us. When he told me about how my mother had woken in terrible pain and he had to call an ambulance, he came as close as I'd ever seen him to crying. In spite of how upset he was, he was dressed in his usual impeccable manner, and he managed to give my jeans and sweatshirt a grumpy once-over.

"Estelle should be finished by now," he told me. "Let's find the doctor." A nurse told us that my mother was out of surgery and in intensive care.

"Is she all right?" my father asked.

"As far as I know," she replied.

"What's that supposed to mean?" my father grumbled. "And what about the gangrene?"

She said she was sure that everything was fine, but the doctor would be out to talk to us as soon as he was free.

We sat and waited for twenty minutes, my father fidgeting and growing more and more impatient. Finally, he stood up and said, "Let's go."

"Where?"

He didn't answer. I followed him past the nurse's station. "Men's room," he said to the nurse, and then he turned down another corridor, past the bathrooms, toward a sign with an arrow pointing down another corridor that said "Intensive Care."

"Dad," I said, "what are you doing?"

He didn't answer, just kept walking. At the end of the corridor there was a set of double doors under a large sign that read "Intensive Care. Medical Staff Only."

"Dad, wait!" I took his arm. "Don't you see the sign?"

"Never mind," he grunted. He pulled away his arm and began to push open the doors.

I had never before witnessed my father disobeying a sign — any sign — whether it was "Do Not Enter," "No Parking," or "Keep Off the Grass." *Rules are rules.*

And yet, here he was, brazenly pushing his way through the verboten doors of the intensive care unit. I followed, my hand on his shoulder, trying to hold him back, but we both stopped moving when we saw my mother. Inside the ward there were patients on gurneys along three walls, hooked up in various ways. My mother, her eyes shut, wearing what looked like a shower cap, was lying under a sheet on a gurney that was parked in the middle of the room, apparently waiting for a spot to open up.

A nurse in scrubs, tending to a patient, clocked us and yelled, "Hey!"

My father ignored him and began walking toward my mother, arms out straight like a zombie, calling softly, "Stell, Stell . . ."

"Wait! It's not . . ." the nurse shouted, but before he could finish, my father lunged for my mother's gurney, his upper body landing on her feet and legs, which was when the gurney shot out from under him. He slid off as my mother rolled away, and down he went, in slow motion, arms still outstretched, until his head hit the linoleum floor with a dull *thunk*.

My mother's surgery was successful. No further mention of gangrene. She was released the following afternoon. Meanwhile, it was my father who wound up spending two nights in the hospital, being treated for a possible concussion and a broken wrist.

• • •

"IT'S LUCKY YOU were here when it happened," I joked when I visited him the next day in his room.

"Never mind," he scowled.

I was never able to come up with a straight answer the couple of times he asked me if I knew that he loved me. But there was never any doubt in my mind that he loved my mother.

DURING MY YEARS in Boston I churned out masses of cartoons, not just for my weekly spot in the *Boston Phoenix,* but enough to stuff into envelopes every week and send out to all kinds of magazines and newspapers around the country. By the mid-seventies I was having considerable success getting published (with the notable exception of *The New Yorker*). Having mostly cut myself off from my family, and in particular from my father, and living in another city for the sake of my mental and creative health, I had convinced myself that out of sight meant out of mind. And yet a voice (I wonder whose?) in the back of my head was saying, *You're having too much fun. If you're not suffering, maybe you're not doing real work.*

I decided the answer for me was to be both a serious artist and a comic artist. I took up life drawing and drew cityscapes and clandestine portraits of strangers I saw in the subway or sitting on benches in Boston Common. It was hard going, and the only kind of drawing I ever did that wasn't fun. A struggle with a drawing of a model often ended with my ripping it up or defacing it by sticking a cartoon head on top. I switched to creating small sculptures made of found materials. I had long admired the sculpture of artists who worked that way, and that approach seemed ideal for someone like me who had no technical training to speak of. Plus, my art supplies were cheap—picked up off the street, dug out of dumpsters, or lifted from construction sites—ideal for someone living on meager earnings as a cartoonist. But doing the work was rarely what I'd call fun; a day in the studio often left me feeling lost and unhappy.

"Who's happy?" my father had gibed during the famous phone call. The internalized question kept me struggling in the studio.

I increasingly felt that I needed to be in New York, the center of the art world. I had missed the City—it was my real home. Unfortunately, it was also home to my family. This fact kept me frozen in place until, in

the summer of 1983, an opportunity to share a loft with a friend on the Lower East Side proved irresistible. On a hot day in early September, I loaded a U-Haul truck with boxes and boxes of art supplies — junk, that is — and everything else I owned, and headed south. My new home was a large, raw, former industrial space on Chrystie Street on the Lower East Side.

The evening I moved in I had a scheduled phone appointment with my therapist back in Boston. We had agreed it would be our last conversation. While we spoke, I stood looking out the window at the front of the loft onto the wide concrete rectangle that still divides Chrystie Street from Forsyth Street. Today that space is a vibrant neighborhood park. That evening, in the fall of 1983, it was a giant bazaar stretching three city blocks from Delancey Street south to Grand Street, where drugs were openly hawked to a never-ending parade of customers. People wandered back and forth making connections, some screaming obscenities, some arguing — I witnessed at least one fist fight — some nodding out against lampposts. Scantily clad sex workers paced the sidewalk, now and then falling into conversation with a passerby. At one point a completely naked man walked by my building and nobody seemed to notice or care.

I was telling the therapist how five minutes after I moved in the landlord knocked loudly on our door and shouted at my roommate and me that the loft was an illegal sublet and he was going to get us evicted.

"It's all a little scary," I said.

"Wow. Not your parents' New York, is it?" she ventured.

"No, it's not, but you know what? I'm feeling happy too. Sort of elated."

"Say more."

"I can't believe I got myself here. The fact that I could finally do it — that I've *done it* — is a big deal. Because it means I'm free."

"Free?"

"Free from their clutches — from their *mishegas*. I must be, otherwise I'd still be back there in Boston, lying on your couch, going on about how I was too afraid to move back here."

I MADE A lot of new friends in my first years back in New York, many of them fellow artists. In early June 1989, one of those artist friends

started a women's group in Tribeca that included my future wife. At one of their meetings, Ginny mentioned that she was looking for a rental in Maine for August. The previous summer, she had stayed on Deer Isle for a month in the house belonging to Robert McCloskey, the author of the beloved children's books *Make Way for Ducklings* and *Blueberries for Sal,* but that house was not available again. My friend suggested another place on Deer Isle, a former boathouse that had been converted into a primitive cabin with a sleeping loft but had no indoor plumbing or phone; since our mutual friend knew that I was renting it for July, and after Ginny arranged to rent it for August, she gave Ginny my number so she could ask me about sharing the cost of putting in a phone.

Noting that we were both single, someone in the women's group playfully suggested that we might like each other. "Never happen," my artist friend insisted. "He's too silly, and she's too serious."

After Ginny graduated from Harvard Law School in 1976, she went to work for a Wall Street law firm for several years, then left to spend a year in Florida doing death penalty work, after which she returned to New York and began working for the Coalition for the Homeless, heading that organization's AIDS project. Not long after we met, she and two colleagues founded Housing Works, now the largest AIDS service organization in the country. Today she works as a consultant, mostly for Housing Works, focusing on public policy but still keeping one foot in the advocacy side of things, including, now and then, a bit of civil disobedience (see page 170), such as her 2019 arrest while protesting the lack of action on the creation of overdose prevention sites for people who inject drugs in New York State.

Is it any wonder that our friend had doubts about our compatibility? But as it turned out, Ginny can be plenty silly, and now and then, I can be somewhat serious.

When she called about the boathouse, something about Ginny's voice — probably the soft Alabama inflection — led me to ask her if she'd like to meet for a drink. We went on a couple of dates. She came to Maine a week early for her August rental so we could spend a few days together, I never left, and we've lived together ever since. In 1990 we were married at Bargemusic, a floating music venue on the East River under the Brooklyn Bridge. Among my enduring memories of that night is the

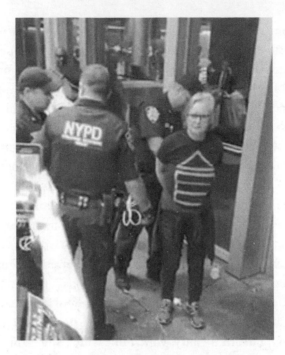

image of the Twin Towers in the background as we spoke our vows, and the sight of our two sets of parents, Nat and Estelle, Ray and Wylene, sitting side by side on a bench as we begin to make our vows, silently watching, looking like they had arrived from opposite ends of the universe without a common language.

Are We There Yet?

A YEAR AFTER MY marriage, I had a one-person show at a gallery in Soho. My parents came to the opening, and I kept a close eye on them the entire time, this being the only instance other than my wedding where my worlds collided — my parents meeting up with everyone else in my life.

Nat and Estelle were dressed to the nines for the occasion, my father in a dark gray three-piece suit, flawless red-and-blue striped Hermès tie, pale blue dress shirt, matching twin-peaked pocket square, and emerald and silver cufflinks, the gold fob of his pocket watch dangling from his vest pocket. My mother was tiny and resplendent in a beautiful black dress with a black mesh neckline, the dress made for her thirty years earlier by the Japanese dressmaker I had visited with my father on that Christmas shopping trip long ago; she wore the pearl necklace that my father would one day show me in the vault. All night long, people came up to me and remarked how elegant my parents were.

My mother seemed happy, if a little confused, smiling her irresistibly sweet smile, accepting compliments about me and my work from various friends, many of whom she had met at the wedding, asking me or Ginny over and over, "Who was that?" At one point a friend came over when my mother and I were standing together and asked what she thought of my sculptures. She put her arm through mine and replied, "He's my son — of *course* I think they're wonderful." Then she looked up at me with a twinkle in her eye and added, "If he's a good boy, maybe I'll buy one."

My father also seemed happy. He became especially animated when talking to various women friends of mine. He had a long conversation with the owner of the gallery — he later assured me that she was "very refined and knowledgeable." And he told me, with obvious pleasure, that someone had come up to him and said that her parents had been his customers and always talked about the beautiful things in his shop.

At one point I went over to him and asked how he was doing. He took my hand in his and said, "Congratulations. Everyone comes up to me and says, 'You must be very proud, Mr. Sipress.'"

"And . . ."

"What else? I tell them I'm proud." Then, catching himself, he squeezed my hand and said, "I'll always be proud of you, David. Why wouldn't I be?"

When the opening ended and I was helping him and my mother with their coats, my father pulled me aside and asked if there had been any sales. "Not yet," I replied, "but there's apparently a lot of interest in a couple of the pieces."

"That's good," he said, "but don't count your chickens."

"Believe me, Dad, I won't. You know, it's not about how many pieces I sell . . ."

"Spoken just like someone who's never understood the meaning of money."

IN ORDER TO complete the story of my art career, I need to jump forward a bit, to 1997. In the years that followed my Soho opening, I was unable to secure another show. I continued to be plagued by doubts about myself as an artist, and these had a way of morphing into doubts about myself in general. I worried more and more about money, including the cost of renting the big studio in Soho where I made my pieces. My increasing level of anxiety about this and pretty much everything else led to some particularly bad bouts of insomnia.

At some point, Ginny started to question why I was investing so much in my sculpture when it made me so unhappy. All along she had been insisting that my cartoons were no less important, and she was concerned that lately I seemed to be disparaging them relative to my serious art. The subject came up the night we celebrated my fiftieth birthday in

1997 at our favorite French bistro. "Cartoons *are* serious," she insisted. "Why on earth would you accept your father's definition of what's serious? Frankly, it wouldn't matter if you were a nuclear physicist, the secretary of state, or had a one-person show at the Museum of Modern Art — he'd still make you feel like you weren't good enough. You know what I think?"

"What?"

"I think he doesn't like the competition. Think about the bargaining — he always has to come out on top."

Later, thinking about this, I did this cartoon:

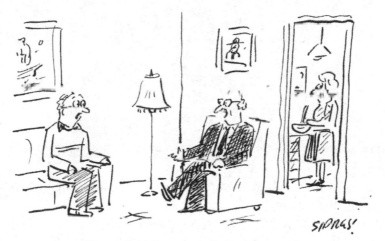

*"I never said I was proud of you because I
didn't want you to get a swelled head."*

Ginny reached across the table, took my hand, and said, "Here's an idea — why don't you do something nice for yourself for your birthday? Try not making sculpture for a while, just to see how it feels? You can always go back."

Maybe I had just needed someone to give me permission, because the next day, I put the plan into action — or inaction. For the next six months I abandoned the pieces I had been working on, stopped trying to contact potential galleries, happily did cartoons all day long, and slept like a baby. When the trial period ended, I hired a dumpster for my "art supplies," kept a few pieces for myself, and gifted the rest to friends.

And only a few months after I finalized my decision, I sold my first cartoon to *The New Yorker:*

"*Are we there yet?*"

I've always considered the caption to be exquisitely appropriate.

WHEN I FIRST told my therapist about my big decision, he asked if I was sure about it.

"I am," I told him. "I've even given up my studio."

"Does that mean you'll be working at home?"

"No way. I'll find a small office — something inexpensive."

"Why 'no way'?"

"When I do my cartoons, I need to be in a quiet, totally separate, hermetically sealed space. It goes with the territory. Most of my fellow cartoonists would agree — why do you think there are so many desert island cartoons?"

"Couldn't you just go into a quiet room at home and shut the door?"

"Nope. I have to go somewhere else to work. Besides, I like the fact that when I leave the house at eight o'clock every morning it's as if . . ."

"As if . . . ?"

I sighed. "As if I'm going to an actual job," I muttered.

"What was that?"

I repeated what I said, and then added, "It's pathetic, but now and then I still feel guilty about what I do for a living."

"Guilty?"

"That it's not a real job. That it's too easy — more like play than work. We both know whose voice *that* is — I still can't seem to entirely shut it up."

Then I sat straight up on the couch.

"What is it, David?"

"I'm thinking about all his talk about suffering — how he's always saying that if you're *not suffering,* you're probably doing the wrong work."

"Yes?"

"The thing is — it just hit me that the only time I ever saw him truly happy was when *he* was working — when he was in his shop, being Mr. Revere."

"So?"

"So where was all the suffering?"

"Good question."

ALTHOUGH I PUT my "serious art" career permanently behind me in 1997, it has had many lasting benefits for my cartoon work — in particular, what I learned about *seeing.* Knowing how to see, any artist will tell you, is half the battle when it comes to drawing. When I was making sculpture, I taught myself to see my pieces clearly by employing a trick I learned from friends who had gone to art school — looking at the reversed image of my pieces in a hand mirror. For some reason that I don't fully understand, this ruse always produced instant objectivity, allowing me to spot anything inessential, out of place, or just plain wrong. To this day, I do the same with my cartoons, and the hand mirror has rescued me from countless out-of-proportion body parts, skewed horizon lines, and cats who appear to have five legs because their tails droop down too far.

After all, striving for objectivity and becoming your own harshest critic is a good policy, no matter what the art form:

"Bad drawing."

On the other hand, something else I learned doing my sculpture that has informed my cartoon drawing is that sometimes it's better to leave your mistakes — i.e., those *happy accidents* — alone.

Along with these invaluable bits of knowledge, I got some of my favorite cartoons out of my twenty-year art career:

"This artist is a deeply religious feminist and anti-smoking advocate, who made a lot of money in the computer industry before going off to paint in Paris, where she now lives with her husband and two little girls."

"*I just wish I could loosen up like you.*"

"It was still breathing? You are <u>such</u> a foodie."

Secret Sauce

DURING THE YEAR after our wedding in 1990, my mother's short-term memory loss took a turn for the worse. I noticed big changes in her each time I visited the apartment, and even more so when Ginny and I ventured out with my parents to a museum, or took a walk with them in Central Park, or when we joined them for a dinner, which now almost always meant dinner out, since my mother's cooking had become increasingly erratic. And dinner out always, *always,* meant Gino's.

My parents adored Gino's. We dined there on countless Friday nights throughout my childhood and it continued to be my parents' favorite for the rest of their lives. The restaurant, shuttered since 2010, was a high-end, tie-and-jacket version of the classic Neapolitan-style eatery. Although Gino's couldn't be more different from the type of Italian restaurant I favor these days — as different as *prosciutto e melone* is from wood-roasted pancetta crostini with smoked sungold tomatoes — it's where I first fell in love with the pleasures and rituals of eating in restaurants. One only has to count up the number of cartoons I've done on the subject of restaurants and food in general to understand that both are a major obsession of mine, an obsession born on those Friday nights at Gino's.

Gino Circiello and my father opened their businesses within a few months of each other, in the mid-1940s. Both men were proud first-generation immigrants who made it; both were elegant dressers with intense, compelling faces that proclaimed their origins, my father from the Ukrainian *shtetl,* Gino from the sunbaked Mezzogiorno. They liked

"What will change my life?"

each other, and although their friendship never extended beyond the confines of the restaurant, their mutual respect was obvious from the warm handshake they shared every time we walked in the door.

My father loved being greeted like a celebrity at Gino's with a resounding, "Good evening, Mister Nat" by everyone from the bartender to the hat-check "girl." The moment we sat down, Gino would arrive at our table with my father's double scotch on the rocks and my mother's whiskey sour. Sipping his drink, my father would scan the room, taking inventory, noting which of his wealthy customers were in attendance. "There is so-and-so, Estelle," he'd whisper to my mother, "don't look, but she's wearing that diamond and ruby necklace I sold her last Christmas." He liked being around wealthy people; eating with them at Gino's made him feel like he belonged.

Gino's offered all the classic Neapolitan dishes. My favorites were *scaloppine piccata* and sausage and peppers. The single-page menu was handwritten in blue ink and covered by a plastic sleeve that smudged the text so that the names of many dishes were impossible to decipher — never a problem for regulars like us.

My father never even bothered to glance at the menu, since his order was always the same: clams *oreganata* to start, followed by lobster *fra diavolo*. He treated the bow tie–clad, ultra-professional waiters with

respect, undoubtedly because they treated him with the deference he craved — although a stocky, good-natured waiter with a florid complexion named Mike loved to tease my father about his rigid consistency.

Mike: "What's for dinner tonight, Mr. Nat? We're out of lobster *fra diavolo.*"

My father winced. Mike looked at me and winked.

Mike: "Just pulling your leg, Mr. Nat. We always have *fra diavolo* for you. But maybe you should try something different once in a while."

My father: "Never mind that, Mike. I'm not changing my horse in midstream."

Mike (pointing downtown in the direction of the nearby restaurant Le Veau d'Or): "Sorry, Mr. Nat. If it's horse you want, you'd better go to the French place around the corner."

WHEN I WAS growing up, my father's days unfolded in a never-changing pattern. Up at seven, black coffee and rye toast for breakfast, out of the house at eight, enter Central Park at Eighty-First Street, cross the bridle path, walk around the south end of the Great Lawn, exit at Seventy-Ninth, walk south on Fifth, turn left at Sixty-First, open the store at precisely nine o'clock. Every evening except around the holidays, he came in the door of our apartment between six and six-thirty, went directly to the bedroom, took out his billfold and placed it on his dresser, emptied his change into a small Wedgwood bowl, sat down in his favorite chair in the bedroom, and watched Walter Cronkite until seven, at which point my mother rang a little silver dinner bell. Still wearing his suit and tie, he would sit down at the head of the table, take one sip of his Miller High Life, belch discreetly on cue, and then nod to my mother that it was time to eat. There was some variation in the after-dinner routine, depending whether it was a *Danny Thomas Show* night, a *$64,000 Question* night, an *I've Got a Secret* night, or something else, but lights out for my parents was always eleven. Friday nights were the exception to the routine, since we often dined at Gino's — always at six-fifteen.

As he grew older, his resistance to change and need for certainty only hardened. From what I saw in my infrequent visits during the years immediately after his retirement, he made every effort to impose the same

kind of rigid structure on his work-free daily life as he had on his work life. By the time I returned to New York in the eighties, he appeared even more stuck in his ways, and more determined than ever to keep change at bay. The phrase "All I want now is my peace of mind" made increasingly frequent appearances in our conversations.

I understood my father's anti-change impulse quite well from my own struggle to overcome a knee-jerk preference for the safety of the familiar at the expense of the new and unexpected.

*"I know that change is a normal part of life,
but I prefer the other parts."*

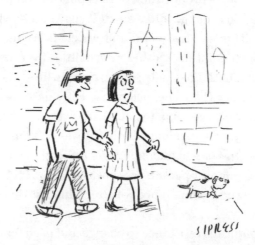

*"I'll promise to quit being so negative, if you'll promise
to quit making suggestions."*

For my chicken-counting father, however, the struggle to accept change as a normal part of life was long over, and "new and unexpected" was, for him, just another way of saying "trouble waiting to happen."

Of course, a person can only do so much to keep everything the same; eventually life is going to intrude. As I said to Ginny after a visit with my parents in 1990, grinning over my felicitous mixture of metaphors, "The change in my mother is the bump in the road that's upset the apple cart." My father fretted constantly now about my mother, especially when she left the apartment on her own, or when she was out with him and they encountered someone they both knew. One afternoon in 1990, they were walking in Central Park and ran into the actress and dancer Gwen Verdon, a longtime customer of my father's from the old days who lived in the neighborhood. "Where is Humphrey?" my mother asked her first thing. The actress looked confused. My father worried my mother had somehow mixed her up with Lauren Bacall, but then my mother said, "I don't usually like little yappy dogs, but he is an exception." She was mixing up Gwen Verdon with a tall blonde neighbor of theirs, dead for many years, who had a toy poodle named Humphrey. When he told me this story, he said that he worried every minute they were out together that something similar was going to happen.

My mother, on the other hand, the former world champion worrier, forgot how to worry. She certainly didn't fret about the forgetting — in fact, she seemed to get a kick out of it. At Gino's, she would forget what she ordered the minute the waiter wrote it down; when he placed her entrée in front of her ten minutes later, she would look down and laugh, and then turn to the rest of us with a big smile and say something like, "What a nice surprise! Maybe someone can tell me what this is?"

In all kinds of ways, she was driving my father absolutely crazy. Her favorite dish at Gino's was a pasta called *paglia e fieno* (straw and hay) that was famously served with Gino's "secret sauce." She loved it almost as much as she loved being in the presence of the celebrities who showed up on any given night. My father would always admonish us not to "gape," which was especially difficult back in the day when Elizabeth Taylor and Richard Burton could be seen carousing at a corner table with Peter O'Toole, or Joe DiMaggio strode in the door, but we did our best to obey.

Cut to 1991, on my mother's eighty-sixth birthday. We found ourselves seated at a table next to television journalist Mike Wallace and three colleagues, who were digging into their bowls of pasta as we arrived.

To my father's shock and horror, my mother turned in her chair. "*Estelle . . .*" he hissed.

She ignored him and said, "Excuse me, Mr. Wallace, may I ask you a question?"

Mike Wallace scowled, but his irritation melted away when he was confronted with the impish smile on my mother's tiny, wrinkled face. "Of course," he replied.

"I see you're enjoying the *paglia e fieno,*" she said. "Are you going to conduct a *60 Minutes* investigation to find out what they put in that secret sauce?"

Were these changes in her behavior, like her newfound feistiness, simply a result of memory loss? Or were they also little acts of rebellion? I've often wondered if, after fifty years of marriage and being the good soldier, her memory loss had liberated her, turning her back into the independent young woman she was before she married my father in 1937. Back then, she lived with three roommates on the Lower East Side, taught first-graders in the public school system, played tennis on the weekends, loved to go to the beach or hiking in the Adirondacks with her friends, dated regularly, and didn't have to adhere to a strict daily schedule or check with anyone if she decided to change her mind about what to do or where to go.

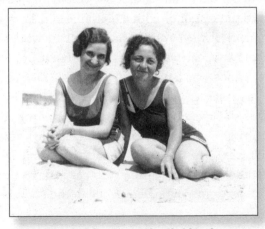

My mother (right) with an unidentified friend, c. 1930

One early afternoon in 1993, she said good-bye to my father, left the apartment to go to the supermarket with her shopping cart, and didn't come back. He called me and I dropped what I was doing and hurried uptown. After three hours, during which I circled the neighborhood, we were ready to call the police when she walked in the door.

"Where *were* you, Estelle?" my father pleaded. "I've been worried sick."

She smiled her sweetest smile. "I was taking a little walk," she replied. "It's so lovely out."

This was in February. It was cloudy, freezing, and threatening to snow.

"You didn't go to the supermarket?"

"No. I just went for a walk."

"For *three* hours?" And then, "Where is the shopping cart, by the way?"

"I don't know, Nat. When was the last time you saw it?"

After my mother went to her bedroom to change clothes, my father and I retreated to his "den." This was a room off the living room where he now spent most of his time, sitting at a small desk that was empty except for a phone with an oversized senior citizen keypad, his hands clasped as if in prayer that God would send him some work to do. One wall of the den was lined with packed bookshelves containing expected titles such as a biography of Henry Kissinger and the novels of Leon Uris. But there were plenty of surprises too, like *The Bolsheviks* by Adam Ulam, *Crime and Punishment, Madame Bovary,* and the poems of Baudelaire, books that were hand-me-downs from my sister and me, relics of our long-lost educations.

(More than once my father informed me of his intention to read every book in the apartment "before . . . you know what.")

On another visit two years later, Ginny and I came for dinner and when we arrived we found him sitting at his desk reading *The Stranger.*

"Do you like it?" Ginny asked him.

"Sure," he replied. "He agrees with me that nobody is watching." It was about the most my father had ever revealed about his core beliefs, and it led to an interesting conversation.

"So you're an existentialist?" I asked him, after we'd sat down on the couch.

"What's that?"

"It's what Camus was. It's someone who believes what you just said. It's kind of like an atheist."

"OK, so I'm an existentialist."

I grinned and said, "To tell you the truth, Dad, I've always suspected that deep down you're still Jewish — with the God who's *always* watching."

"Why can't I be both? Jewish and whatchamacallit."

"Existentialist."

"Right. Like that new shortstop on the Yankees."

"Jeter? What about him?"

"He's both — fifty percent Black and fifty percent Irish."

"It's not the same, Dad."

"Anyway, I tell you what — if, God forbid, the Nazis ever come back and take over, I won't be fifty percent anything. You either. We'll both be one hundred percent Jewish."

"That's a cheerful thought."

Ginny squeezed my thigh and said, "Why don't we change the subject?"

NOW MY FATHER and I sat in the den listening to my mother, fresh from her walkabout, clang around in the kitchen doing who-knew-what.

"She's got some energy," he muttered. "You'd think she'd be exhausted."

He turned on the television and we watched the end of a nature show on PBS (the television had been permanently set on PBS since 1980, the year Walter Cronkite retired from CBS). When it was over, I turned to him and said, "*Now* will you agree that you need some help, Dad?"

"What for?" he snapped. "Everything is fine. She's home now."

"But what about the next time? And the next?"

"There's nothing I won't be able to manage."

"Don't count your chickens, Dad."

"Don't be a smart guy."

"I can't come up here every time there's a problem."

"Who asked you?"

"You did."

He shook his head and then lifted his eyes to the ceiling. "I don't want to bring some stranger into my house and upset the apple cart."

"Dad . . ."

"What if they . . ."

"Rob you? Raid the liquor cabinet? Rearrange the stuff in the refrigerator?"

"Never mind. I just don't like the idea of changing . . ."

"Not the horses, again. And where we're at right now is hardly midstream. The status quo isn't working, Dad."

"Maybe I like the status quo," he pleaded softly. We were silent for a few seconds. Then he said, "All this change is giving me indigestion. And there's the expense. I just don't know . . ."

I shook my head.

"OK, OK," he said, "I get the picture."

"You'll get used to the person. I promise. Pretty soon everything will be just like it's always been, only you won't have to worry all the time about Mom."

He fiddled with his moustache and ventured, "Here's an idea — what if we only have them come to take her to places — like to the supermarket?"

"Dad . . ."

"Or I could start going out more with your mother. I just need to get a little strength back."

I sighed.

"What if I took up swimming again to get in shape?"

"I give up."

"Hey! Take a joke, mister cartoonist. So, listen . . ."

"Yes?"

"So, we'll get a girl for your mother."

"Thank God," I sighed.

"But she has to be a looker."

"Please, Dad."

"Just pulling your leg. Where's that famous sense of humor today? Anyway, I wouldn't want to make your mother jealous."

A couple of weeks later, he hired Maeve. Many years later, I came up with this cartoon:

"Here's the deal: we call the shots when you're young, you call the shots when we're old, and everything in between is a non-stop battle for control."

The Whole Story

"Then what happened?"

A FEW WEEKS AFTER my mother's disappearing act with the shopping cart, my father again called me sounding upset.

"Is it Mom?"

"No, no, your mother is fine. Intoxicating Woman took her to the museum, and then to visit somebody — now I can't remember who. What's the matter with me? Maybe what your mother's got is contagious. Anyway, the girl is back now and whoever it is your mother went to visit is going to bring her back later."

"What's wrong, Dad? Are you sick? Is it your back again?" His back had been bothering him for several weeks, ever since the day of my mother's walkabout.

"My back is the same. Everything is the same. I felt a little dizzy earlier, but now I'm OK."

"*Dizzy?*"

"Take it easy. It's nothing medical."

"Then what is it?"

"Something happened."

"What?" I asked.

"Something," he replied.

I sighed. "Maybe I'll come over," I suggested.

"Good. I'll tell you when you get here. But if you're coming, make it soon, so I can talk to you before your mother gets back. She doesn't have to hear this."

He opened the door immediately when I rang the bell—he'd obviously been sitting in a chair in the foyer by the front door. I greeted Maeve, who was reading a magazine in the kitchen, and followed him into the den. With a series of grimaces, he lowered himself into the upholstered chair at his desk in segments, like a marionette.

"The back looks bad, Dad," I said, when I had settled onto the couch. He dismissed this with a wave of his hand.

As usual, it was a million degrees in the apartment. I said, "Aren't you hot? Do you ever think of turning the heat down?"

"Why? I get it for free, don't I? Not like the electric, which costs an arm and a leg every month. Not to mention the phone bill. And of course, the nurse. Meanwhile, your sister is worried that I'm frittering away her inheritance."

"What? She said that?"

"Not in so many words." He dismissed the topic with a wave of his hand. "Anyway," he said, "a few minutes after your mother and Intoxicating Woman left this morning, I had a visitor."

"A visitor? What visitor?"

He looked down at his hands. "A relative," he said, his voice lowered.

"A relative? Since when do you have visits from relatives? Who was it?"

"Since this morning. And who it was isn't important. You don't know him. He's somebody's son."

"*Somebody's son?* What does that mean?"

He lifted his eyes and, frowning, stared fixedly at me for several seconds. I shook my head — message received — *we're not going to go there.*

Finally, I asked, "What did this 'somebody's son' want?"

"What do you think? A minute after your mother left, he calls me from the pay phone on the corner, asking if he can come up and talk to me. He said it was important. What was I supposed to do? I buzzed him in and when he arrived, he had a little kid with him. That was how I knew right away what he wanted — the little girl was obviously supposed to tug on my heartstrings. Which she did. She was very polite, shook my hand and everything. I called in Maeve and told her to take the kid to the kitchen and fix her a snack. As soon as the kid left the room, he told me his sob story."

I'm not sure I want to hear this, I thought.

"He said, 'Business is not so good. I made some bad decisions.' Long story short, he wanted to borrow money for his mortgage. He couldn't pay it and he claimed he was about to lose his house somewhere in Westchester, maybe he said Scarsdale, which is not a place you should be living if you can't make your ends meet."

"What did you say?"

"I told him I'm with Shakespeare: 'Neither a lender or a borrower be.'"

"Please tell me you didn't say that?" I was starting to feel really uncomfortable, worried about what was coming next.

"Why not? I explained to him that I never borrowed a penny in my life, that I couldn't live with the obligation. If I couldn't afford something, I told him, I did without. The golden rule is, stay within your means."

I looked away and said, "I thought the golden rule was the customer is always right."

"What?"

"Nothing."

"Anyway, I said I don't believe in mortgages and I bought this place with cash on the barrel. I told him I don't believe in credit cards either. I never owned one in my life. Which doesn't stop them from trying to entice me, by the way. Do you want to see the letters?" He started to open the desk drawer.

"No, Dad. Please just go on."

"OK, so now he was sweating. He kept wiping his forehead with his

shirt sleeve. He was wearing one of those fancy shirts with the polo player. It was pink, believe it or not. The shirt he could afford. In any case, I explained that lending goes against my grain, that it only makes for trouble. Besides, I have to watch every penny like a hawk, I told him, for my children's future. And that's when he started to cry — a grown man and he started to cry."

"Oh no."

"'I have a child too,' he told me, pointing in the direction of the kitchen, 'and two more from a previous marriage. I'm at the end of my rope.'"

"'You have to be strong,' I told him, 'you have to fight like the dickens and make hard decisions. It's like I always tell my son,' I said, 'it's never too late to learn the meaning of money.'"

"Oh, *God,*" I groaned.

"That's when he got nasty . . ."

"What a shock," I muttered.

"He stood up and started calling me names and bringing up ancient history — about my family and the estrangements — which I don't need to go into. He pointed his finger at me and called me an egotistical son of a you-know-what who thinks he's better than everyone else and doesn't give a shit — pardon his French — about others who are worse off."

"Jesus, Dad."

"I wasn't about to take *that* lying down. 'What the hell do you know about it?' I said. 'What do you know about what I give to charity every year?'"

"'Sure,' he said, 'you give to *strangers*. But where your own family is concerned, your own flesh and blood, you turn your back. You've forgotten where you come from. *Who* you come from!'"

"'That story's not all one-sided . . .'" I started to tell him.

"But he shook his finger at me and said, 'How dare you sit there like King Solomon and lecture me about the so-called meaning of money!' By this time he was really shouting. 'The *meaning of money*? I'll tell you the meaning of money: It turns some people into selfish old bastards!'"

"Take it easy, Dad," I cautioned. His face had turned bright red.

"I'm OK. I'm OK." He exhaled. "So . . ."

"Yes?"

"So, that's what happened."

"I am *really* sorry, Dad."

"What can you do? It shook me up, if you want to know the truth. Who knows? Maybe if he had calmed down, I might have relented a little. But just then Maeve came in from the kitchen to see if everything was all right. The kid was hiding behind her. 'Fine!' the guy said, and he shoved Maeve out of the way, grabbed the kid, and next thing I heard was the front door slam."

He pushed himself up from his chair, turned around and stared out the window. He sighed and said, "The whole thing made me dizzy. Maeve brought me one of those pills for my nerves, but I didn't take it — I hate the way they make me feel."

"He had no right, Dad," I said.

"Maybe, maybe. Sometimes . . . I don't know . . ." He sat back down. After a pause, he said, "We all have times in our life when it's no bed of roses. Once, long ago, believe it or not, I was in big trouble just like him, and, God forgive me, I almost did something."

"Did something?"

"I needed money," he continued. "I made some big mistakes. I was going to lose the jewelry business after coming all that way from nothing. I thought maybe I would have to go to work for someone else again, which I swore I'd never do, considering how I'd been cheated and treated like a piece of dirt in the past, which I don't need to go into. And there were medical bills for someone, and other problems too, again which I don't need to go into. Most of all, I had to keep postponing asking for your mother's hand. Every morning I woke up worried sick."

"What did you do?"

He leaned forward, elbows on the desk, and said, "Nobody knows this, not even your mother."

I leaned forward too, but mostly to suppress the gurgling sound suddenly emanating from my insides.

"I went one afternoon to a building on Forty-Seventh Street. I was supposed to meet with some shady diamond dealer who was known to lend money — a real shyster, if you'll excuse the expression. His office was on the top floor and I stood outside his door for a few minutes gathering my forces. Then I looked down the hallway and saw the door to the roof. I climbed up the stairs and went outside. It was summertime and

hot as hell up there. The asphalt was like a soggy sponge. I walked over to the edge and sat myself down on the little wall that surrounded the roof and let my legs hang over the side. I looked up at the skyscrapers. Then I looked down. People on Forty-Seventh were scurrying around like ants. 'That's me,' I thought, 'all I'll ever be is an ant.' I shut my eyes and said a little prayer from childhood. Next, I slid my rear end right up to the edge, still with my eyes shut. What I thought about next was my poor mother, may she rest in peace."

He paused to take a breath. Between picturing him on that wall and the nearly unprecedented mention of his mother, I was beginning to feel lightheaded.

"And then?" I asked.

"Then, nothing. For some reason, after my mother, the next thing I thought was, 'I have on a brand-new suit.' And believe it or not, *that's* what stopped me. Who can explain? But for a minute there it was fifty-fifty."

Fifty-fifty, I thought.

"And as you can see, I'm still here." He grinned. "Lucky for you."

"Right."

"Anyway," he continued, serious again, "I went down the elevator. Once I was back out on the street I told myself, 'If you don't want to wind up an ant, you have to fight, Nat — starting right now. Quit bellyaching and fight your way out' — just like I told him who was here earlier."

"So . . . what happened?"

"What happened?" He raised both hands and made a wide circle with his arms, taking in the apartment and everything in it, including the view out the window across Fifth Avenue to Central Park. "*This* happened," he said. "My success happened."

We sat quietly for a few seconds before he placed his hands affirmatively on the desk and said, "Why shouldn't I be proud? Of what I accomplished."

"Of course you should, Dad."

"You do what you have to do," he said. "There's no point dwelling on water under the bridge."

"I understand," I said, even though I didn't. I was still up on that roof.

"But here's the best part," he said, smiling now. "I was shaken up from

what almost happened, so I walked a few blocks trying to calm myself down. To make myself feel better, I went into a drugstore where they had a phone booth and tried to call your mother. I wanted to hear her voice. I put in my dime, and then . . . nothing. No dial tone — nothing. I cursed and hit the coin return. Nothing came out. I put in another dime. *Again*, nothing. 'I can't win!' I thought. I cursed louder and slammed the coin return really hard with the palm of my hand and *bam!* Out they came — like in Las Vegas — *dimes!* A regular river of them, flowing out of the coin return chute. I cupped my hands but I couldn't catch them all. They were falling everywhere. I opened the door to the booth so I could bend down to pick them up off the floor, the whole time checking that nobody was watching. A dime was worth something in those days, by the way — not like today. Today, with my back, I wouldn't bend over for a ten-dollar bill."

"The story . . ."

"OK, so, finally I managed to pick them all up. I snuck out of that drugstore as nonchalant as I could under the circumstances. I walked around the corner and pretty soon I stopped and stuck my hands into my pockets. I felt those dimes slide all over my hands and between my fingers and I thought, 'It's a sign. A miracle. Everything is going to be all right.' I turned around and marched straight down to your mother's apartment on Essex Street and there and then, I asked her to marry me. You see? A happy ending."

"I never knew that, Dad."

"How could you know?"

I was grinning now.

"What?" he asked.

"So, it's a money story that turns into a love story . . ."

"So?"

"So, maybe the *meaning of money* is love?" I had a recollection of my therapist once telling me that in some families money and love were interchangeable, the former a convenient, at times unavoidable, substitute for the latter. I'd have to give that one some serious thought when I had the chance, I decided.

"Don't be a smart guy," my father admonished. He stood up and said, "Here's an idea — let's have a drink before your mother gets back."

I followed him to the liquor cabinet in the living room. He got out two glasses and poured us both a generous shot of his favorite libation, Haig & Haig. We clinked glasses, and while we were still standing there, he looked up at me through the fog of his bifocals and said, "Sometimes I feel like I know next to nothing about you, David. I guess maybe you get that from me."

I drew back my head and frowned.

"Don't give me that look. You know what I mean. Don't pretend you don't. Remember from *Dragnet*? 'Just the facts, ma'am?' That's you."

"That's not true . . ."

"It's OK. These days with my other worries, maybe I prefer it that way — for my peace of mind. I just hope your wife gets more information than we do. Come to think of it, while we're on the subject of money, there's something I want to ask you."

"We're doing fine, Dad. Everything's OK. Ginny and I are happy and we don't need . . ."

He held up his hand. "Never mind that right now — it's not what I want to ask you about. It's about something I was reminded of a few minutes ago. We were talking ancient history and my question refers to that."

"What?"

"OK. Remember that time at the beach when I sent you for the paper and you threw away the dollar?"

"Here we go . . ."

"Wait! I haven't asked my question yet."

"What's your question?"

"Are you sure that's what happened?"

"What do you mean?"

"Like I said. Are you *sure* you threw it away? You didn't spend it at the store, by any chance?"

"It's a million years ago, Dad."

"You're going to say you don't remember? I know you remember from the way your face is turning red." He was grinning. "What was it? Did you buy some ice cream? Some candy?"

"Why do you care about this?"

"Why do *you*? Like you said, it's a million years ago. Just tell me the truth. Don't worry, I'm not going to spank you."

I smiled and raised my eyes to the ceiling.

"There's no sense lying, David, and I'll tell you why: You remember the Argyle Sock King? What was his name? The one who switched all his machinery to make argyle socks and then a few months later they went out of style and he lost his shirt? Anyway, later in the morning your mother arrived at the beach and she thought the whole thing with the money was hilarious. You and she went home at lunchtime, and soon after, Mister Argyle Socks showed up carrying a Sunday *Times* he'd just bought. And where did he buy it? Can you guess?"

"Give me a break."

"That's right — at the candy store."

He reached up and pinched my cheek. "Now you're really turning red. So tell me . . ."

"I can't believe this. OK, OK, guilty as charged. I spent it on candy."

"Finally! The cat's out of the bag! So, was it the whole entire dollar you spent on candy?"

"No."

"Now we're getting someplace. So there must have been change, right?"

"*Yes.* There was change."

"Bingo! And what happened to the change? I searched you, didn't I? Let me guess — you didn't know what to do with it, so you threw it away, right? Maybe that's where you got the idea to say you threw away the dollar."

"*Yes,* I threw away the change, Dad. Happy now? Is that all? Can we enjoy our drink now?"

"You threw it away," he affirmed, nodding to himself. "So, even from the beginning you didn't understand . . ."

"Don't even say it, Dad. I'm going back to the den."

He followed me. We sat in silence for a few minutes. Every time I looked at him, he had the very definition of a self-satisfied grin on his face.

Finally, I said, "There's something I don't understand, Dad — if you

knew I was lying about the newspapers and the dollar bill, why didn't you ever say something?"

He took a sip of his scotch. "What? And deprive your mother of one of her favorite Little David stories?"

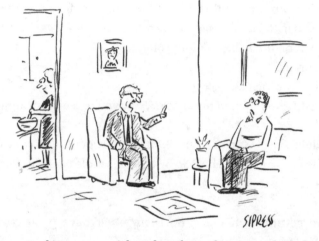

"I came to this country with nothing but a shirt on my back that wasn't even a shirt—more like a filthy rag with holes—and I never even got to go to school because at ten-years-old I had to go out and work my fingers down to the bones in order that my poor mother could have a bowl of thin soup for dinner, and I still managed to save a few pennies every week like a miser so that one day I could spend them giving you the best education money can buy so you could grow up to be a big deal lawyer or professor or some such thing, and now you tell me you want to throw all that down the drain and live like a pauper in some hovel, drawing silly pictures for the rest of your life since money doesn't matter to you because maybe you think it grows on trees? You know what your problem is, mister funny cartoonist? You don't understand the meaning of money!"

PART THREE

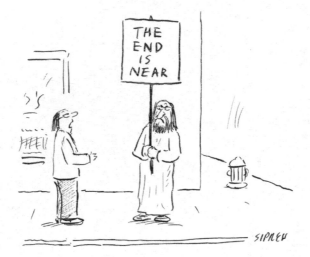

"*Can you be more specific?*"

Bygones

"Did we mention that we spent last summer in Maine?"

SINCE OUR FIRST summer there in 1989, Ginny and I have spent part of nearly every summer on Deer Isle. In 1995, we rented the boathouse for the entire summer. By then, with fax machines and FedEx, we could both do our work just fine from Maine. All summer long when we called my parents, my mother kept asking when we were coming home. We returned just after Labor Day, and a few nights later we went uptown for a dinner with my parents and Linda. The cooking was done by a housekeeper who was now coming in a couple of nights a week.

The change in my mother was shocking. Shrunken and frail, she looked barely there inside the nightgown that she wore day and night.

Her hands shook constantly. She rarely spoke. Even so, she managed to ask me the same poignant question that had become a ritual between us on my visits: "You had a happy childhood, didn't you, David?" For once, I made myself respond without hesitation.

She seemed overjoyed to see us, smiling across the table at me throughout dinner, now and then nodding, as if to say, "There you are." Ginny sat beside her, and at one point, she took Ginny's hand, leaned over, and whispered something in her ear. Ginny looked surprised; when I raised an eyebrow, she signaled to me that she would tell me later.

The two of us didn't manage to be alone together until we left the apartment. Going down in the elevator, I asked what my mother had said.

"She said, 'You know, I've been waiting for you.'"

Two nights later, one month short of her ninetieth birthday, my mother went to sleep and never woke up. The doctor said she'd had a massive stroke.

MY FATHER ONLY discovered that she had died when he woke beside her body in the morning. He called us right away and we jumped in a cab. When we arrived, Linda was already there. My father, more than anything, seemed angry. We sat in the den waiting for the medical examiner to arrive, my father at his desk, silently fiddling with papers, opening and closing drawers. At one point my sister said to him, "Well, given her condition, it was bound to happen sooner or later."

"What are you talking about?" he snapped, and he slammed his palm down on the desk. "You have no goddamn idea!" I could not recall another time in recent memory that he had raised his voice to Linda.

"Sorryyy..." she said, and then she smiled at me and rolled her eyes.

"This was not supposed to happen," my father muttered. He took off his glasses, wiped them with the belt of his bathrobe. "I better put on a suit before they get here," he said. He got up and left the room. All I could think about was what it must have been like for him to wake up beside her body. I wanted to comfort him, but he clearly was not in the mood. He never was in that mood, I reminded myself.

The medical examiner arrived and requested that someone identify the body. I volunteered and Ginny came with me. My mother's tiny,

ashen head lay peacefully on a pillow, her lips slightly parted, her eyes shut, her bare white arms and mottled hands arrayed on top of the sheet that covered the rest of her. This was my first dead body. I suddenly felt scared. Ginny put her hand on my back and said, "We should bring your father her wedding ring." She had to use soap to get it off my mother's finger. When she handed it to my father, he thanked her — it seemed to calm him down. And then he handed it back to Ginny and said that she could have it. She has worn it ever since.

My father had long ago decided that Frank Campbell would be the venue for whatever service would be held for himself and my mother, it being the funeral home of choice for many of his wealthy WASP customers. Even in death, he was determined to assimilate. Two gentlemen from Frank Campbell arrived. There was an awful moment when they wheeled my mother out of the bedroom. My father quickly turned away and looked out the window.

He kept looking out the window until he was sure my mother's body was out of the apartment. Then he went over to the couch and lay down. He removed his glasses and draped one arm across his eyes. "This was not supposed to happen," he said, repeating what he'd said earlier, speaking so softly that I almost couldn't hear him. "She wasn't supposed to go first."

But not so long ago you told me you were determined not to leave her alone, I thought.

I recalled something I once heard someone say, that there are two things you can't control — cats, and what's going to happen. Concerning the latter, in the case of my father, it wasn't for lack of trying.

Ginny and Linda changed the sheets and the bedspread on my parents' bed. Then they went to the kitchen to make something for us to eat. I entered my parents' bedroom and sat on the corner of the bed. I thought about my mother — my mother the worrier, my mother the joker, my mother the artist, my mother the housewife, my mother the charmer, my mother the martyr, my mother the good soldier, my mother the mischief-maker. I looked around the room. In one corner I noticed a pair of her shoes. They were standing on the carpet in front of her closet as if she had just stepped out of them. I thought about the negative space in a drawing — how it's nothing and also something. My

mother's empty shoes evoked something similar — an absence that was also a presence.

The funeral was well attended. There were several old friends of my parents', some elderly customers of my father's, friends of my sister, friends of mine and Ginny's, people who knew my mother from her volunteer work at the hospital, even her tiny Japanese dressmaker, who had to be pushing ninety-five. Two spry, loquacious, handsomely dressed women in their late eighties or early nineties arrived together and came right over to me and explained that they were friends of my mother's from way back in her single days.

"Look at this," one of them said. She pulled an ancient snapshot out of her purse. It was my mother, grinning at the camera, standing in front of what looked like a clubhouse, wearing a long skirt, white socks, and an early version of sneakers. Her hair was wrapped in a sort of turban that was knotted at the front.

"Is that a golf club she's holding?" I asked, amazed.

"Yes!"

"She played golf?" *My mother played golf?* It was like finding out she'd been an airline pilot, or a flamenco dancer.

"She sure did," the woman replied.

"You see her putter?" the other woman asked. "Can you tell how short it is? We always had to rent her children's clubs!"

The service was to be conducted by the young Reform rabbi from the synagogue my parents attended every year on Yom Kippur. Two days before the funeral he came to my parents' apartment to discuss the service. My father was in another angry mood. Over and over, he praised the rabbi's predecessor, who had recently died, actually saying things like, "There will never be another like him." Nonplussed, the new rabbi graciously carried on. When he asked us what we wanted him to say about my mother, my sister shrugged, and my father turned to me and said, "You decide."

I gave the rabbi a brief biography, mentioning her teaching, her painting, her travels, her volunteering, her long marriage.

"You could say this," I told him, "you could say that everyone loved her."

My father nodded. My sister looked away. As it turned out, I would hear those exact words over and over from one person after another on the day of the funeral.

As the rabbi got up to leave, my father shook his hand and said, "Don't make it too religious."

The day before the funeral, Ginny and I went to Frank Campbell and met with the funeral director in his office. We were surrounded on all sides by shelves displaying urns of various shapes and sizes. The funeral director's name was Edward Something-or-other, and he definitely looked the part. He was tall and rail thin, completely bald, very pale, with long arms and large hands. He had dark rings under his eyes, cheekbones like slashes, and a small mouth that turned down at the corners, giving him a perpetual look of disapproval. My father had stipulated in their wills that he and my mother should be cremated, so Edward explained to us how that worked. He *ahem*-ed every ten seconds or so as he spoke, now and then pulling out a handkerchief and coughing into it. After we chose an urn, he left the room to find someone to give us a tour of the different chapels on offer, at which point Ginny whispered to me, "He looks like death eatin' a cracker."

From that day on (we would have several more encounters with him in the coming years) we referred to him as Half-Dead Ed.

At ten-thirty the next morning, Ginny, Linda, and I stood in the lobby of Frank Campbell greeting people as they arrived, while my father sat inside the chapel where the service was to take place, accepting condolences. When the piped-in music started up, Half-Dead Ed tapped me on the shoulder. He said, "Someone, *ahem*, has to come with me to identify the body — for the cremation, as I, *ahem*, explained to you."

When I saw my mother, it was a bit of a shock. Her makeup was so garish — her eyelids were painted teal blue, her lips brick red — that I was tempted to tell Ed that it wasn't her after all, because she never would have gone out of the house looking like that.

Ed closed the coffin, looked at his watch, and told me that we needed

to get started. I went back to the lobby and the rabbi and I ushered some stragglers into the chapel. As we checked the lobby a final time, the street doors swung open and a tight knot of eight or nine adults, most of them elderly, all but two of them men, filed in. They were dressed head to toe in black, and the men wore wide-brimmed black hats.

I said to the rabbi, "They must be here for someone else." He crossed the lobby and went to talk to them.

I realized that my father was standing beside me. There was a look of total stupefaction on his face. "What is it, Dad?" I asked.

But instead of answering, he began to shuffle across the lobby, arms stiffly at his sides, heading for the mysterious new arrivals, who were having an animated conversation with the rabbi. All at once, the group did an abrupt about-face and exited the funeral home. My father stopped in the middle of the lobby and stood staring at the spot they had vacated. I hurried over and put my arm around him.

"Who was that, Dad?" I asked. "Are you OK?"

"I have to go to the men's room," he said. "I'll just be a minute."

The rabbi reported to me that one member of the group had told him that they were "relatives of my father from Brooklyn." They had seen the notice in the *Times*. They had asked where my mother was going to be buried and when he informed them that she was going to be cremated, they left without another word. For Orthodox Jews, the rabbi explained, cremation was *farbotn*.

"Right," I said, "I knew that."

All at once the shadowy gulf between my father and the family he left behind took on a more defined shape than it ever had before.

Ed came over and pressed me again about getting started. "What's the matter?" I snapped. "You need the room?"

I went into the men's room. My father was standing at the sink. He had taken off his glasses and was wiping one eye with his handkerchief. When he saw me come in, he put the glasses back on and before I could say anything, he walked past me to the door, saying, "Let's mosey. Your mother is waiting."

"Dad, I'm sorry . . ."

"Never mind," he interrupted. "Bygones are bygones."

Beautiful Things

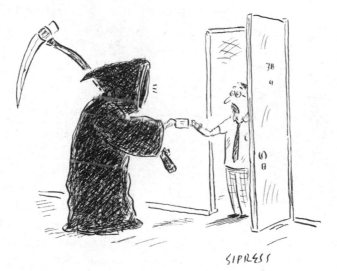

SIPRESS

"Don't freak out—it's just a save-the-date."

AFTER MY MOTHER died, my father's imminent demise was on my mind, and I found myself wondering what I could say in a eulogy that would be an honest expression of the true Nat Sipress. I kept returning to his excellent "eye" and to the four words he so often said about himself: "I love beautiful things." They would do the trick, I realized, both for what those words said, and for what they left unsaid.

My father died on January 3rd, 1998. Ginny and I had called him earlier that day from London and he'd told us that he had caught a cold and wasn't feeling well. We said we'd phone again later. At around ten that night, we called from a phone booth on Marylebone High Street and it was Linda who answered. She told us he was gone.

His death, just a little more than two years after my mother's, meant that the Grim Reaper was very much on my mind at the time, and has been ever since, for that matter:

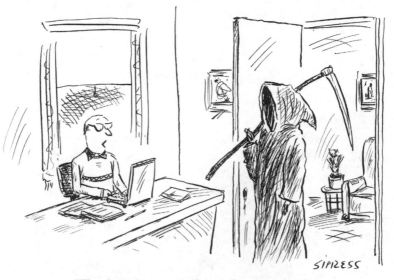

"Thank goodness you're here—I can't accomplish anything unless I have a deadline."

It was truly bad timing on my father's part to die when he did, considering my lifelong quest to convince him that I was a success. Two months before it happened, in early October 1997 — Friday, October 3rd to be exact, at 11:27 in the morning — I got the fax from the cartoon editor at *The New Yorker,* congratulating me on my first sale to the magazine. The second person I called after Ginny was my father.

"That's good," he said when I gave him the big news. "When will I see it?"

The answer, sadly, turned out to be never. I had no idea at the time that the date that you sell a cartoon to *The New Yorker* has nothing whatsoever to do with the date it gets published. As it happened, my first one did not appear until the following July. Every week between my first sale and our departure for London, my father would call and report what I already knew: "Well, *The New Yorker* just arrived and I still don't see it." After several weeks he actually began asking me if I was "really sure" that they had bought it.

MY FATHER'S FUNERAL at Frank Campbell was a lot like my mother's—equally well attended. A part of me was hoping for a reappearance of the long-lost relatives. *Perhaps I can summon the courage to start a conversation and learn a thing or two,* I thought. But another part of me was relieved when they didn't show.

Before the ceremony began, I once again had to go with Ed to do the identification for the cremation. Following behind him to the small room containing the casket, I thought about the word "mortician"—that *mort* is the French word for death—hence, Half-Dead Ed, death-tician.

My father, dressed to the nines as always, looked very much like his alive self, minus the ubiquitous bifocals. Linda had picked out a blue suit and red tie. I whispered good-bye to him and I told Ed I was ready, but I didn't move. The funeral director gave me a perplexed look, undoubtedly because I had a big smile on my face.

When we had returned to our apartment from the airport two days earlier, I immediately pulled my only suit out from the back of the closet, only to discover that it had been thoroughly eaten by moths. The jacket and pants were riddled with holes and the cuffs of both looked like shredded wheat. The next day was Sunday and the funeral was Monday, so there was no way I could shop for a replacement in time. I was left with a stark choice: wear the suit with the holes, or wear my only sport jacket—a lightweight, tan, un-funereal summer number with a wide check pattern—which I ended up going with.

The reason Ed saw me smiling? Because *this* had just popped into my head:

Ten minutes later, I got up to give my speech. I scanned the chapel — my sister was in the front row, looking around nervously and crossing and uncrossing her legs. She caught me watching her, and for a split second, I had the crazy thought that she was about to stick her tongue out. Instead, she smiled and lifted one hand in a little wave.

Should I mention their special connection? I asked myself. Probably not. I couldn't think of a way to do it that wouldn't sound weird.

I switched my gaze to Ginny, who was sitting next to Linda, sending me positive vibes. She took a sidelong glance at Linda, then turned back to me and raised her eyebrows. Just before the service began, I had reported to her that Linda had pulled me aside and thanked us profusely for taking care of everything to do with the funeral, and for dealing with Ezra, the executor, so that she wouldn't have to.

"Then she gripped my arm kind of hard and asked when we would like to have dinner with her," I told Ginny. "I mumbled something garbled and turned around, saying I had to review my speech. I can't deny that I was having a frisson of worry about what life is going to be like for her without my father around."

"Not to mention what life is going to be like for *us*," Ginny added, "*with her* — without your father around."

"Yikes," I said.

The chapel was almost full — in addition to a large contingent of our friends and Linda's friends, there was a smattering of elderly men and women (Old friends? Former customers or jewelry business colleagues who saw the obit in the *Times*?), none of them paired off — widows and widowers, I assumed.

I'd been wrestling with what to say, hoping that when I faced the crowd I would finally experience some strong emotion, something closer to traditional grief, and that this would inspire me to say something more moving than the words I had prepared. But it didn't happen. So, I started with a bit of humor. I said, "My father was a great lover of aphorisms. He came out with one nearly every time he spoke." I noticed several of the old folks nodding. "A lot of them involved animals — chickens in particular, but also horses — *you can bring a horse to water, a horse of a different color, don't change horses in midstream* — which was surprising since he

had virtually nothing to do with horses during his adult life, unless you count the ones he encountered crossing the bridle path in Central Park." This got a few laughs. "Among his favorite sayings," I continued, "was one he relentlessly drilled into my head over the years — it could have been his motto: *If at first you don't succeed, try, try, try again.* And that is exactly what Nat Sipress did throughout his life."

I then described his journey from impoverished immigrant with a fifth-grade education to successful businessman, his tenacious drive to be the best, his exquisite taste, his personal charm and reputation for honesty that earned the respect and loyalty of his customers (more elderly nods). And of course, as I had rehearsed many times in my head over the past few years, I praised his remarkable, self-taught eye.

I ended with a few words about his love for my mother; as I returned to my seat, I had to wonder if anyone had noticed that the only other mention I had made of love was his love of beautiful things.

A few days later, I opened the bottom drawer of a file cabinet in my father's closet. It was filled to the brim with index cards like the ones he had shown me that day in the vault — an illustrated history of the inventory from his shop. I picked one card at random. It featured an exquisite drawing of a braided gold bracelet with rubies and emeralds, so confidently and lovingly rendered that I felt a little jealous. I pulled out the next card. The lined side was blank. I turned it over and saw this:

I closed my eyes and pictured Nat Sipress sitting at his little desk in the back of Revere Jewelers, working on his inventory, a few pieces he'd recently purchased spread out in front of him, along with a bunch of

sharpened pencils and a pile of index cards. Looking up, he sees out the window someone walking a dog on Sixty-First Street. He grabs a blank card, turns it over, and quickly sketches the dog.

I slipped the drawing into my shirt pocket, and that was the moment when I shed a tear for my father.

Losing Linda

I WAS LYING ON the couch in my therapist's office one afternoon in 2017 when he asked me if it was possible to make funny cartoons about tragic events. A school shooting had occurred a few days earlier.

"Maybe not hilariously funny, but it can be done." I reminded him of several of mine that filled the bill, including this one from the day after the horrible suicide-bombing attacks in Paris in 2015.

"What goes on down there in the name of
religion is turning me into an atheist."

Then we talked about 9/11. I recalled that for weeks afterward, the cartoon editor at *The New Yorker* rejected not only the drawings that referred directly to the attack, but also ones that had nothing to do with it, but included a tall building in the background, or depicted an airplane, or contained any other random image that could inadvertently trigger PTSD.

"Plus, timing is everything," I went on to explain. "People have to be ready to laugh about difficult events, and that can take a while." I described this one of mine that was among the first in the magazine after 9/11. It didn't appear until a full month after the attack:

I've always considered making cartoons about tragic or frightening events an art in itself. The cartoonist has to thread the needle and come up with ideas that aren't necessarily ha-ha funny and don't offend but use humor to make a relatable point, ideas that express what everyone is thinking and feeling, and do it in a way that is unexpected.

This one is the most quoted, reprinted, and shared of all my cartoons:

SIPRESS

*"My desire to be well-informed is currently
at odds with my desire to remain sane."*

This one about social distancing was penned in the midst of the
coronavirus epidemic:

SIPRESS

"I guess that whether a cartoon is funny or not is in the eye of the beholder," my therapist said.

I agreed, and then I reminded him about the email from an irate reader I had once received, via the *New Yorker* cartoon editor, about my drawing inspired by my father's shrinking stature in old age (see page 70).

I found the email on my phone and read it to him:

> In the current issue, I see a cartoon in which an elderly woman is noting the declining height of an elderly man. They are both white, of course, and it is the male who is declining, of course. Another joke on old white males. Ha ha. The wit. It's nice, I'm sure, to be young and rude, but someday you'll be old, unless, as is my wish, you drop dead first.
> Cordially . . .

"I guess you never know," my therapist said. "I especially like that he signed it 'cordially.'"

"And speaking of dropping dead," I went on, "I've done many cartoons that feature the Grim Reaper, and I imagine that if you had recently experienced the death of someone in your family, or a good friend, you might find such a cartoon painful and you might understandably be offended by it. On the other hand, you might not — after all, a good laugh about our inevitable demise can be comforting."

"For the cartoonist who thinks it up as well?"

"Sure. It feels really good to make something funny out of something scary."

"Are there some things that are just too scary? Too awful?"

"Meaning?"

"What about on a personal level?"

I sighed. "Are you thinking about Linda?" I asked. The question, we both knew, was rhetorical.

On the subway heading home after that session, sitting across from me on the train were a mother and her two boys. The older boy was engrossed in a game on his phone. The mother was reading something on an iPad. The younger boy was fidgeting with an action figure that brought to mind the toy I carried with me everywhere when I was his age — a tiny mummy in a coffin. My mother bought it for me at the Metropolitan Museum after my first visit to the Egyptian Wing. The coffin was magnetized. When I took the mummy out and placed it anywhere near the coffin, it flew back — *zip-zip* — and landed snugly in the coffin with a satisfying "click."

Something funny out of something scary, I thought. *That's why I loved it.*

After a couple of minutes, the boy looked up from his toy and, pointing to his brother, asked his mother, "How old will Michael be on his birthday?"

"Eleven," she answered, putting down her tablet.

"Like how many players on a soccer team."

"That's right, Benny," the mother said. "How many other eleven things can you think of?"

"A football team," the little boy offered.

"Good."

"The First World War," the older boy chimed in, not looking up from his phone.

"What?" asked the mother.

"We just learned about it. The First World War ended on the eleventh day of the eleventh month at eleven o'clock in the morning."

"Wow," said his mother. "OK, here's another one — the movie *Titanic* won eleven Academy Awards."

"What's *Titanic*?" the little boy asked.

"A big ship that sank a long time ago. It was a big disaster."

"Like 9/11," said the older boy. "There's another eleven."

The plane that crashed into the first tower was American Airlines Flight 11, I thought.

A hefty middle-aged man sat next to the little family in an oversized orange parka in spite of the mid-May heat, with a face that my wife would describe as "ten miles of hard road." His eyes were shut, so I assumed he was asleep, but he suddenly sat up straight, turned to the mother,

and held up both hands. "Twelve apostles," he announced, flashing ten fingers and then two. Then he lowered one finger and said, "Minus Judas — that makes eleven." Then he sat back, nodded to himself, and shut his eyes again. This put an end to the eleven discussion.

But not for me. I was thinking about my sister, and the finger thing she did at the dinner table that drove me crazy when I was four or five. Sitting across from me she would say, "Guess what, Pip — I've got eleven fingers."

"Ten," I objected.

"No, eleven. See?" Holding up one hand she would count down from the pinkie . . . "Ten, nine, eight, seven, six . . .". Next she opened her other hand and said, "Plus five makes eleven."

I shook my head in confusion, carefully recounted my own fingers, something I had only recently learned to do, and cried, "No, ten!"

I turned to my father for help, but he was focused on his lamb chops, or his liver and onions, and never looked up.

I realize that so far I've depicted Linda as being, well . . . pretty mean when we were kids. I'm sure that this picture of her is far from complete, but in my memory, she *was* mean. Teasing was her main way of relating to me. The finger thing was no big deal, but it was typical of the way she was constantly finding ways to tie my brain in knots. And she had an uncanny ability to identify the things I was most self-conscious about — my crooked teeth (later fixed by three years of torturous orthodontic dentistry), my frizzy hair, my fear of the lion house in the Central Park Zoo after I watched a lion bring down a zebra on television, and, above all, my nose, which everyone seemed to agree was too big, and to this day has an unfortunate tendency to turn bright red in the winter. Calling me "Rudolph" when we were out in public was a regular part of her repertoire. To my dismay, when she made fun of my nose at the dinner table, my father would sometimes crack a smile behind his glass of beer; even worse, my mother began raising the possibility of my getting a nose job when I got older. I vividly recall my father telling her, "Don't worry, Stell — he'll probably grow into it."

(I'm certain that all of this goes a long way toward explaining the outsized noses in my early cartoons.)

Beyond the teasing, there was also the six-year age gap. During

Linda's teenage years the raging shouting matches between my mother and sister became a daily fact of life. If I wasn't cringing in my room with my fingers in my ears, I was hovering by the door of my sister's bedroom, feeling scared, blaming Linda and hating her for the way she was treating my poor mother.

More than once I asked myself, *Does Linda hate Mom for having* me?

Now and then, their fights were reported to my father when he got home in the evening. He usually made it clear that he was too exhausted to be bothered, but when he did get involved he seemed always to find a way to excuse Linda's behavior. I'm sure this infuriated my mother but, true to form, she never openly disagreed with him about it. As for me, I gradually became aware of the nearly unbreakable bond between Linda and my father.

When Linda was home, she was usually sequestered in her bedroom, immune for the most part from my mother's snooping, since my father had given *her* permission to keep her door closed. She also managed to convince him to allow her to have her own phone and separate line — no worries about my mother listening on the extension for Linda. At the dinner table, her mood alternated from sullen and withdrawn to bubbly and chatty, the latter in exchanges with my father, or when she was teasing me. She paid little attention to my mother, and I can still see

her rolling her eyes and making sarcastic faces when my mother voiced an opinion or told my father how she had spent her day.

At some point, Linda developed a fascination for everything French. She excelled in French in high school, read French novels for pleasure, and her record collection consisted mainly of French albums — Aznavour, Chevalier, Dalida, and of course Piaf. There was a movie poster for *Les Quatre Cents Coups* on the wall of her bedroom. (My own passion for French film is the only example I can think of Linda having had a positive influence on me.) And she found a surrogate mother in her high school French teacher, known to one and all by the mononym "Mademoiselle." By the time Linda graduated from high school she was fluent in French, thanks, in large part, to extended trips to France with Mademoiselle. Somewhere along the way, while other girls her age were falling for Elvis, Linda developed a schoolgirl crush on Albert Camus. She was devastated by his death in a car accident at the age of forty-six, and when she returned from her last trip to France with Mademoiselle as a sophomore at Vassar College, she proudly told my father that she had made a pilgrimage to Camus' grave in the tiny Provence village of Lourmarin.

Linda entered Vassar in 1958, the year I was eleven. From then on, what little I know about her life has been gleaned from hazy, intermittent memories, things my parents told me, and a few documents, such as her work résumé, which she sent to Ginny after my father died in the hopes that my wife could find her a job.

At Vassar she excelled. In 1964, she started grad school at Harvard in French literature and, unlike me, she saw it through and earned her Master's degree. Her first job, in 1966, was in the publications department of the Metropolitan Museum of Art. If you Google her name, what comes up over and over is *The Unicorn Tapestries,* the title of a book she co-wrote about the enigmatic tapestries that are the pride of the Cloisters, the museum's satellite dedicated to medieval art and architecture. This job lasted six years, twice as long as any other on her résumé. After the museum, she held several jobs, one doing development for a neighborhood nonprofit, another writing reports and proposals for a large management consulting firm. When I spoke to my mother on the phone

several months after my father had his heart attack in 1977, she hinted to me that the consulting firm job had ended badly.

"Was she fired?" I asked.

"Who knows? All I know is, it was a big crisis last year, and it lasted for months. She was here all the time, talking nonstop to your father. Some of it was embarrassing, the kind of thing a woman should keep to herself, especially not blab to her father. The whole thing nearly killed him." *Was she blaming Linda for the heart attack?*

Linda did have a lot of friends, many of them loyal and caring. In the mid-seventies, she began her longtime affair with the married man from Argentina. Two or three times a year they would meet somewhere in the world — Europe, Asia, South America, Africa — and travel together for a few weeks. Now and then he came to New York and stayed with her for a week or so. I did not know he was married with kids until Linda told me after my father died. My parents certainly never knew. Linda once confided to Ginny that sometime in the past the boyfriend had offered to leave his wife and marry her, but Linda had said no because it would have meant moving to Argentina and she didn't want to be separated from my father.

The job after the consulting firm also ended badly, but not for any reason involving Linda. In 1978, she took a job with former governor and vice-presidential candidate Nelson Rockefeller's fledgling art print company, which employed an innovative color printing process to create reproductions of famous paintings that mimicked the textured surface of the originals. The prints looked pretty convincing, at least until you got up close. This job ended when the company folded following Rockefeller's fatal heart attack, an event that became a tabloid scandal when it was revealed that he was with his twenty-something assistant Megan Marshack when it happened. Of particular interest to me about the whole affair was a factoid I read sometime later in one of the tabloids: The next man Marshack dated after Rockefeller was *New Yorker* cartoonist Charles Addams.

Looking at Linda's résumé, there is a conspicuous gap of twelve years between the Rockefeller job and her next regular employment. Although we were both living in New York during that time, I was totally unaware

that she had stopped working until the day in 1985 I paid a surprise visit to my parents' apartment with an advance copy of my soon-to-be-published cartoon collection entitled *Wishful Thinking*.

Speaking of wishful thinking, when my father opened the door I held the book out in front of me, a big grin on my face, certain that now that I had published a book, albeit a book of cartoons, I would finally impress the old man.

"OK, OK," he said. He took my hand, squeezed it, pulled me toward him, and whispered, "That's good, but don't overdo it — your sister is here."

"What?"

I followed him into the den. My mother was perched on the edge of an ottoman as usual, ready to exit the room at a moment's notice should something in the kitchen need her attention, or if something were to happen between Linda and my father that made her uncomfortable. When she saw me, she popped up and greeted me warmly.

My sister was sitting cross-legged on the couch; it was two o'clock in the afternoon, and she was dressed in a nightgown.

"Pip!" Linda exclaimed. She jumped up and grabbed the book out of my hands. "You're famous!" she said, and began flipping through the pages at breakneck speed, commenting excitedly about particular cartoons. When she exclaimed "Look, Daddy, this one's about you!" and went over to show him, I knew exactly which one she was referring to:

"Never mind," my father said, and he put the book down on his desk. My mother came over, stood beside him, and started going through the book from the beginning.

"You know what that cartoon reminds me of, Pip?" Linda asked me. "*The Drama of the Gifted Child.* Have you read it? You *have* to read it. It explains *everything* about them . . ." she nodded toward my parents, "and everything about you and me — why we are the way we are."

I thought, *What you mean* we, *Kimosabe?*

My mother stood. Her eyes were fluttering when she looked at my father and said that she needed to do something in the kitchen. I followed her a minute later. This was a couple of years before her memory problems really kicked in. I asked her why Linda was in her nightgown. "Is she staying here?"

"Yes."

"For how long?"

"For a while."

"But why? She has her own apartment ten minutes away."

"Don't ask me," my mother said. "She says she has insomnia. She can't sleep in her apartment. Ask your father about it. But not now, or he'll get upset. He's upset enough about her as it is. Maybe you could talk to her, David?"

I ignored this. Getting involved in their *mishegas* was the last thing I would ever do. Instead, I asked, "What about her job?"

"What job?" my mother said, bitterly.

I came by the apartment a couple of months later on my father's birthday. When I entered the den, I immediately noticed that the couch was covered with shopping bags from Bergdorf Goodman, Saks, and Lord & Taylor. Dresses and skirts and blouses were draped over the back of the couch. I kissed my father on the cheek, gave him my birthday gift, and asked, "What's going on?"

"A fashion show," he replied, glumly.

I kissed my mother and she said, "Oh, David, I'm so glad you're here."

Before I could answer, the bathroom door opened and Linda came out wearing a black dress with the price tag showing. She greeted me and then said to my father, "What do you think, Daddy? This one or the green?"

"This one," he said.

"I agree," said my mother, cheerfully.

"I didn't ask you," Linda snapped.

Crestfallen, my mother stood and left the room. I joined her in the kitchen, where she was heating up the tea kettle.

She said, "What can I do? Nothing I do is right. God forbid I should have an opinion."

"Sorry, Mom," I said.

"She only wants his opinion, and she wants it about everything. The fact is, she can't make a single decision without your father — what to wear, what friends she should keep, what to say in a job interview. You'd think she was five years old. Meanwhile, she's running your poor father ragged. This is how she celebrates his birthday. Big deal — she gave him another necktie — so now he has a hundred and one. Would you like some tea?"

"Sure."

She took out two cups from the cabinet and a box of tea bags. "It's your father I'm worried about," she went on. "He can't take it. She doesn't give him a minute's peace. Why can't she bring these things to her psychiatrist? Or her friends. She's got a million friends, but she brings all her problems to your father."

"She sees a shrink now?"

She nodded. Then she turned and, with a terribly sad look on her face, she asked, yet again, "You had a happy childhood, didn't you, David?"

"Yes, Mom," I answered.

"I tried with your sister. I don't know . . ."

"Is she still sleeping here?"

"On and off, whenever she has one of her nervous breakdowns."

"Nervous breakdowns?"

"That's what your father calls them," she explained. "Help me make this tea. I need it — otherwise I'll have a headache."

When I had made our tea, I sat down on the ancient metal stepstool she used to reach things on the top shelves of the cabinets. My mother stood leaning against the stove, holding her cup in both hands, reflexively nodding her head — a tic I hadn't seen before.

"She gets nervous all of a sudden, especially when she can't find a

job," my mother explained. "I'm not sure she's even looking, to tell you the truth." She sighed deeply, sipped her tea, and said, "But why would she look when she can just go on taking advantage of your father? Like always, she's got him wrapped around her little finger. Who do you think is going to pay for all those clothes? Every other week she goes on a shopping spree."

We were quiet for a minute or two, until she sighed again and said, "Your sister knows exactly what she's doing, including her so-called nervous breakdowns. Since she was a little girl, she's always known how to get what she wants."

I nodded. This version of Linda matched my own. It certainly was the Linda I knew. Or thought I did.

BY THE TIME Ginny and I got married in 1990, Linda was working again, writing grant proposals and doing fundraising for an arts-related nonprofit. She was happy and loquacious at the wedding, chatting up our friends, announcing her wedding gift — we were going to Italy on our honeymoon, and she was giving us one night in the honeymoon suite of the luxurious Hassler Hotel in Rome.

For the next few years, we saw very little of Linda, but when we did, it was obvious she was feeling better — busy with a new job, friends, and travel with the boyfriend. She didn't want to get together with us, and that suited us just fine. We saw a bit more of her around the time of my mother's death, but, as Ginny had predicted at his funeral, it was in the aftermath of my father's death that our relationship with Linda really changed. For three or four months, she and Ginny and I were thrown together several times a week as we sorted and catalogued the endless stuff in my parents' apartment, collecting papers and documents, giving away piles of clothing to thrift shops, identifying all the beautiful things — selling most of them and dividing a few between us. Every single item involved tough negotiations with my sister, who turned out to be her father's daughter in the bargaining department.

If there was one thing all three of us agreed on, it was that none of us trusted Ezra, the executor. Linda in particular was convinced that he was stealing from the estate, so Ginny did some research, and came to the conclusion that in fact everything he was doing was above board.

Still Linda couldn't let it go, even after we consulted a lawyer. In what would become a pattern going forward, no amount of assurance or documented proof could make a dent in my sister's anxiety on the subject.

Things were particularly tense the morning Ezra accompanied Linda and me to the vault to empty my father's safe deposit box. On the way there, every time Ezra said something, Linda made a sarcastic face or emitted an exasperated sigh, none of which was lost on him. Downstairs at the bank, Mr. Moses was still in charge, and when I told him my father had died, he looked genuinely sad. "He was one of my regulars," he explained to Ezra, while he showed us to my father's favorite room.

When we opened the box, we saw that my father had left a piece of paper on top that listed who was getting what. We did the divvying up, and I have to admit, I took some pleasure in watching Ezra's face as I slipped my beautiful, hard-won icon into my backpack.

Once the estate had been settled, we saw less of Linda for a while. At some point, however, she started to call us more often, asking to get together, seeking my or Ginny's advice about various problems, laying out her various worries over the phone as she once had with my father, chief among them her worry that she was going to run out of money. She had apparently stopped working again. Ginny and I tried to convince her that the money she had inherited from my father plus her considerable savings and investments (where those funds came from was a mystery — she hinted the boyfriend) were more than enough to sustain her indefinitely in the style to which she was accustomed. One evening we went to her apartment, sat down with her, and reviewed the monthly reports from her broker. By the end of the discussion we thought we had proven to her that she had nothing to worry about. But it wasn't long before she called again, once again in a nervous state about her financial situation.

"She gets this crazy running-out-of-money thing from your father," Ginny said, after I hung up and screamed at the ceiling in frustration.

Later, Ginny asked me if I'd noticed that Linda no longer mentioned the Argentinian boyfriend. "Their last trip was to Sicily," she said, "but that was a while ago. Do you think we should ask her about him?"

"No way," I responded. "I do *not* want to get involved. She has her friends to talk to if there's a problem. And her shrink."

"She hasn't mentioned him in a while either," Ginny pointed out.

Linda called several times right after 9/11. It really scared her. I asked her if she was talking to her psychiatrist about it and she was noncommittal. We were concerned and invited her over for dinner two or three times, and she always arrived in a good mood. We were relieved.

Not long after one of those evenings, she kept Ginny on the phone for almost an hour with one question after another about whether or not she should get a cat. She had met Nigel at our apartment and, like everyone who ever met him, she fell in love. The next time she called, it was to say that she had definitely decided to get a cat, and she quizzed us endlessly about what kind to get. A few days later she called again and insisted that we come to her apartment for dinner because she had a big surprise. The surprise turned out to be Sancho, an Abyssinian who was the spitting image of Nigel, but his polar opposite in personality — aggressive, whiny, and unfriendly. Nevertheless, Linda seemed to love him. On our way home, Ginny said, "He'll keep her company, which has to be good."

"Yeah," I agreed, "maybe she can discuss her problems with him from now on and give us a break."

"Don't you think that it's a little creepy that he looks so much like Nigel? It feels like she's trying to replicate us with the cat."

I said, "She's getting really clingy, and the clingier she gets, the more determined I am to keep my distance. I'm beginning to realize she wants me to step in for my father — the job he tried so hard to recruit me for over the years."

ON A MONDAY afternoon in early October 2002, I was finishing up my weekly cartoon submission for *The New Yorker* when I got a call from Linda's across-the-hall neighbor. She was concerned. My sister had recently knocked on her door and given her a set of keys to her apartment. Now, she hadn't seen Linda in a few days, she told me, but she'd noticed that Linda's umbrella was still outside her apartment, and it hadn't rained since Thursday. She was at work and had the keys with her if I wanted to come by. I hung up and called Linda — no answer. Then I called Ginny and together we went to the neighbor's office and picked up the keys.

On the cab ride uptown my stomach was churning. "I have a bad feeling," I said to Ginny.

"Me too," she replied.

Every detail of what happened next plays out like a film clip inside my head — often when I least expect it — and once it starts, I can't look away.

We let ourselves into her apartment and I called Linda's name. When she didn't answer I said to Ginny, "Whew. She's not here."

But then I noticed the dining table. It was covered with papers — from across the room I could see they were mostly piles of financial statements and bills.

"I'll check the bedroom," I said.

And there she was, in bed, under the covers. The cat, Sancho, was hunkered in a corner of the room, his cat eyes wild, his back twitching. Ginny came in. "She's dead," I said.

"I know," Ginny said. "She left a note. Leave the room while I make sure."

I saw the note on the table. Besides the statements and bills, there was a copy of her will and various other documents. When Ginny returned from the bedroom she said Linda was definitely gone. I felt helpless. I had no idea what to do. Ginny picked up the phone and called her therapist for advice, who said we should call 911. We did, and while we waited for the police and the medical examiner to arrive, we sat close together on the couch, both of us cycling through a million scary feelings.

"What did the note say?" I asked Ginny. "I can't bring myself to read it."

"She apologized — said she was sorry but she couldn't go on. She said she knows that we all tried to save her, but nobody could. Then she asked us — *you* — to pay her outstanding bills and take care of everything else. It seems like she hadn't paid anything for months."

"How could we not have known?" I asked.

"We couldn't, David," Ginny assured me.

I nodded. Then I pointed to the table. "Those piles of papers, all those documents," I said, "it's like a physical manifestation, a summing up, of everything that was tormenting her."

The medical examiner arrived along with several police officers. After half an hour or so, he came into the living room and told us that Linda

had probably been dead for twenty-four to thirty-six hours; that she apparently had hoarded a large number of antidepressants, sleeping pills, and various other medications, for many months judging by the dates on the bottles. She had taken all the pills, gotten into bed, and gone to sleep.

After Linda's body was wheeled out on a gurney, we were told that we could leave. The medical examiner explained that the apartment would have to be sealed until he finalized his investigation. This left the problem of the cat. We started to look for him but couldn't find him anywhere. A big, burly cop with a kind face offered to help. He located Sancho under Linda's bed, but when he reached in to grab him, the cat bit his hand. Sancho then shot out of the bedroom and began streaking around the apartment, yowling like crazy.

The final scene of the film clip is a kind of farce, a physical comedy, with Ginny and me and the huge policeman chasing Sancho all over the place, until the cop managed to grab his tail and corral him into Linda's cat carrier. He was still yowling when we carried him out of the apartment, just before that same officer spread the yellow tape across the door.

ONE MORE FUNERAL at Frank Campbell (it was stipulated in her will), one more identification — meaning one more morbid image lodged permanently in my memory bank — one more box of ashes, one more estate to deal with, one more apartment to clean out. After the funeral, we held a get together at our apartment. Many of Linda's friends came, as well as a few of ours. It was an odd event since nobody seemed to want to talk about the elephant in the room — the manner of Linda's death. Ginny said a few words about Linda's accomplishments, and then several of her friends reminisced about her. I read a poem by Edna St. Vincent Millay, a Vassar grad like my sister.

Once everyone left, Ginny and I collapsed on the couch. "I'm totally exhausted," I said to her. "I don't think I've ever felt so worn out."

"I know," she agreed, "my get-up-and-go got up and went."

Then she yawned and suggested that we get away for a few days.

There used to be a wonderful and wonderfully affordable old-fashioned motel outside Montauk, New York, long gone now, called The

Panoramic View, so named because nearly every room had a breathtaking, wide-angle view of the beach and ocean. We arrived there on a gray, chilly late afternoon, and after we unpacked, we sat out on our balcony wrapped in blankets, me with a vodka martini, Ginny with a glass of Sancerre.

"This is perfect," Ginny said. "Let's stay out here for an hour and then take a walk before dinner."

"Works for me."

"What's for dinner, by the way?" Our room had a kitchenette and we'd planned to self-cater.

"Bay scallop risotto, sautéed broccoli rabe on the side, your almond cake for dessert."

"Yum."

We sat quietly for a few minutes, until I said to her, "I guess we should talk. How are you feeling?"

"OK. Not great."

"Tell me."

"I can't stop thinking about it," she said. "Every time I'm not busy, I go straight back there. It's so sad, the worst thing that's ever happened."

"Yes."

"I have to admit, sometimes I feel really angry."

I nodded.

"But, the truth is, I'm mostly worried about you. I love you so much and I worry you're not OK."

"I love you too, Ginny. I don't know what I'd do without you."

"Tell me what's going on."

"I get these waves of sadness — about her — about her suffering. But, also about the loss. Not the loss of Linda, really, but the loss of my family — such as it was."

"I understand."

"And like you, I feel angry — angry at her for doing it, and angry at her for everything she's dumped on us — everything we have to clean up and take care of."

"I know."

"My father knew what he was asking." I sighed. "I had to take care of her after all."

Ginny took my hand and squeezed.

"But that gets into something else," I said. "Guilt, I guess — I admit I've been asking myself about whether or not I should have done something, whether we could have . . ."

"No, David." She let go of my hand.

"But . . ."

"We've talked about this — there was *nothing* we could have done. Nothing is our fault. She was *mentally ill.* You saw the letter her psychiatrist sent us. She was bipolar — manic depressive — he had been treating her for it for many years, right?"

"Right."

"According to him, she couldn't cope — before, too — but especially after your father wasn't around. And how could we know about her boyfriend breaking up with her? She told the shrink, but she never told us. And apparently, right after that happened, she ended her treatment, which we also didn't know."

"How could he not have realized she was at risk?"

"Maybe he should have, but he insists he never suspected."

"I guess."

"I know, but the fact is, everyone who knew her who's willing to talk about it says the same thing — no way they saw it coming. Your sister, who never met a secret she could keep, who would go on and on about every single thing she was feeling at the drop of a hat, for once in her life managed to keep everyone totally in the dark. She was absolutely determined, that's clear. She planned it for months and months, saving her meds . . ."

". . . that's the part I can't get my mind around."

". . . and nobody, *nobody,* saw it coming."

I sighed. *My father saw it coming,* I thought.

We sat without speaking for a bit, watching the waves break over the beach. The silhouette of a big tanker drifted along the horizon.

Then I said, "There's something else."

"What?"

"I've also been feeling kind of scared, but . . ."

"Scared? About what?"

"Don't get mad at me for saying this, but I've been realizing that

there's a part of me that understands her — relates to her — and it scares me that . . ."

"Relates to her how, exactly?"

"To the things that drove her to do it . . ."

Ginny frowned. "I just said . . ."

"I *understand* that she was bipolar. Even so, her fear about running out of money, her belief that she couldn't cope, her insomnia, the chronic worrying — all that is familiar to me. After all, we had the same parents . . ."

Ginny sat up straight. She pointed at me and said, "Once and for all, you are *not* your sister. She was sick, David."

"Ginny, please — just let me finish, OK?"

She sat back again, crossing her arms. "Go on," she said.

"When we got into bed the other night after the funeral and the thing at our apartment, you fell asleep immediately, but I lay awake for over an hour. I finally put on my headphones and listened to sports talk on my radio — they were having an endless back and forth about what went wrong with the Yanks this year — a lot of moaning and groaning. I was hoping the conversation would bore me to sleep, but instead, it started me thinking about my father's baseball predictions and his pessimism, his negative chicken counting and the rest. And then my mind went to that thing he once told me — about what he almost did all those years ago, when he thought he was going to lose everything. And then I thought about that memory, or dream, or whatever it was, about someone purposely walking in front of a trolley. Then I thought about Linda, and then about the time I rode my bicycle . . ."

Ginny held up her palm. "You can stop right there — I'm not going to listen to this."

"Please, Ginny . . ."

"Let me tell you what's always stood out to me about that story about you and the bicycle — it's what you did right afterward: You ordered a cheeseburger and drew a cartoon. *That's you,* David — that's who you are. So if there's some dark strain that runs in your family, *you don't have it,* OK?"

"I *know* that. If you give me a chance, I'm really trying to say the same thing. Wait here a minute. There's something I want to show you . . . actually, two things."

I went into the room and brought back my small leather portfolio. I unzipped it and took out two of copies of a drawing I'd brought with me.

"Look at this," I said, and I showed her the first drawing:

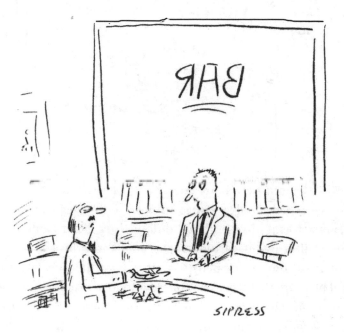

She said, "That's always hanging above your desk."

I smiled. "That's right. The fact is, I've been staring at it forever, because I've always been convinced that there's a terrific cartoon idea hiding in plain sight somewhere inside it. It's like when something is on the tip of your tongue and you just can't come up with it — but for years! And then, the first time I sat down at my desk since everything happened, I was contemplating it as usual, and before I realized what was happening, I had added *this* to it."

I put down the first drawing and showed her the second:

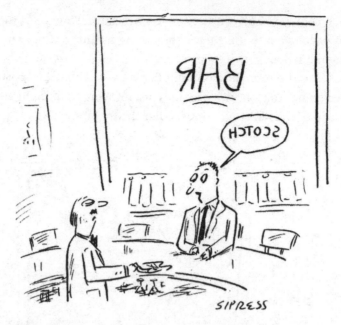

"Ha! That's fantastic!" Ginny exclaimed. "I *love it!*"

"Listen — when an idea comes to me like this, it's as if it happens *to* me, almost as if I had nothing to do with it, like it came out of nowhere — a gift from the cartoon gods. And I know this sounds over the top, but every time it happens like that, I get this rush — an intense physical pleasure that feels like pure joy, and it's like fireworks go off in my brain — starbursts behind my eyes. More than anything else about my work, it makes me love what I do." Ginny started to say something, but I stopped her with a raised finger. "As long as I can have that experience," I went on, "as long as I can sit down and draw, come up with ideas, blow my own mind once in a while with what pops into my head, I will always feel like everything is going to be all right. Since I was a little kid . . ." I held up the drawing and shook it ". . . *this* has been my happy place. *Fershtay?*"

"Yes."

"Plus, even though I've struggled with depression like . . ."

"I said, I *fershtay,* David."

"No, wait. Let me finish. There's one other thing."

"Go on."

"Even though I've struggled with depression and anxiety at times,

and with the occasional dread about the future thrown in, there's one big difference between me and my father and my sister. You know this better than anybody — maybe it's something I got from my mother. It's that I've always, *always,* been able to laugh at myself. In fact, I've made a career out of laughing at myself."

"Yes!" she agreed.

"Speaking of which . . ." I reached into the portfolio and pulled out a copy of *The New Yorker.* "Now, my dear, I present what can only be called 'the proof in the pudding' . . ."

"Huh?"

"With everything that's gone on, I totally forgot about this until yesterday. This is the September 30th, 2002 issue of the magazine. That's one week *to the day* before we found Linda. And it's exactly two weeks ago from right now, when we're talking about what we're talking about, and about to take a walk on the beach." I opened the magazine to a page I'd marked with a sticky. "For the rest of my life, I will never cease to be amazed that this cartoon of mine was published in *this* issue of *The New Yorker.*"

I held up the magazine to show her:

"All right, Stephanie, you win—it's great to be alive!"

"Wow," she said.

"Exactamundo," I replied.

Discoveries

THE WEEK AFTER we got back from Montauk, Ginny and I re
turned to Linda's apartment to begin the task of going through her
stuff and cleaning the place out. I started with the closet in her bed-
room. It was jam-packed with brand-new clothes, some obviously never
worn, still in the hanger bags from the store.

I noticed that there was something tucked away on the floor in one
corner, covered with coats. It turned out to be a large carton with *re-
cords/docs/photos/other* written on the side by my mother. I carried the
box over to a table and opened it. On top were several receipts for furni-
ture my parents had purchased. Under the receipts were bundles of what
looked like bank statements. I scooped up a bunch of them and dropped
them on the table. They were indeed my father's bank statements, going
back many years, and in every one I opened, the canceled checks told
the same story: My father had been paying Linda's bills — medical bills,
maintenance bills for the apartment he had bought for her, pharmacy
bills, electric and phone bills — pretty much everything. There, too, was
the answer to the question of where Linda's mysterious nest egg had
come from; it wasn't the boyfriend after all. My father had been writing
her hefty personal checks every month for more than two decades. It ap-
peared that Linda had purloined the entire box to hide from us the fact
that he had been supporting her, but she never got around to disposing
of the evidence.

"So much for 'even-steven,'" I said out loud, a little bitterly.

But I immediately reminded myself that the money and all the other

ways my father took care of Linda and kept her close had been a terrible trap for my sister. Almost from the start, wary of those parental clutches, I was determined to build a separate life, whereas Linda had never been able, and in some ways was never allowed, to do the same.

I picked up one of the canceled checks and thought about the meaning of money. I remembered what my therapist once said: "Sometimes in families, money and love become interchangeable." From the beginning, my father saw Linda's situation for what it was. *He tried to help her in the only way he knew how,* I reasoned.

But still . . .

I kept digging in the box. Under the few remaining bank statements, I discovered a cache of family photos, including the one of the four of us in the park featuring me with my six-guns. There were several of my father, including one of him in an elegant tuxedo, standing on the deck of the SS *France*. I found, as well, Linda's college diploma, a review of her book on the Unicorn Tapestries, my letter of acceptance to Williams, my tuition bill from Harvard, and some birthday cards I had made for my parents.

Beneath the birthday cards I found my parents' wedding announcement and a bunch of congratulatory telegrams tied with a silver ribbon that were sent to the hotel in Provincetown on Cape Cod where they spent their honeymoon. There was a short love note my father wrote to my mother on their first anniversary. At the bottom of the carton I found an envelope containing my mother's birth certificate, photos of her teaching a first-grade class in the 1920s, photos of her frolicking on the beach with friends from around that same time, and one of her as a little girl in which she's standing on one leg making a funny face at the camera and performing a silly version of a ballet pose while wearing a frilly dress, ankle boots with buttons, and a giant bow in her hair.

Predictably, there wasn't a single photograph or document relating to my father that predated his wedding in 1937. I picked up the most recent photo of him, taken by someone at Gino's in the late eighties, and studied his face, remembering the last time I'd seen him and the surprising conversation we'd had that shed a few slim, gauzy rays of light on his distant past.

He and I were sitting on his living room couch, surrounded by many

of the beautiful things he had acquired in the course of his life — the Tiffany vase and the Lalique bowl displayed in an antique glass cabinet beside the couch; the pastoral landscape painting on the wall across from us by a member of the Hudson River School; the rare Queen Anne side table with a lovely bronze figurine of Buddha sitting on top of it; the large table lamp, its ceramic base decorated with images of Russian peasant women (the lamp base, I would learn after my father's death, had originally been a vase that belonged to the Russian royal family) — all purchased, I had no doubt, only after he had gotten "his price." His diminished, ninety-two-year-old frame was folded so deeply into the cushions that his cracked leather slippers dangled six inches above the floor. His eyes, even flattened by his bifocals, still had their fixed, recalcitrant edge. We talked about my upcoming trip to London with Ginny and he began reminiscing about the time he and my mother visited the Victoria and Albert Museum. Then, suddenly, in mid-sentence, he leaned forward, shook his head, and said, "Look at this place, will you? Can you imagine? The house I was born in had a dirt floor, David, and this is where I wind up." He took off his glasses, wiped them with a handkerchief, put them back on, and said, "But I'm telling you, that little house, dirt floor and all, was clean as a whistle. My mother made sure of that, even though she also worked day and night taking in sewing just to keep the food on our table."

"Your mother . . ." I started to ask a question about her, but he ignored me.

"Things were tough, believe you me," he went on, staring into the middle distance, "but everyone chipped in. She was strict, God knows — you did what you were told."

He sighed. "One thing for sure, you were never lonely in that house. Life was good, in its own way."

After a pause, he shook his head again and went on: "That was some awful journey we took to get here — you can't imagine. But it was my mother who kept us going — across Europe and across the ocean — I don't even want to go into the conditions. But the worst, believe it or not, came at the end — at Ellis Island. One of my brothers was a hunchback. The s.o.b. in charge wasn't going to let him in. He threatened to send us *all* back. But she wouldn't take 'no' for an answer. How did she

do it? Who knows? All I know is, pretty soon we were free and clear, and she marched us right out of there. She was so brave, my mother. She was like a queen to me."

He let out a long exhale and sat back against the cushions. Meanwhile, in the wake of this unprecedented flood of revelations, my first thoughts were, *What were my problems when I was a boy? That I couldn't have a dog? That my mother had migraines? That my sister was mean?*

The image of his hand resting on his mother's knee in the family photograph popped into my head. I kept silent and waited, hoping he would say more, but suddenly he started to cough. He bent forward over his knees and the coughing got worse. I hurried to the kitchen to get a glass of water, but when I returned, he impatiently waved away the water, cleared his throat a couple of times, and said he was fine. I could tell that the mood had changed — our previous conversation was over.

Next time, no matter what, I'll just go ahead and ask him to tell me more, I promised myself.

"One more thing . . ." he said. He slid to the edge of the couch and pushed himself up, reached into his trouser pocket, and pulled out a small wad of bills. "British pounds from our last trip," he explained. "Your mother saved them."

I thanked him.

"Don't say I never gave you anything, Duvid," he added, grinning.

"The country Poppa came from was a stinking hellhole of unspeakable poverty where everyone was always happy."

. . .

NOW AND THEN, when I look up from my desk and ponder the solemn faces in the Medzhybizh photograph, faces that are disconcertingly familiar, I experience a surge of regret that I never felt I had the chance to ask him to tell me more, and am left with my unanswered questions about his early history and his estrangement from his relatives. Two descendants of my father's siblings (perhaps they are the children of the relatives who showed up and then left my mother's funeral) recently sent me Facebook messages, asking if I would like to make contact. I thought about responding, but I couldn't help remembering my father's distress after the one time he let a relative in, and the painful request for, and refusal of, money that ensued. In the end, I chose not to reply. Maybe I'm turning into my father. Or maybe I don't want to know.

Or maybe bygones should remain bygones, since that's what my father wanted.

Epilogue

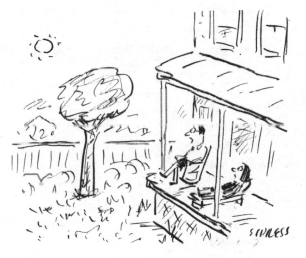

*"This is one of those beautiful spring afternoons
when I'm flooded with memories of things
that never happened to me."*

IN THE INTRODUCTION to his memoir, *The Pigeon Tunnel*, my favorite novelist, the late John LeCarré, wrote, ". . . pure memory remains as elusive as a wet bar of soap." In the course of writing this book I've wondered at times about the accuracy of my memories about various things, chief among them the thoughts and feelings I had as a child. Now and then, I've had to ask myself if something I've written is the result of projection, or hindsight.

There is one part of the story that I've always been certain is neither

projection nor hindsight—that my dream from the time I was little was to be a cartoonist. A recent discovery has reinforced that certainty. The same year I started writing, several of my classmates from Hunter College Elementary School organized a reunion of our sixth-grade class. It was a delightful event, all of us together after nearly sixty years, eager to see how the other little geniuses turned out. A month before the event, the organizers asked us to look for any memorabilia that we might want to display at the reunion. I pulled out the box where I kept that sort of thing from the back of a storage closet. I hadn't opened it in many years. Going through it, I came across my autograph book. Way back in the pre-digital age, schoolkids passed around autograph books for their classmates to write notes in and sign when they graduated from elementary school. Most of my classmates' notes were intentionally dumb, like this one:

> The stork flew from North to South,
> With Little David in its mouth.
> When he reached the little hut,
> There he dropped the little nut.

Our teachers wrote notes too, and when I turned to the last page of my autograph book, I came upon an inscription from Miss Boylan, the art teacher. I had totally forgotten about it.

There it was, another proof in the pudding:

THE REUNION TOOK place at the Hunter College building that once housed the elementary school. At the end of the evening, I was feeling nostalgic, to say the least, and even more so when I wandered a few blocks south on Lexington to the corner where my father's store was once located. Memories of the shop, thoughts of him, flashbacks from elementary school, all swam around in my brain as I stood there. Later, on the subway ride home, I made this list on the back of my invitation to the reunion:

NAT	ME
HAD A PLAN FOR THE FUTURE EVEN AS A BOY	✓
CUT HIMSELF OFF FROM HIS FAMILY TO MAKE THAT PLAN A REALITY	✓
HIS WORK MADE HIM HAPPY AND PROUD	✓
HAD TO BE HIS OWN BOSS	✓
CONFLICT AVERSE	✓
CHANGE AVERSE	✓
BIG WORRIER WHO NEVERTHELESS, TOOK BIG RISKS	✓

I brought the list with me to my therapy session the next day. When my therapist had finished reading it he asked, "Why was it important to show this to me?"

"I've always thought of my father's life story as the complete opposite of mine," I said.

"And now?"

"Standing on the corner where his shop used to be, it suddenly dawned on me that there are all these parallels, all these ways I can see my story in his story."

"And . . ."

"And it made me wonder if he saw himself in *me*." I felt my voice crack a little. "If only I could ask him," I murmured.

"How do you think he would answer?"

"He wouldn't. And I never would have asked him, either. If there's one way he and I definitely were similar, it was that neither of us was ever ready to have that kind of conversation."

"Hmm."

Silence. My mind took a walk, back to the long-ago conversation with Ginny about my father and the robbery and how she had convinced me to think differently about all of it. About him.

"What's going on, David?" my therapist asked.

"Sorry," I said. "If he *did* see himself in me, then maybe there's another explanation for his disapproval and anger about the choices I made, his trying to control me, the curse on the phone call, his never accepting that all I wanted was to be a cartoonist, and all the rest — everything I've always resented and begrudged him. Is it possible that all of that could have been because he was genuinely worried about the risks I was taking? Starting with dropping out of grad school and cutting myself off from him?"

Now I thought about him on that roof, his legs dangling over the edge. *It was fifty-fifty,* he had told me. Maybe all along he had just wanted to protect me from what he had been through — the stuff he had such a hard time talking about, the stuff I'll never really know the whole truth about.

I said, "Maybe all of it was simply because . . ."

"Because?"

"Because he loved me."

"Ah," sighed my therapist, in an unprecedented display of something like emotion.

I heard him shift in his chair, and after a few seconds, he asked, "Tell me this — what you just said about love — how does that make you feel?"

More silence.

"What's going on?"

"Nothing."

"David — for once — *please* just answer my question and don't turn this moment into a cartoon."

Too late:

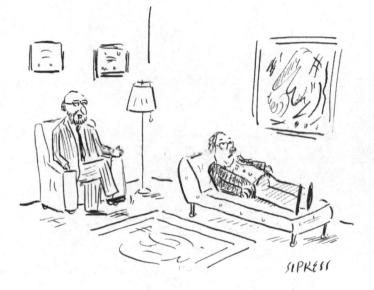

"When I ask, 'How does that make you feel?',
how does that make you feel?"

Acknowledgments

I MUST BEGIN by acknowledging the two cartoon editors I have been fortunate to work with at *The New Yorker*, Bob Mankoff and Emma Allen. It was Bob who ended my long sojourn in cartoon wilderness by advocating for my work as soon as he took over as editor in 1997. I will always be grateful to him for my first "OK." Bob, himself a storied cartoonist, has a highly developed nose for the truly funny, and is a relentless champion of the art of cartooning. A high-energy dispenser of cartoon wisdom, Bob was nonetheless a hands-off editor (at least as far as I was concerned), saying next to nothing to me about any individual cartoon over the years, letting his continuing support of my work do the talking.

As the editor since 2017, Emma Allen, no slouch herself in the nose-for-the-truly-funny department, has brought in a slew of new voices and drawing styles to the magazine, while keeping the door wide open for grizzled veterans such as myself. She has a knack for choosing my favorite cartoon in every batch I submit. Emma, like Bob, takes a hands-off approach, and yet her accessibility and supportive emails have made what can be a sometimes grueling and dispiriting process of submitting and mostly, if not totally, being rejected on a weekly basis so much easier to bear.

That process goes something like this: We cartoonists submit as many as ten or fifteen "roughs" a week. The editor is then tasked with whittling down those hundreds of roughs to a precious few that are then presented at the weekly art meeting to The Decider — *New Yorker* editor David Remnick — who alone chooses the very few that will

ultimately make it into the magazine. And so, it is to David that I owe a very large debt of gratitude for the nearly seven hundred times he has given a thumbs up to one of my cartoons over the past twenty-four years.

I must acknowledge, as well, my fellow *New Yorker* cartoonists who have inspired me and kept me laughing for . . . well . . . a lifetime. Before the magazine decamped from Midtown to lower Manhattan, the cartoonists would recover from the stress of presenting their batches to the editor on Tuesday mornings by gathering for lunch at a not-fancy theater district French restaurant called the Pergola des Artistes. The Pergola served an $8.95 lunch special and — this was crucial — a free glass of wine. It was at the lunches that I met many of my longtime cartoon heroes and forged friendships with a younger crowd of my contemporaries. What always struck and delighted me at the lunches, beyond the general hilarity that sometimes ensued, was the way everyone was willing to lend their wisdom and support to fellow cartoonists, in spite of the highly competitive nature of our chosen profession. Although the lunches are a thing of the past, it is still my experience today when I meet with colleagues that this unique generosity of cartoonists continues to be the rule.

My first real attempt to write nonfiction was a postscript essay I wrote in honor of my culinary hero, the Italian chef and cookbook writer Marcella Hazan. I wrote it the morning she died in 2013, and immediately sent it to Michael Agger, culture editor of the *New Yorker* website, newyorker.com. Michael accepted it, and he has continued to publish my essays ever since. I'm thankful to Michael for that, and for how much I've learned about writing from his sharp, clear, and perceptive editing of my pieces.

I'm especially grateful to my good friend, the wonderful — and wonderfully funny — *New Yorker* writer, Sarah Larson. Sarah announced herself a fan of my writing early on, which meant an enormous amount to me, not in the least because I am such fan of hers. Her advice and encouragement have been invaluable.

Sarah gets additional thanks because it was at one of our semi-regular lunches at Cafe Mogador in the East Village that I mentioned I was interested in finding an agent for my partially written memoir, and she offered to introduce me to another Sarah, my terrific agent, Sarah

Burnes. Sarah B.'s wise guidance, astute editing, ardent advocacy, and thoughtful friendship have meant the world.

I am also grateful to my superlative editor at HMH, Deanne Urmy, for her excitement and enthusiasm about *What's So Funny?* from the get-go, for her endlessly helpful and spot-on suggestions and edits, and for all she has done to make the book so much better.

Thank you, as well, to Martha Kennedy, HMH art director, for her smart, imaginative work on the book jacket and for our fun collaboration putting together the image.

I am deeply grateful to my therapist (you know who you are) for helping me make sense of my family — not to mention, myself.

Speaking of family, I am thankful to my mother, father, and sister, for making life complicated and interesting, for doing their best, and for leaving me with so many stories to tell.

What's So Funny? is dedicated to my wife, Ginny Shubert — trusty first reader, insightful first editor, loving partner in all things, and my hero. Thank you for laughing at (nearly) all my cartoons, for keeping me focused on the big picture, for always believing I could write this book, and for always telling me the truth, in spite of moments like this:

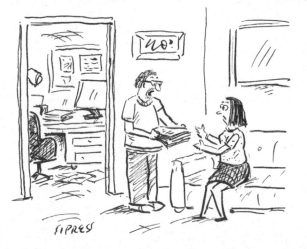

*"Here it is—my book. I'll be interested to
hear your compliments."*